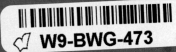

W9-BWG-473

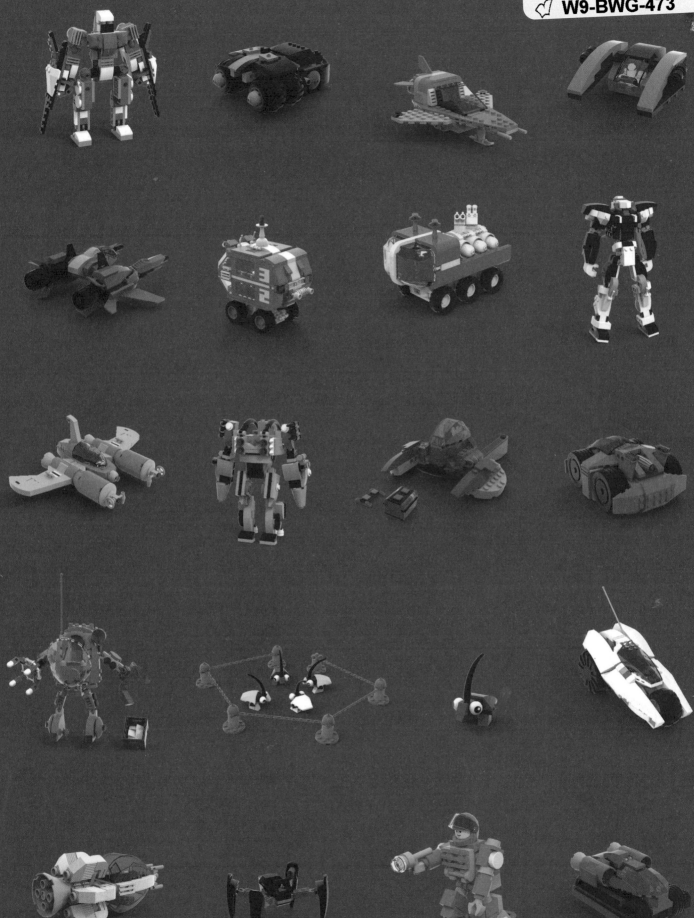

HOW TO BUILD
SPACE EXPLORERS WITH LEGO® BRICKS

Francesco Frangioja

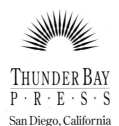

THUNDER BAY
P·R·E·S·S

San Diego, California

FRANCESCO FRANGIOJA

Francesco Frangioja, born in 1971, is a LEGO® enthusiast and builder. He rediscovered his love for LEGO® bricks in 2010, and immediately began an active collaboration with several communities of LEGO® enthusiasts (AFOL—Adult Fans of LEGO®). He's especially interested in the ludic-educational aspects of "playing with LEGO® bricks" concerning children—aspects lying at the heart of the project for this book. In 2016, he decided to "expand" his passion for LEGO® bricks to the professional sphere, obtaining the certification of Facilitator in the LEGO® SERIOUSPLAY® Method from the Association of Master Trainers in the LEGO® SERIOUSPLAY® Method. He subsequently started planning and holding workshops at private companies and public corporations. He is also the author of *How to Build Easy Creations with LEGO® Bricks*, published by NuiNui.

Thunder Bay Press
An imprint of Printers Row Publishing Group
10350 Barnes Canyon Road, Suite 100
San Diego, CA 92121
www.thunderbaybooks.com

Thunder Bay Press
Publisher: Peter Norton
Associate Publisher: Ana Parker
Publishing/Editorial Team: April Farr, Kelly Larsen, Kathryn C. Dalby
Editorial Team: JoAnn Padgett, Melinda Allman, Dan Mansfield

Graphic Design: Ngoc Huynh
Translation: Contextus s.r.l., Pavia (Richard Kutner)
Web Support: QLtech, Milan (Italy)

ISBN: 978-1-68412-541-8
Printed in China
22 21 20 19 18 1 2 3 4 5

The publisher would like to thank ItLUG - Italian LEGO® Users Group for its valuable collaboration.
http://itlug.org

Shutterstock Inc. photo reference:
pp. 14-15 and 204: Vadim Sadovski /
pp. 16, 30 and 159: sdecoret / p. 82: Flashinmirror /
pp. 92 and 183: diversepixel / p. 126: ppl /
p. 206: Marc Ward

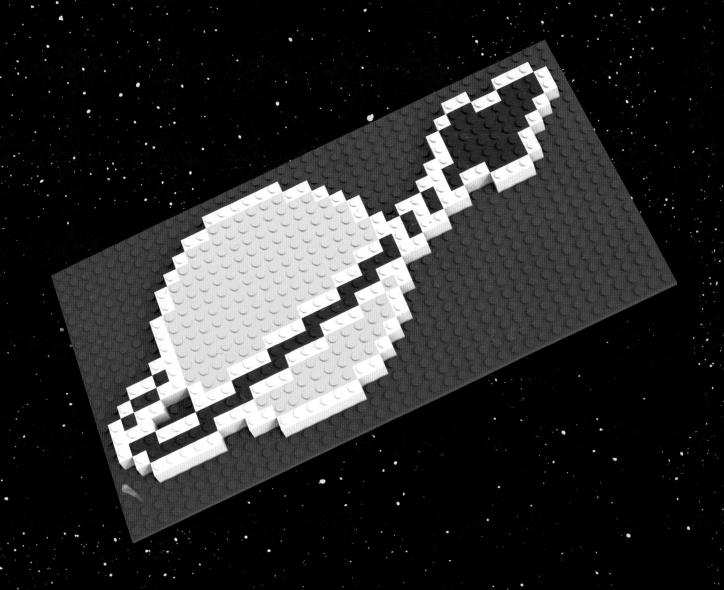

To my family,
who lights my journey

PREFACE

The book you are about to read is the result of the commitment and cooperation of many people rather than the work of a single author. My task consisted in finding, choosing, and combining in a single book, as best I could, a series of spacecraft, fun to build and easy for you to play with. None of this would have been possible or successful without the invaluable contributions of so many incredible creators, spread around the world, who agreed to join me in this project. Some of them changed their own models to make them easier to construct, while others substituted parts to avoid costly or rare pieces. Each one's dedication and willingness to provide his own model explain better than any words can how strong the AFOL (Adult Fans of LEGO®) is, the name we use to describe ourselves. The way they provided support, collaborated, and participated in the project once again shows what kind of people make up our association. We are certainly a community of individuals, but we all join together in the same desire to better ourselves, based on mutual respect rather than competition and rivalry. This is what makes our group so special and what has ultimately made this book possible. You can find each creator's name and some information about him in the paragraph about his model.

ABOUT THIS BOOK

This book includes step-by-step instructions for the construction of each model. The guiding concept is to help the reader learn techniques, hints, and methods for building any kind of object with LEGO® blocks. So get ready to free yourself and to unleash your imagination and creativity so you can start building … anything you wish!

Using the link or the QR code for each model, you can download to your PC, Mac, or tablet a compressed (.zip) file containing:

· an MS Excel® spreadsheet with a list of the LEGO® pieces you need
· an MP4 file with a video of the instructions
· a Wanted List in .xml format to upload directly to the Bricklink marketplace (www.bricklink.com) so you can purchase the LEGO® pieces required to build each model.

CONTENTS

LEGO® SPACE

Launched in 1978, the Legoland® Space theme quickly became one of the favorites of LEGO® fans around the world, with its science-fiction vision of LEGO® sets. At first, the Legoland® Space sets were simple but believable vehicles that could theoretically be set up on the moon or some generic alien planet: domed structures to house astronauts, greenhouses, laboratories, offices, hangars for the vehicles, various kinds of rovers (vehicles with several wheels for moving across the surface of planets), and, obviously, missiles, radio stations, mobile laboratories, etc.

No doubt because interest in science fiction was something brand-new at the time LEGO® Space was launched, as well as in the succeeding months and years, the designers didn't hold back from adding other science fiction elements, like spacecraft, aliens, or invading monsters. Many of the sets were nothing more than precursors of the LEGO® City sets. It was not until 1987 that the theme reached its peak: that was the year of the launch of Blacktron, a version of the Legoland® Space theme with a certain aura of morality, a concept of good and evil, and with a decidedly sinister look. The astronauts wore black jumpsuits, and the spaceships had names like Renegade or Invader. Blacktron immediately became one of fans' most popular themes, so much so that when the Legoland® Space theme was dropped in favor of others, LEGO® lovers continued to build MOCs (My Own Creations—original designs created and constructed directly by fans), maintaining the black and yellow colors of the original Blacktron sets.

Legoland® Space continued to grow and evolve, including sets inspired by hypothetical aliens (the UFO theme in 1997 and Insectoids in 1998). However, between 1999 and 2001, the Legoland® Space theme was discontinued, because the LEGO® Group feared that it would compete with the new LEGO® Star Wars theme being launched at that time. In 2001, the last Legoland® Space sets were produced: Life on Mars. There would be no more space-themed LEGO® sets until 2007, when the LEGO® Group launched the Mars Mission theme, adopting the guidelines of the Legoland® Space idea but from a more Martian point of view.

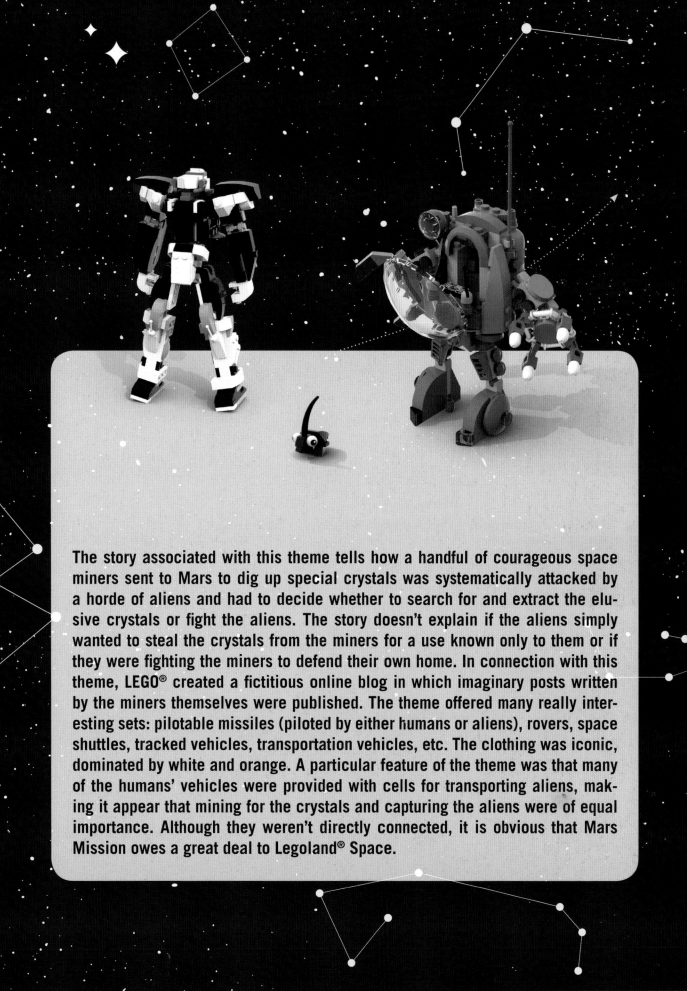

The story associated with this theme tells how a handful of courageous space miners sent to Mars to dig up special crystals was systematically attacked by a horde of aliens and had to decide whether to search for and extract the elusive crystals or fight the aliens. The story doesn't explain if the aliens simply wanted to steal the crystals from the miners for a use known only to them or if they were fighting the miners to defend their own home. In connection with this theme, LEGO® created a fictitious online blog in which imaginary posts written by the miners themselves were published. The theme offered many really interesting sets: pilotable missiles (piloted by either humans or aliens), rovers, space shuttles, tracked vehicles, transportation vehicles, etc. The clothing was iconic, dominated by white and orange. A particular feature of the theme was that many of the humans' vehicles were provided with cells for transporting aliens, making it appear that mining for the crystals and capturing the aliens were of equal importance. Although they weren't directly connected, it is obvious that Mars Mission owes a great deal to Legoland® Space.

GLOSSARY
MOST COMMONLY USED PARTS

Did you know that every LEGO® part and component has its own name? Of course, to build with LEGO® bricks, you don't have to know the names of the parts and components you're using, but it can prove helpful.

For example, if you want to trade pieces with a friend, or if you need to buy some parts online, how would you look for the brick you need without knowing its name?

Although the word "bricks" is used to refer to the pieces in general, only one specific type can actually be called a brick. Each "family" of LEGO® parts and components is identified by a precise name, usually in English. Since LEGO® is an international, multiethnic corporation, it couldn't be any other way.

Let's look at the main "families" of LEGO® components and find out what they're called.

BRICKS

Any element with a height corresponding to that of the basic 1x1 piece is called a *Brick*.

To establish the "size" of a brick, simply count the number of STUDS per side. In the example in *Figure 1*, we find the following Bricks (clockwise): a 2x6 (blue); 2x4 (red); 1x4 (yellow); 1x1 (purple); 2x2 (green).

FIGURE 1

Bricks

MODIFIED BRICKS

Any brick (see previous paragraph) that has been *modified* or altered in any way (e.g., with STUDS placed on one or more sides, various types of connectors, etc.) is called a *Modified Brick*. See *Figure 2*.

FIGURE 2

Modified Bricks

ROUND BRICKS

Any component with a height corresponding to that of a normal *Brick* but with a round/curved shape (and therefore surface) is called a *Round Brick*. In *Figure 3*, clockwise: a Round 2x2 (red); Round 4x4 (green); Round 1x1 (blue); Brick Round Corner Macaroni 2x2 (yellow).

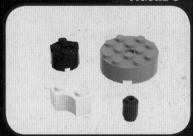

FIGURE 3

Round Bricks

PLATES, WEDGES, AND ROUND PLATES

Any element with a height corresponding to 1/3 (one-third) of the basic 1x1 element. The surface dimensions are the same as for Bricks and are also calculated by counting the STUDS on top. For example, in Figure 4 we find the following (clockwise): a Plate 4x6 (yellow); Plate 2x4 (red); Plate 1x2 (green).

Depending on its shape and type, a *Plate* component is classified as:
- a *Wedge* (due to its angular shape), when a *Plate* component is triangular in shape. In some cases, for example with Wedges used as "wings", the components also present a left or right orientation (*Figure 4*—4x3 blue),
- a *Round Plate* when the component is circular in shape (*Figure 4*—4x4 purple; 1x1 pink and 2x2 brown).

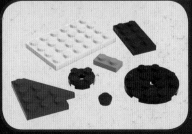

FIGURE 4

Plates, Wedges & Round Plates

MODIFIED PLATES

Any Plate (see previous paragraph) that has been modified or altered in any way (e.g., with various types of connectors or hinges) is called a *Modified Plate*. See *Figure 5*.

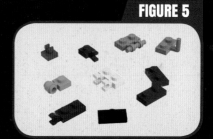

FIGURE 5

Modified Plates

SLOPES

Any component in which one or more sides incline or slope from top to bottom. You can find this type of component (see *Figure 6*) with a certain range of slants, from a minimum of 18° to a maximum of 75°, but the most common are those with an angle of 33° or 45°. They are produced in Standard and Inverted versions; the latter presents a slope from bottom to top (e.g., the light blue part in *Figure 6*).

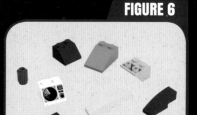

FIGURE 6

Slopes

Any component, generally derived from the *Plate* type, that can be used to build horizontally.

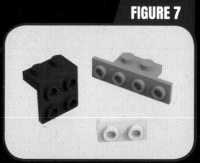

FIGURE 7

Brackets

CONES & DOMES

A conical or hemispheric component is called a *Cone* (or *Dome*).

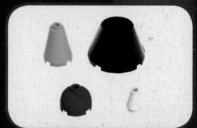

Cones & Domes

TILES & PANELS

Any component identical to a *Plate* but with a smooth surface (that is, without STUDS) is called a *Tile*.
Components that look like they're made out of several Tiles linked at various angles to form a sort of wall are called *Panels*. You can find them in different sizes, with or without STUDS on the surface (e.g., the green "L-shaped" part, the white "L-shaped" part and the light blue "corner" part in *Figure 9*).

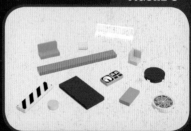

Tiles & Panels

TECHNIC BRICKS & ELEMENTS

Any component initially designed for LEGO® Technic sets, even if it can be used in other sets, is called a Technic Brick. The red parts, the yellow part similar to a 1x2 brick and the orange part in *Figure 10* are Technic Bricks; the blue and yellow "L-shaped" parts are *Liftarms*; the two gray pieces are *Axles*, given their "X shape".

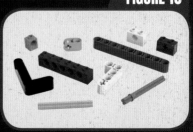

Technic Bricks & Elements

FIGURE 8

FIGURE 9

FIGURE 10

WHERE TO BUY
ASSORTED LOOSE PARTS

Though LEGO® sets are undoubtedly the company's most recognizable product, sooner or later every building enthusiast wants to create something without instructions (or maybe following the ones in this book!). Thus the time comes to stock up on what's known in jargon as "loose parts": bricks, wheels, windows, doors and everything you need for your constructions.

There are several ways to obtain the necessary parts and components for freestyle creation.

For example, you can buy LEGO® sets from the "Classic" line (https://shop.lego.com/en-US/Classic-Sets)—boxes of parts and components that, when combined, make up a sort of "construction warehouse" to draw from. However, these parts and elements are very generic.

Designs like the ones in this book, or the ones you might find online, feature a wide range of parts and components, so buying the sets described above just may not be enough...

So, what to do? Easy! Just access BrickLink®: the most popular online platform among brick enthusiasts (AFOL—Adult Fan of LEGO® and TFOL—Teenage Fan of LEGO®).

Why is BrickLink® the best option?
1. Easy to use
2. Secure (for both creating your order and choosing a payment method)
3. You can "upload" a design created with LEGO® DIGITAL DESIGNER onto a "shopping list" ("Wanted List" on BrickLink®) without having to make a previous list of the parts needed to build your model.

Use the following link or QR code to access a video explaining how to order from BrickLink®.

 ▶ www.nuinui.ch/video/en/f01/lego-space/bricklink-tutorial

TECHNIQUES AND "TRICKS"
TO COUPLE BRICKS

Like any other object, LEGO® bricks come in their own sizes as to length and height. However, unlike normal objects, you don't measure them in inches but in:

- STUD, the "buttons" we find on the surface on a brick

- BRICK, the height of the individual "classic" brick

- PLATE, the height of the individual "flat" brick

Equivalences between the different types of bricks are based on the "STUD measurement" system. For example:

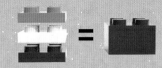

3 2x2 PLATES (STUD)
horizontally wedged
one on top of the other
correspond to
1 2X2 BRICK (STUD)
in height

4 2x2 PLATES
wedged vertically
correspond to
1 2x2 BRICK (STUD)
in width

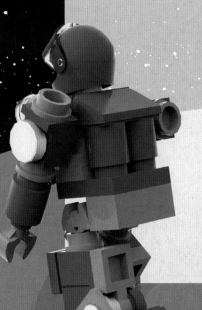

THE J.U.P.I.T.E.R. RACE

Welcome, master builders! Welcome to a future that is both far away and close at hand. A future in which, fortunately, wars, conflicts, and superiority are only a distant memory. Science has taught us that the best use of intelligence, good will, and commitment is to improve ourselves as people and inhabitants of this magnificent planet. In this far-off and close-by future, technology is so advanced that we can use it to show that we're not alone in this infinite universe. We can learn about and contact civilizations from other worlds and galaxies, engaging in exchanges of knowledge and culture in order to remove the word "war" from all dictionaries and encyclopedias.

The impulse to improve oneself and to excel, however, has proven to be a flame difficult to extinguish, so common is it to all cultures. Therefore, the Confederation of United Galaxies and Planets, the assembly of all known peoples, gave birth to the idea—inspired by the ancient Greek Olympic Games—of organizing the J.U.P.I.T.E.R. (Jumbo Universal Pilot Intergalactic Thrilling Extreme Race) GAMES every four years. These games are a speed and endurance competition in three parts in which representatives of the six known galaxies are invited to participate. Its name was chosen to honor the king of the gods, Jupiter (Zeus in Greek), in order to provide a close connection to the ancient Olympiads.

Every part of the competition is a "race" for a different kind of vehicle and has a different degree and type of difficulty. The first part is for one- or two-seater space shuttles. The winner is the vehicle that takes the shortest time to cover the distance between two planets chosen by the J.U.P.I.T.E.R. GAMES Commission. The second part is for wheeled (or tracked) vehicles. Depending upon the choice of planet made by the Commission (which must obviously be a careful one, communicated well ahead of time to the participants), the vehicles have to be adapted and suited to racing on sharp rocks, dirt roads, steep hills, swamplands, etc. The third and last event requires each competitor to plan and construct a robot able to deal with whatever challenge the Commission decides to impose upon it from time to time.

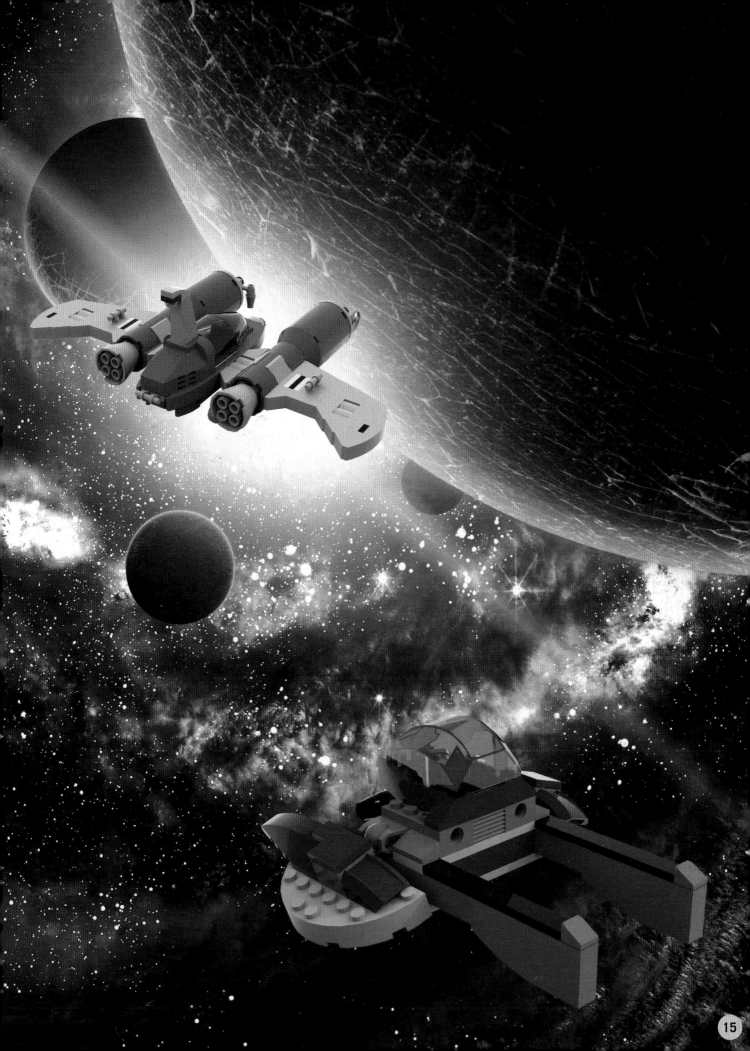

In this chapter you will find LEGO® reproductions of the best space shuttles and other spacecraft that have participated (and were often victorious) in the **J.U.P.I.T.E.R. GAMES**.

Some models are one-seaters and others two-seaters, since over time the rules for participating in the **Games** have changed, as have those concerning technical specifications such as wing area, type of engine, etc.

The pieces used to create the models are a combination of those that can be used to create spacecraft and those used to construct planes and other "flying machines" (wings, tails, jet engines, etc.).

For example, combining some **plate wedge** elements (see chapter 2), you can construct a very efficient wing section for a space shuttle, or you can make a highly functional aircraft rudder by simply using the specific "rudder" pieces.

The same "rudder" pieces can also be used to make lateral **flaps**, just as the helicopter blade elements can be used to make parts of the fuselage.

The great thing about the bricks is that when you don't have the exact shapes you need, you can make them using other bricks. For example, you can use the **curved slope** to make a "space engine" or even create a particular shape of wing by combining **bricks** and **slopes**.

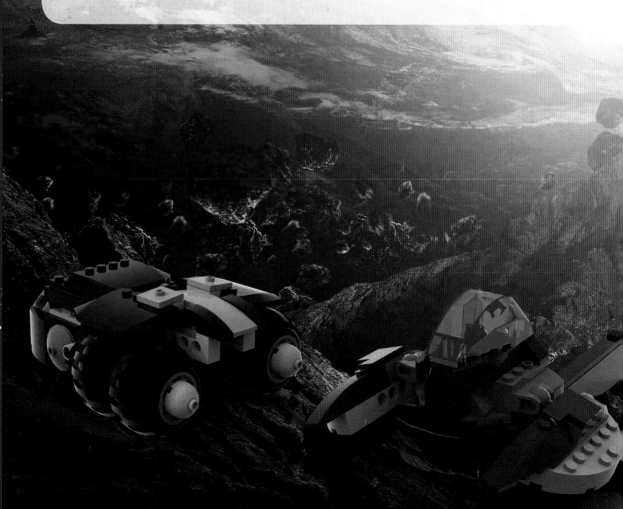

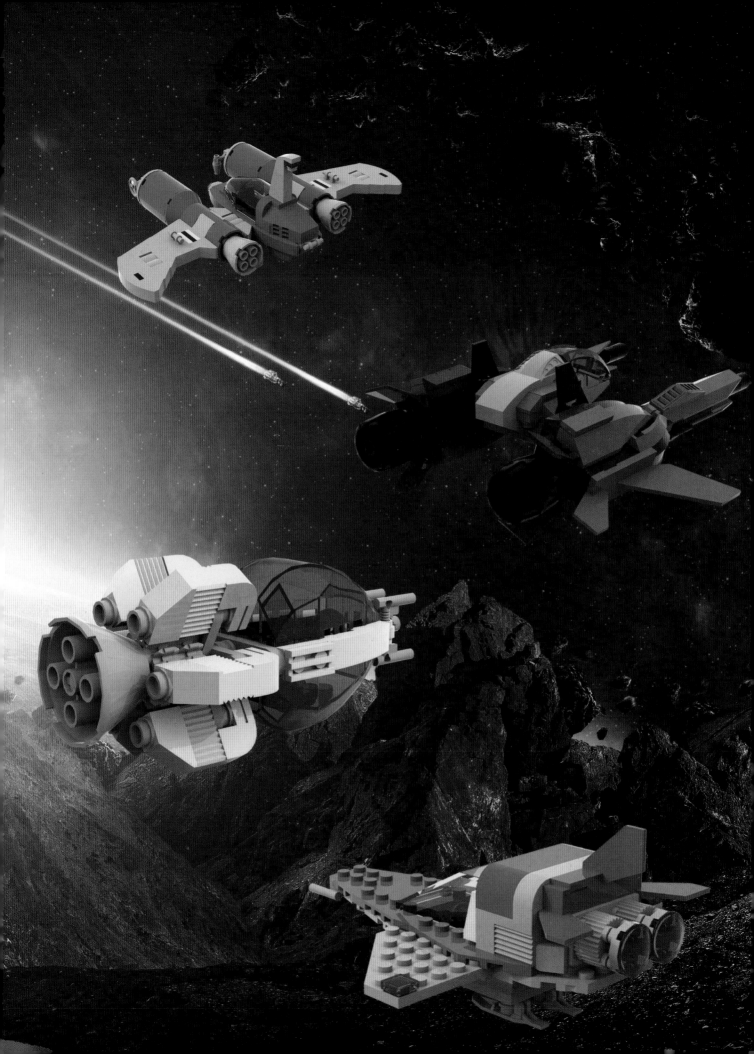

Speed

Load capacity

Range

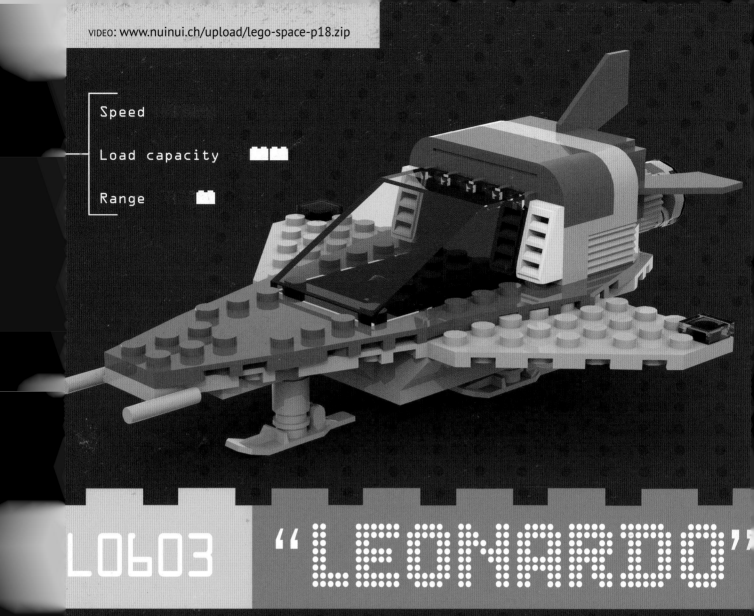

LL0603 "LEONARDO"

nned and constructed by the Kosmodee Space Team to participate in one of the first J.U.P.I.T.E.R. ...MES, the LL0603 has become an icon in the world of space racing. It had simple but functional ...es, conceived to make the most of the performance of the space engines of the time. It was a ...e-seater, like four-wheeled cars that raced on Planet Earth on asphalt tracks called courses, so fast ...t as they passed by, their fans said they were like spacecraft ... exactly!

Creator/Designer: Damiano Baldini

Damiano Baldini is an Italian AFOL (Adult Fan of LEGO®) who has always been fascinated and thrilled by science fiction. Damiano, like so many LEGO® fans, is particularly fond of the LEGO® Space theme and has therefore lent me one of the models he created using the color scheme and shapes of sets of this theme so popular with fans. Married with two beautiful children (who are still of DUPLO® age), Damiano is also the founder of one of the major Italian online communities:

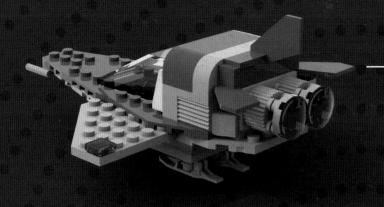

CHARACTERISTICS

- cockpit can accommodate a minifigure
- LEGOLAND® Space color scheme
- small but agile and fast

PIECES REQUIRED

4 x	2 x	2 x	3 x	1 x	2 x	2 x
3070	87079	32062	44661	3710	43722	41769
1 x	2 x	2 x	3 x	4 x	2 x	2 x
4315	2420	2431	3021	6091	43723	41770
2 x	1 x	1 x	1 x	1 x	2 x	2 x
61409	73081	3070	4474	3070	2654	4032
1 x	1 x	1 x	2 x	2 x	2 x	2 x
93274	2431	54384	3665	50746	3023	6091
3 x	6 x	1 x	2 x	2 x	2 x	6 x
6120	87087	3839	92947	2877	3676	6141
1 x	1 x	2 x	1 x	1 x	1 x	6 x
32059	54383	6106	3032	3062	73081	3660
1 x	2 x	1 x	1 x			
3020	3623	3004	85984			

1

1 x

2 x

1 x

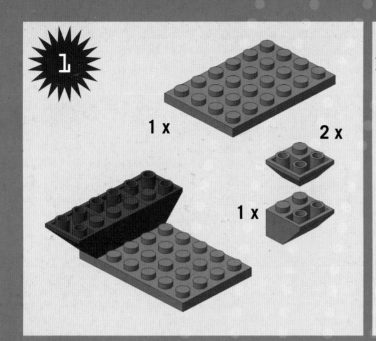

2

5 x

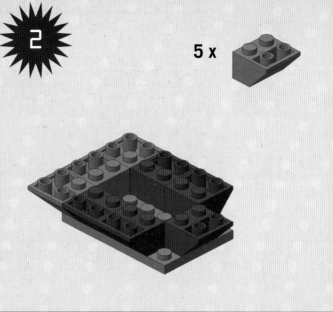

3

2 x

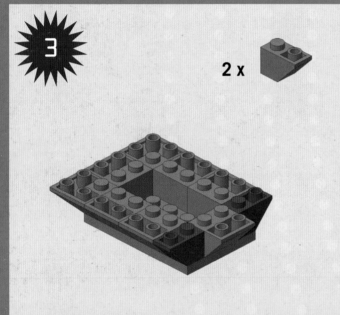

4

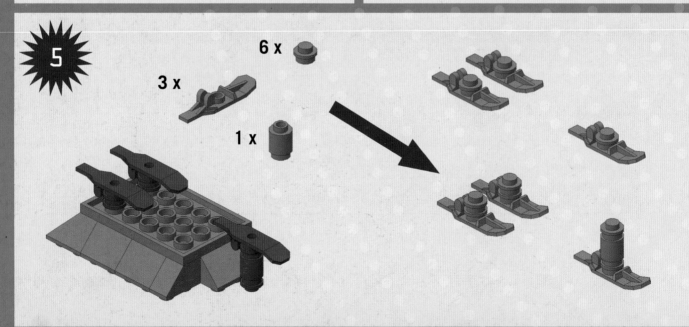

5

6 x

3 x

1 x

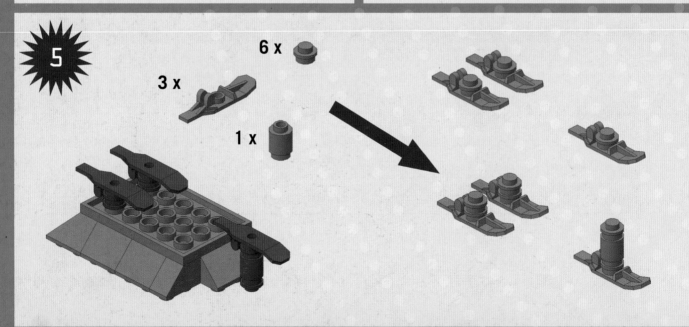

6 1 x

1 x

1 x

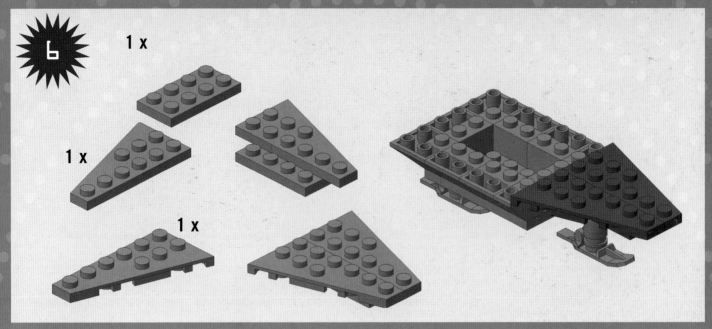

7 1 x

1 x

1 x 1 x

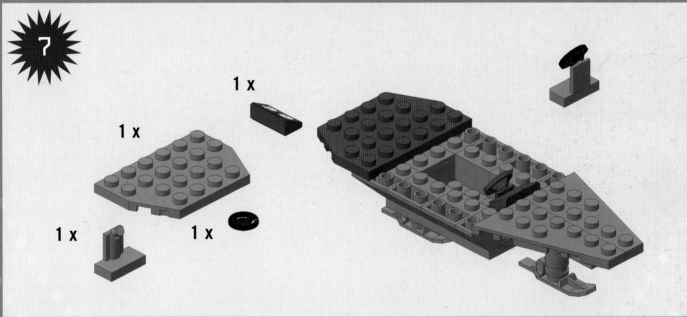

8

2 x

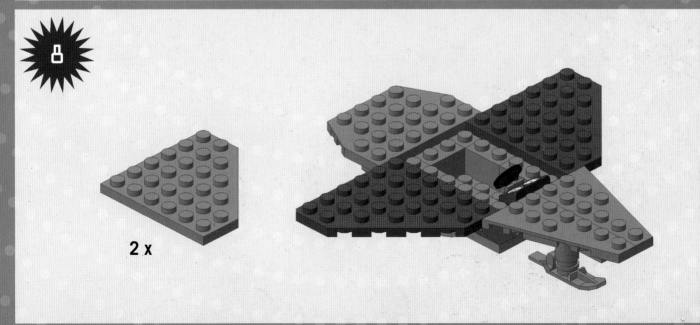

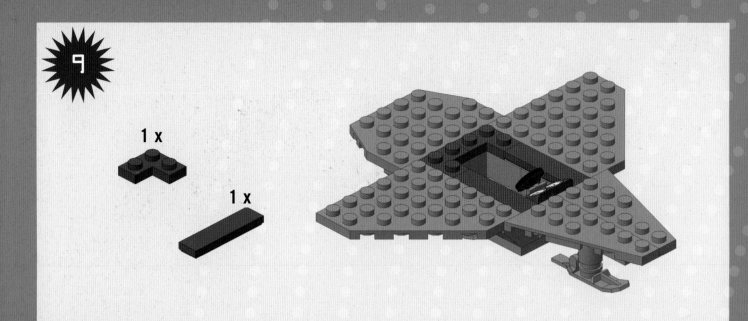

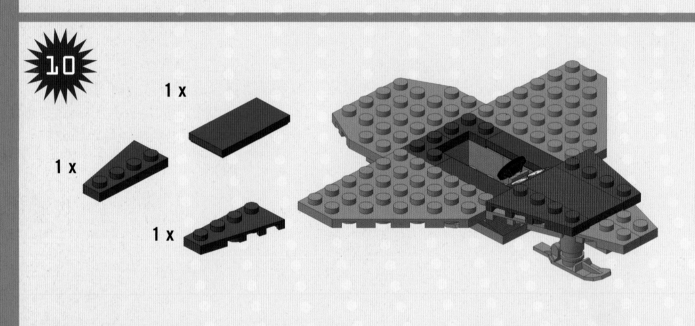

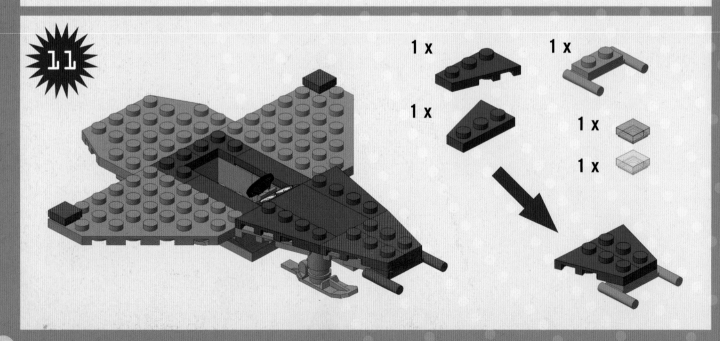

12

1 x
1 x
1 x
1 x

13

2 x
2 x
1 x

14

1 x
2 x

15

1 x

16

1 x

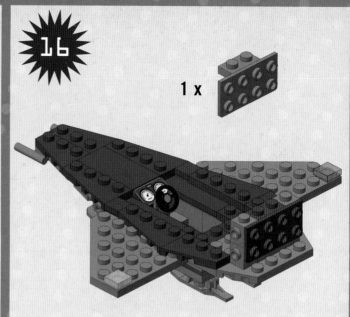

17

1 x

1 x

1 x

1 x

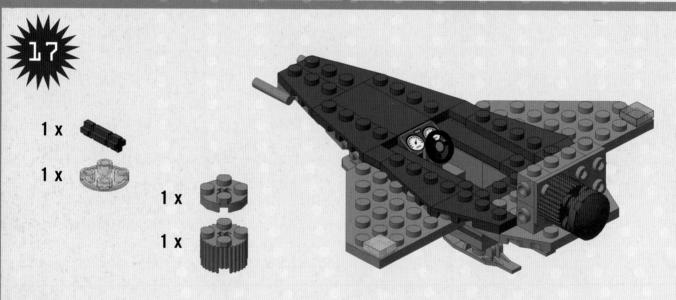

18

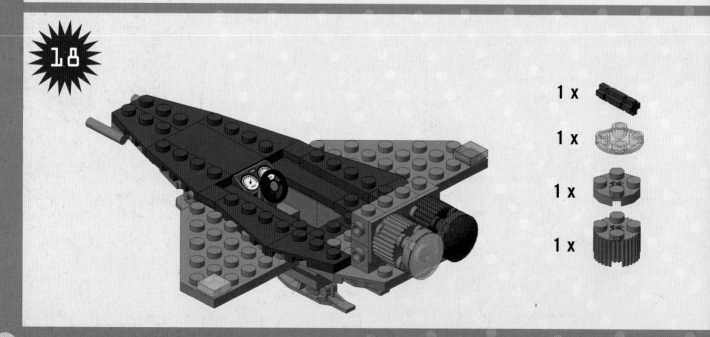

1 x

1 x

1 x

1 x

19

1 x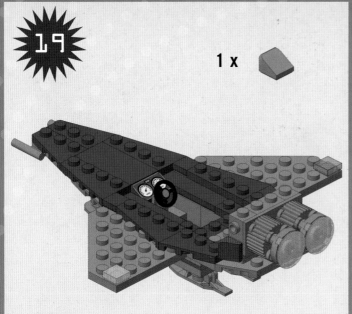

20

1 x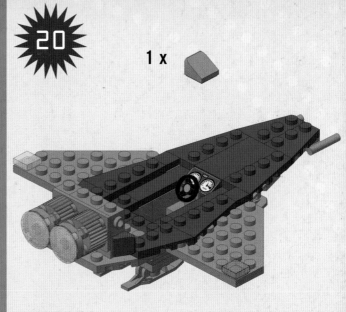

21

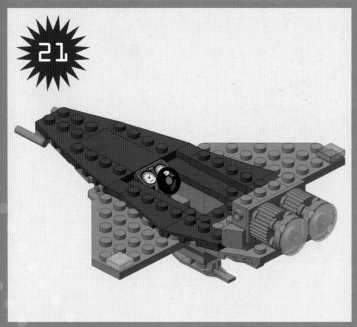

22

1 x

1 x

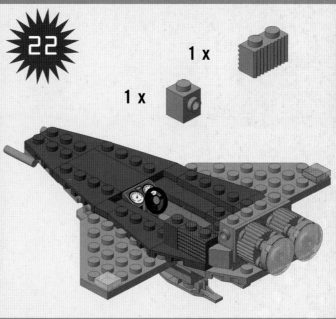

23

1 x

1 x

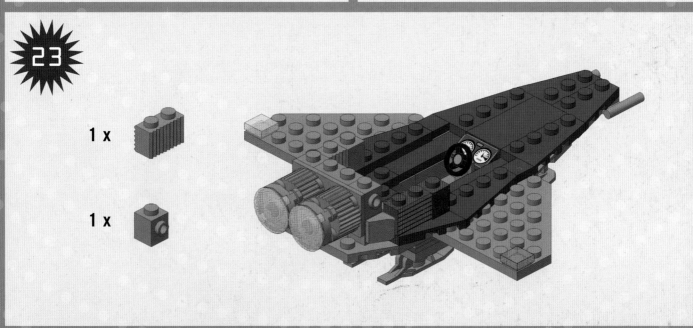

24

2 x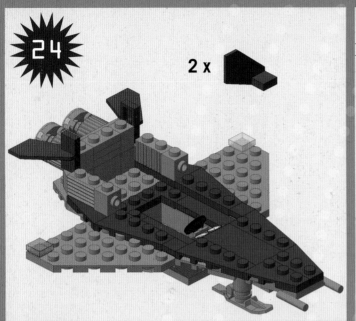

25

2 x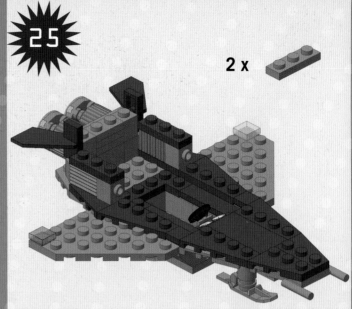

26

2 x
1 x

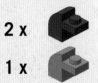

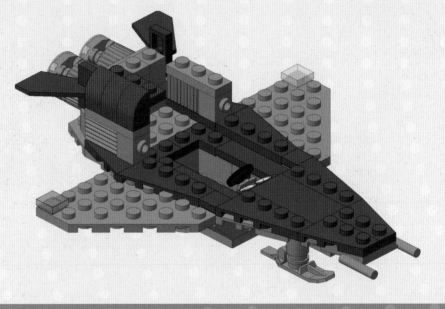

27

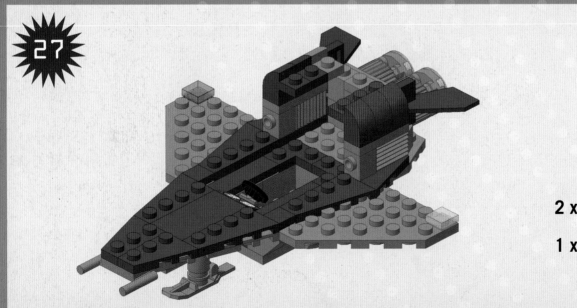

2 x
1 x

28

29

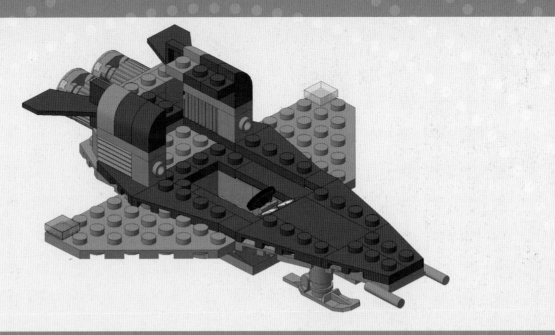

2 x

1 x

1 x

3 x

1

2

3

4

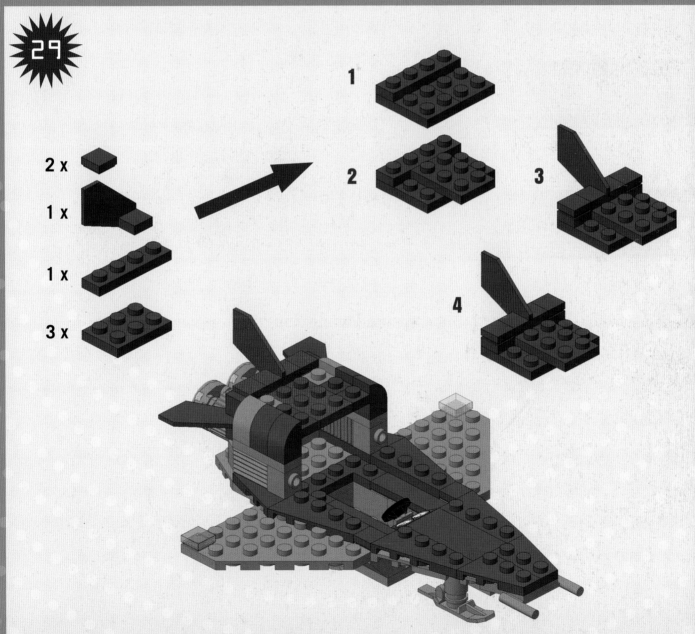

30

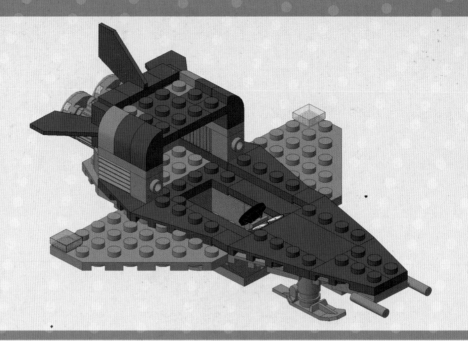

31

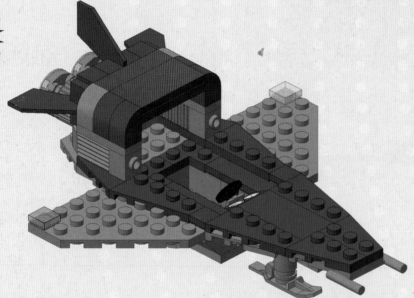

2 x

2 x

32

2 x

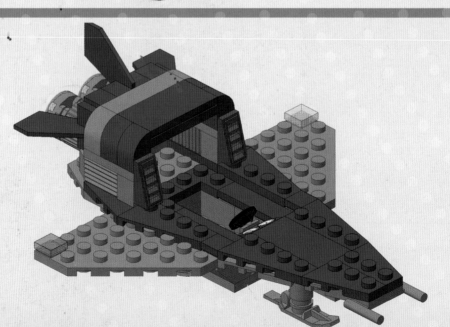

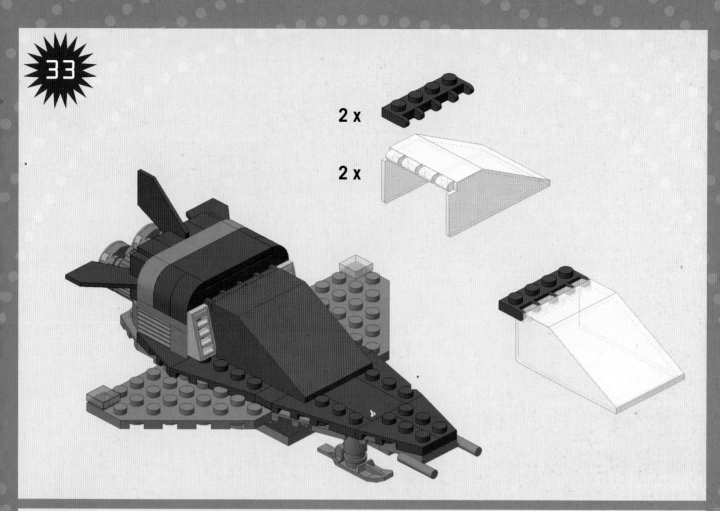

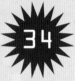

2 x

2 x

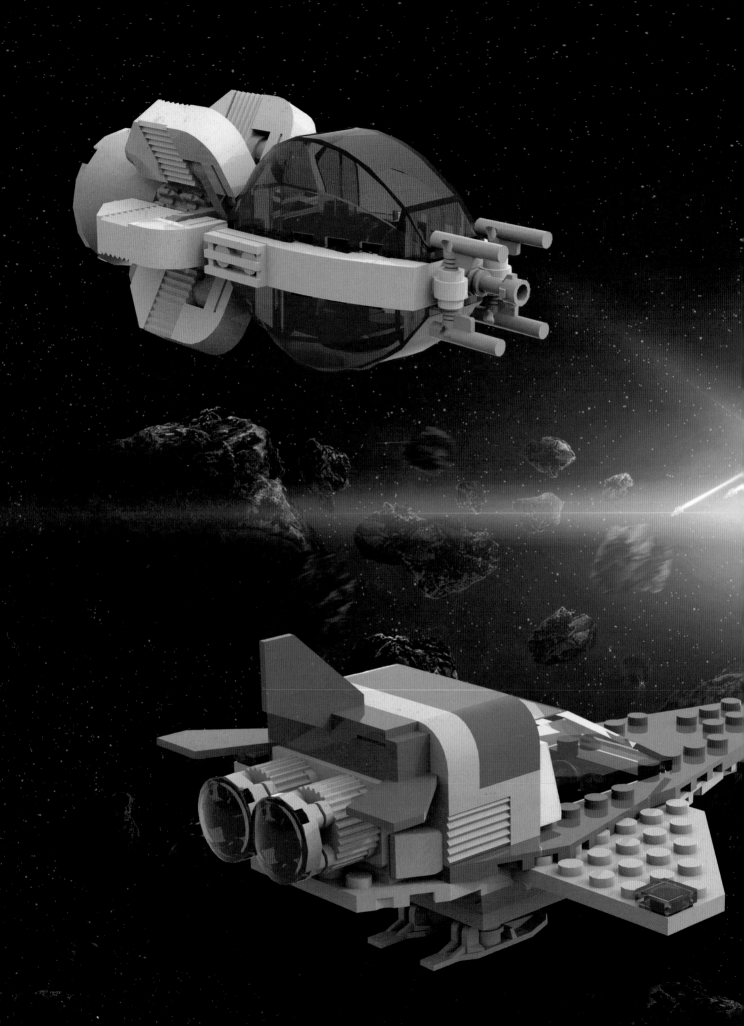

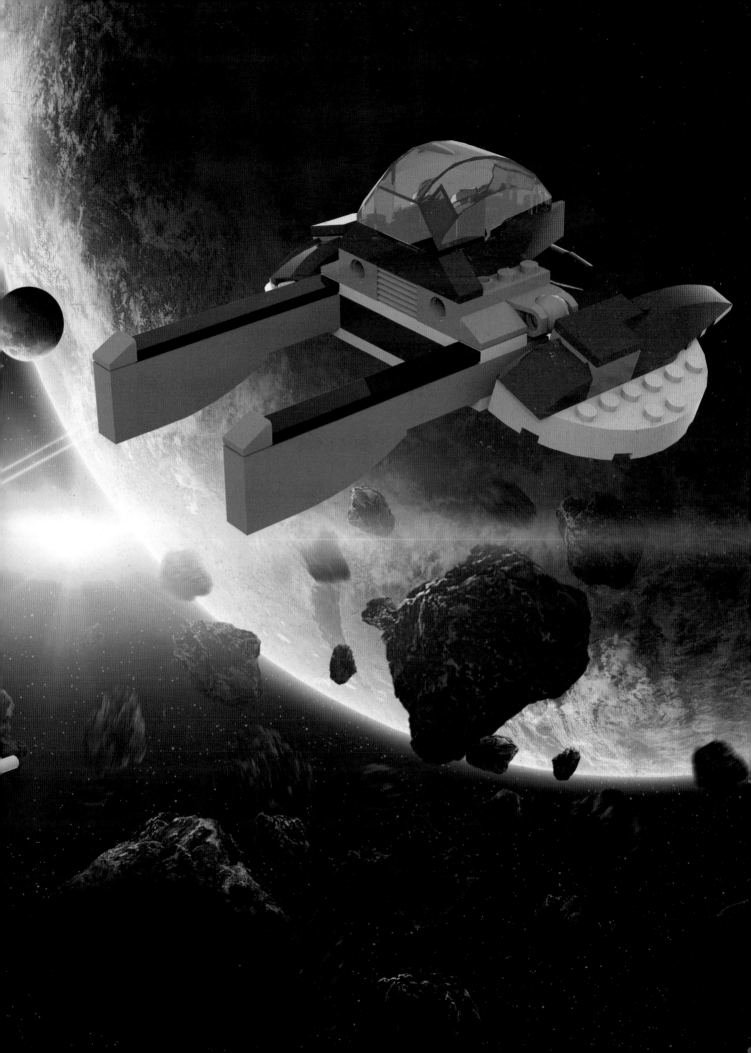

Speed

Load capacity

Range

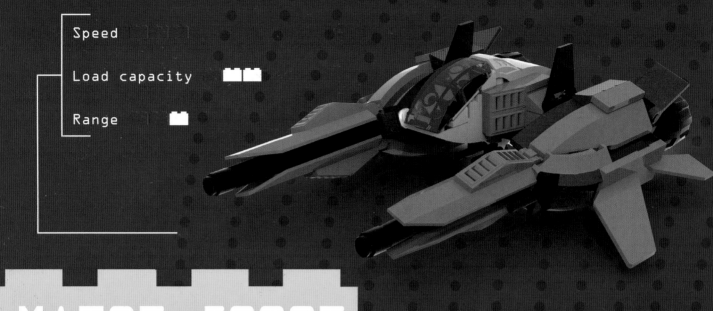

MATSF-5000E

Designed and built by the Red Spacecat Team to participate in one of the most recent J.U.P.I.T.E.R. GAMES, the MATSF-5000E Superbanshee II is one of the first "racing" shuttles to use the so-called "wave engine." The Superbanshee II captures a particular form of recently discovered particle energy through its front vents. It funnels it into its engines, which use it as "fuel." Since its initial appearance on the J.U.P.I.T.E.R. GAMES scene, Part 1 has never been the same!

Creator/Designer: Red Spacecat

Stijn, the real name of the expert builder known in the LEGO® fan world as "Red Spacecat". He is a 41 year old senior webdesigner from The Netherlands, and when he build something with Lego, it's usually as spaceship or some other science-fiction model. He really like to share its building experience with other LEGO® enthousiasts, so he was very happy to share these instructions to will allow others to make their own version of his creation. web: www.flickr.com/photos/redspacecat/

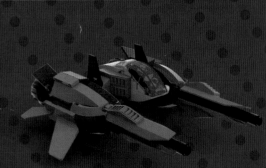

CHARACTERISTICS

- adjustable deflectors and wing surfaces
- constructed on a "microscale": there is no room for a minifigure
- has a very "aggressive" appearance, but if it is steered carefully, it is capable of any kind of maneuver

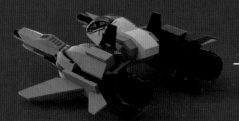

4 x — 2335	4 x — 61678	8 x — 50746	4 x — 30383
4 x — 58367	2 x — 44675	4 x — 3021	2 x — 3062
2 x — 3937	2 x — 2412	2 x — 44676	4 x — 4595
2 x — 2412	6 x — 2540	2 x — 6141	2 x — 30602

1 x — 3795	— 50950	— 85984	2 x — 41763	1 x — 3747	1 x — 3937	1 x — 44675
1 x — 6134	4 x — 30365	2 x — 6239	2 x — 85984	4 x — 44301	2 x — 63864	1 x — 41764
2 x — 3623	1 x — 41747	2 x — 47755	1 x — 3795	2 x — 50746	2 x — 3665	1 x — 3023
2 x — 44728	12 x — 61409	4 x — 4070	1 x — 41748	2 x — 3040	4 x — 3069	2 x — 44661
2 x — 6141	2 x — 85861	4 x — 30407	1 x — 41765	1 x — 3020	1 x — 3022	4 x — 6141

Partially visible left column (covered by form):
4 x ... | 2 x ... | 2 x ... | 4 x ... — 023 | 1 x ...

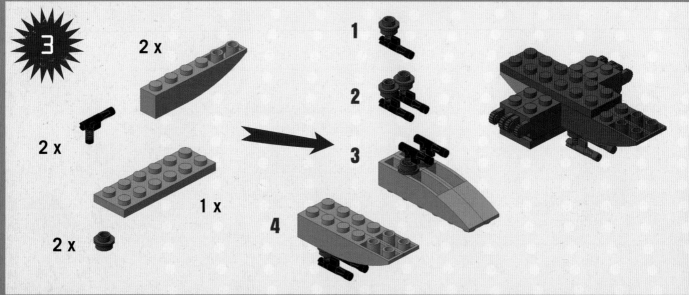

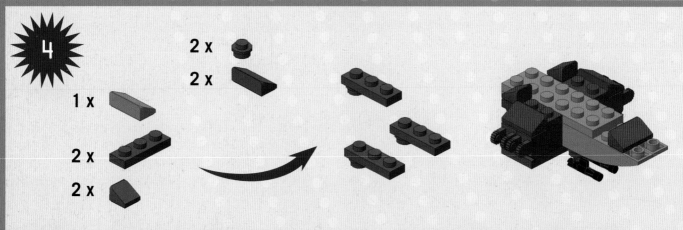

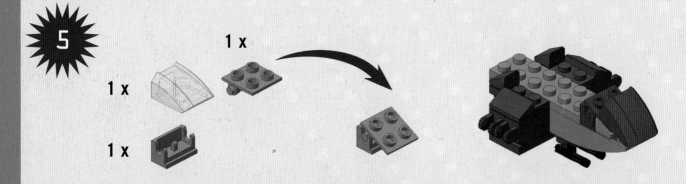

6

1 x

2 x

1 x

1 x

1

1

2

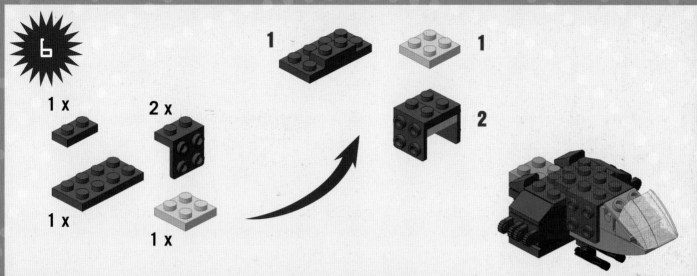

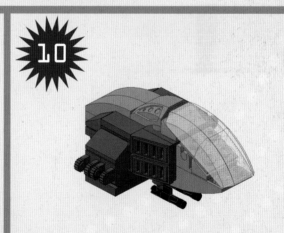

7

1 x

4 x

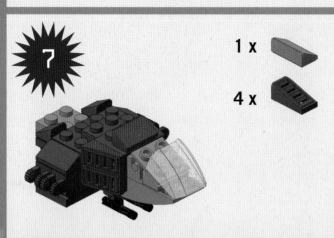

8

1 x

2 x

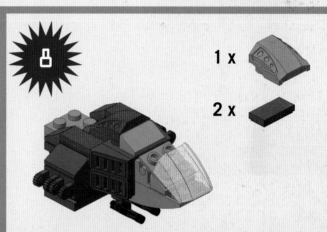

9

1 x

2 x

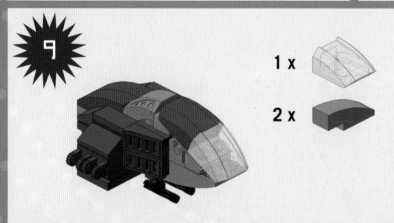

10

11

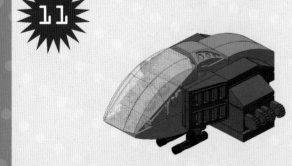

12

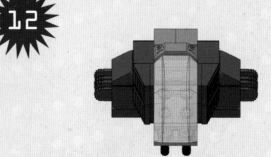

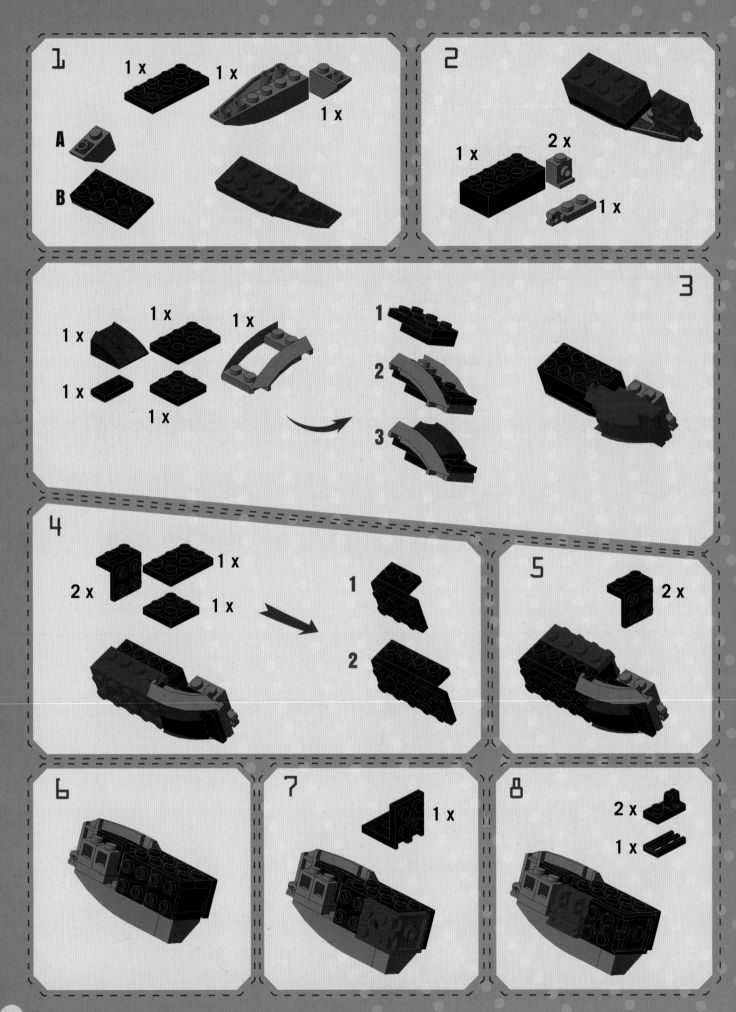

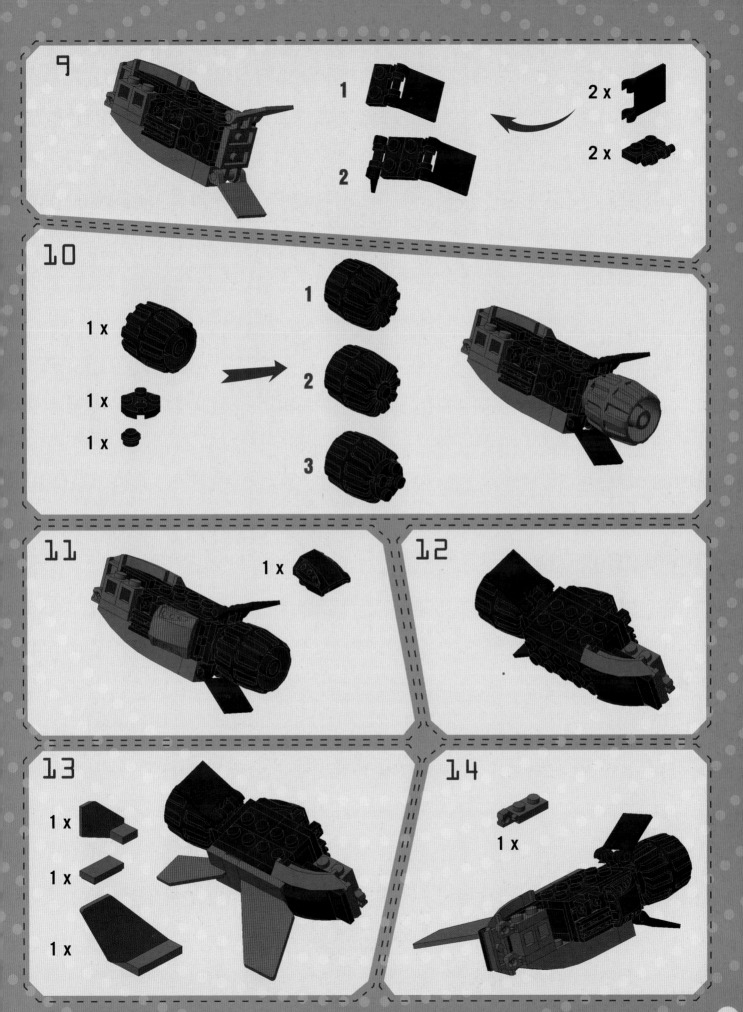

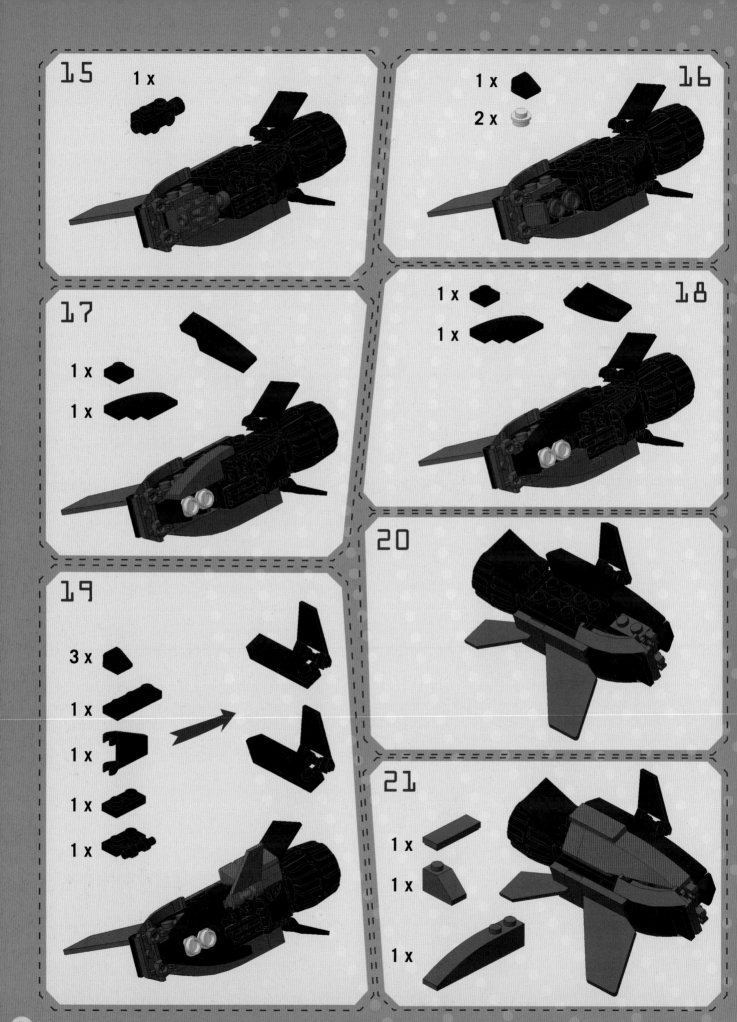

22

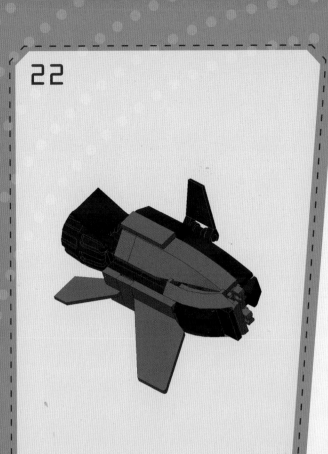

13

1 x

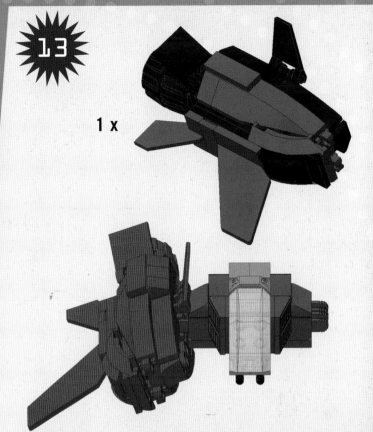

1

1 x 1 x 1 x

1
2

2

1x 2 x

1 x

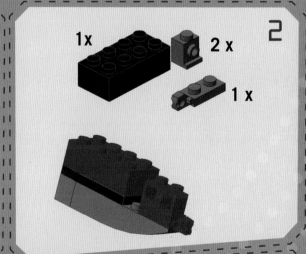

3

1 x 1 x
1 x
1 x 1 x

1 x

2

1

3

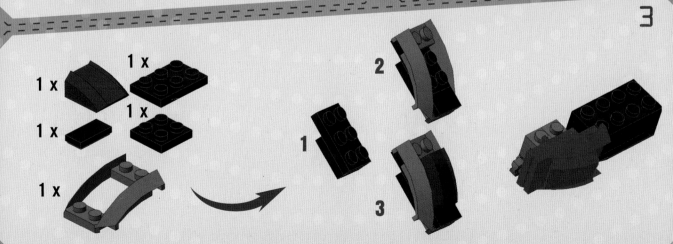

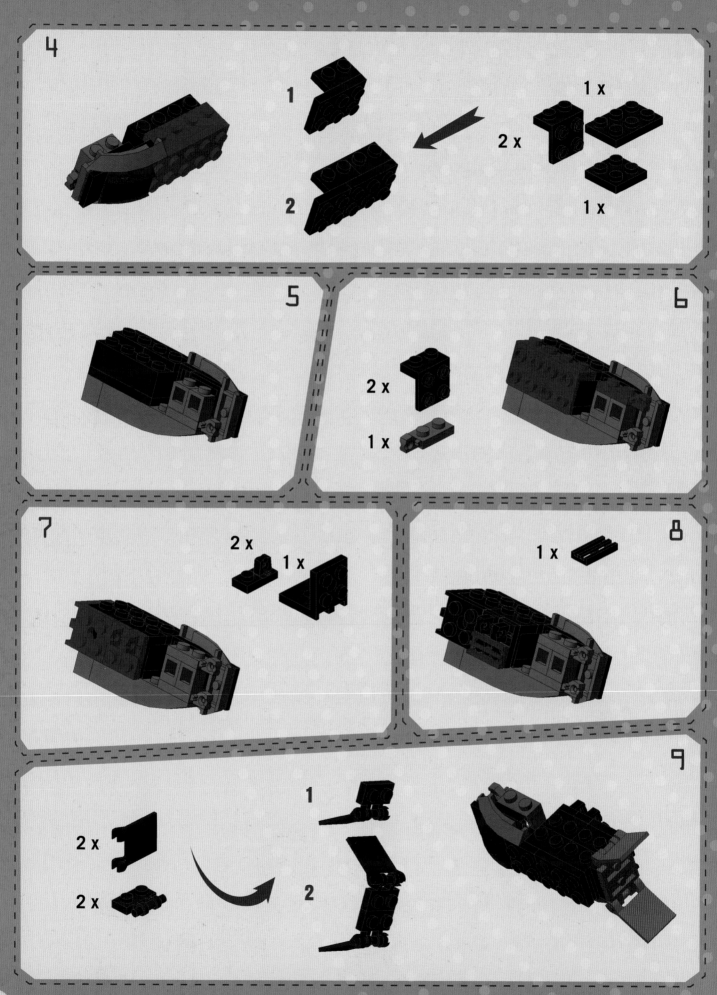

10

1 x

1 x

1 x

1

2

3

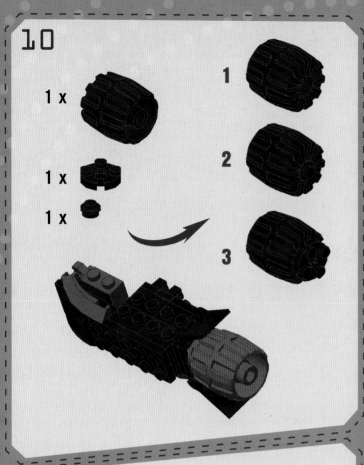

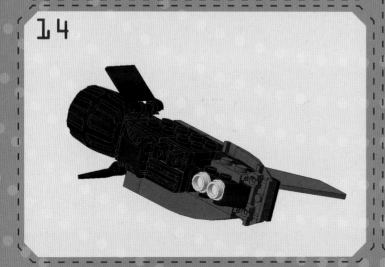

11

1 x

1 x

1 x

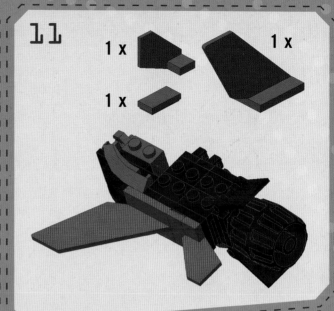

12

1 x

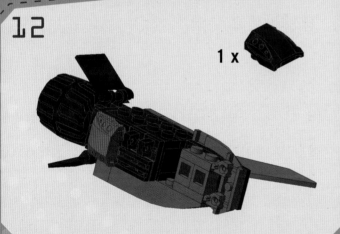

13

1 x

1 x

2 x

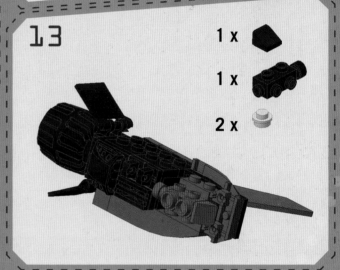

14

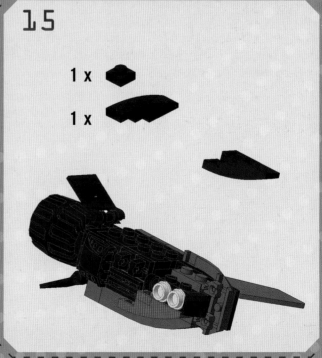

15

1 x

1 x

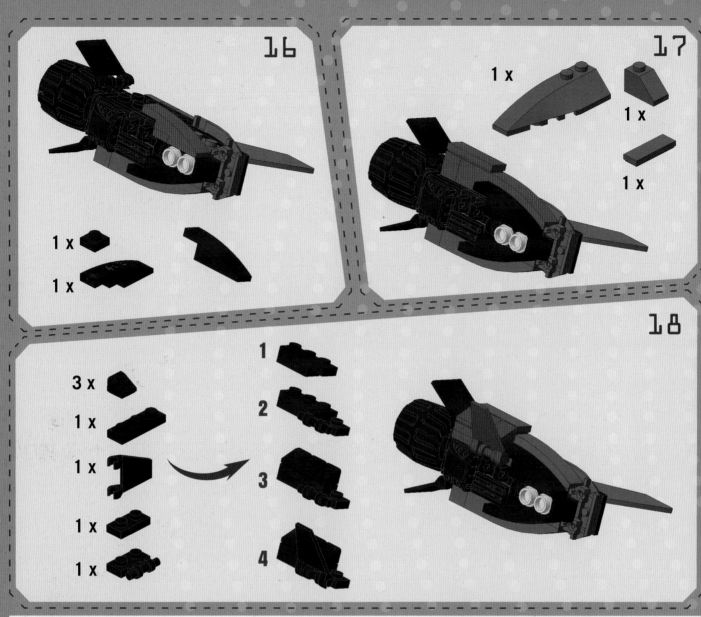

17

1 x

1 x

1 x

1 x

1 x

18

3 x

1 x

1 x

1 x

1 x

1

2

3

4

14

1 x

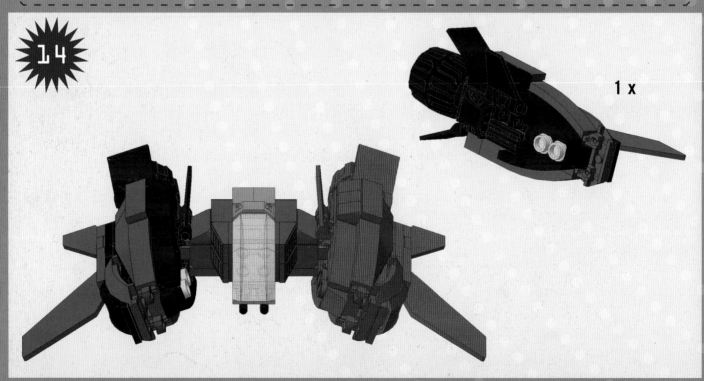

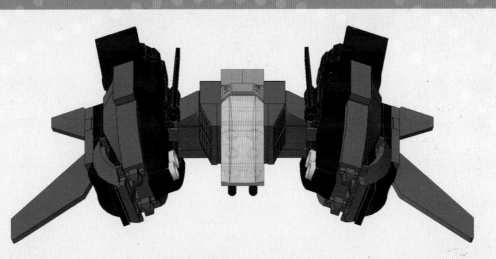

1

1 x

2

2 x

3

1 x

1 x

1 x

1 x

1 x

1

2

3

4

5

2 x

1 x

1 x

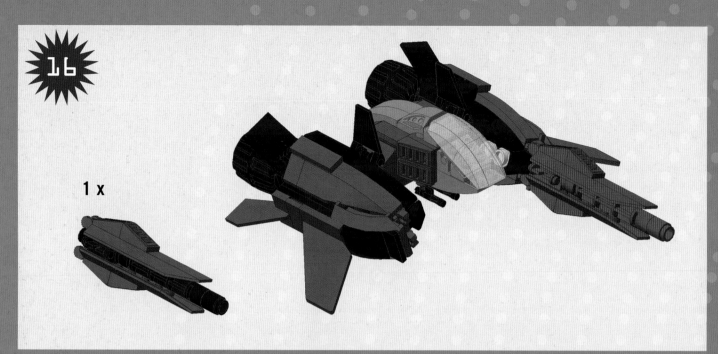

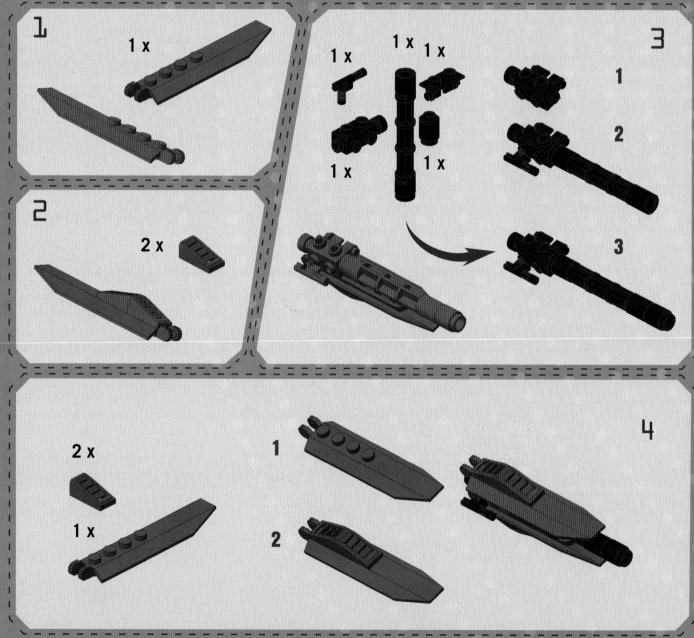

1

1 x

2

2 x

3

1 x
1 x
1 x
1 x
1 x

1
2
3

4

2 x

1 x

1

2

1 x

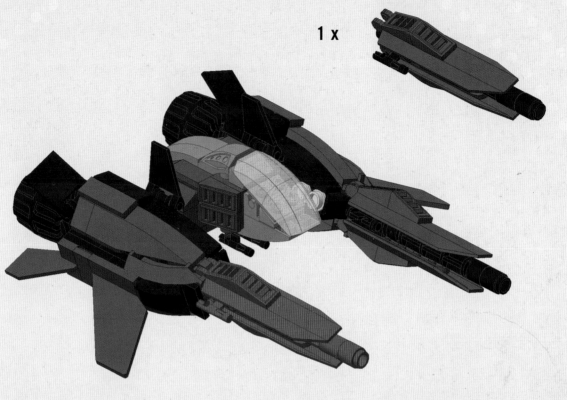

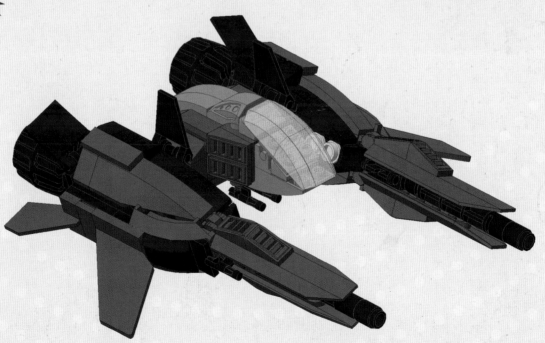

Speed

Load capacity

Range

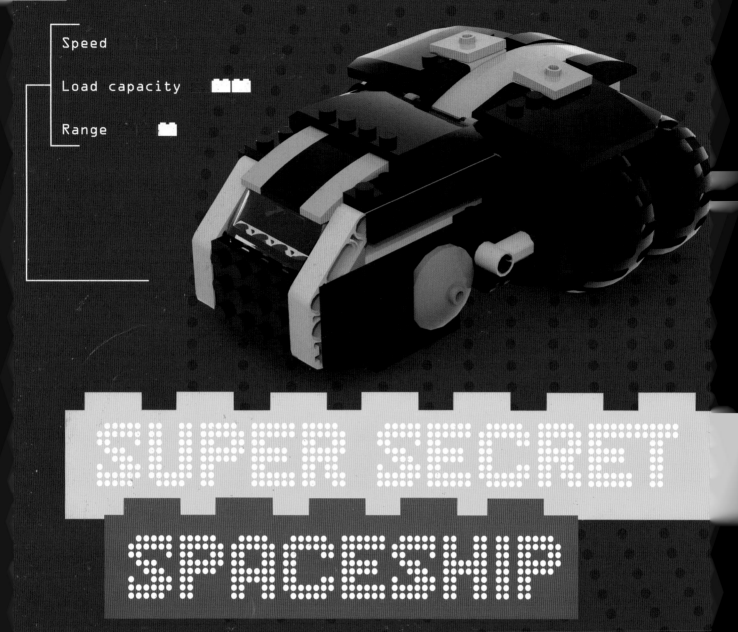

SUPER SECRET SPACESHIP

The Super Secret Spaceship's team of designers gave it this name because, during the many month they worked on its design, they had to try to figure out the secrets of its new propulsion system. T avoid discovery of their precious secret, they requested that the government of their planet co struct a special space station, a request that was granted. The station was supplied with the mo up-to-date concealment and anti-data-gathering systems, which allowed the engineers and techn cians to work safely and peacefully. We all know that in space friction virtually does not exist, s it's possible to construct space shuttles that don't require an aerodynamic, streamlined shape. was because of this very fact that the "Secret Ship" could be designed. The new propulsion syste was capable of reaching speeds never before seen, while still allowing pilots to control the vehicle course. However, it was definitely huge compared to other spacecraft built up to that time. Moreove the planning process took so long that the designers didn't have time to worry too much about th aesthetics of the fuselage. So don't be misled by the stocky, slightly inelegant shape of the Secre Ship. At its debut in the J.U.P.I.T.E.R. GAMES, it defeated its competitors by an enormous distanc

CHARACTERISTICS

- not particularly streamlined but with an engine of unequaled power
- can accommodate a minifigure

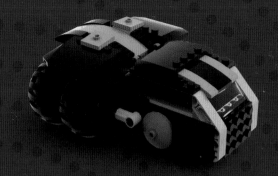

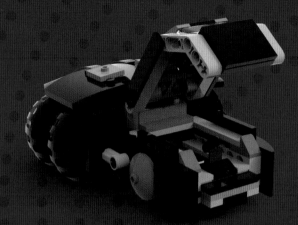

Creator/Designer: Nicola Lugato

Nicola is only one of the builders who so generously "lent" me one of his own models for this book, but, more importantly, he is the developer of two software programs that allowed me to produce it: BluePrint, for generating instructions, and BlueRender, for creating the digital images that you'll find throughout.

Author's note:

All the elements required for the construction of this model can be found in this official LEGO® set:
LEGO® The Lego Movie 70808 Super Cycle Chase.
If you already own this set, you'll be able to avoid purchasing additional LEGO® pieces. Of course, it's likely that some 1x6 tiles, the #52031 sunroof, and other components already have the adhesive included in the set applied to them, but what difference does it make? You can rename this model SECRET POLICE SPACESHIP!

PIECES REQUIRED

1 x	2 x	2 x	8 x	2 x	3 x	4 x
73081	3001	32000	4274	61409	3069	3024

8 x	3 x	3 x	3 x	4 x	4 x	2 x
50950	3747	85984	3021	56145	4070	2815

4 x	4 x	3 x	1 x	2 x	2 x	2 x
2877	60478	3034	30414	13547	92280	3666

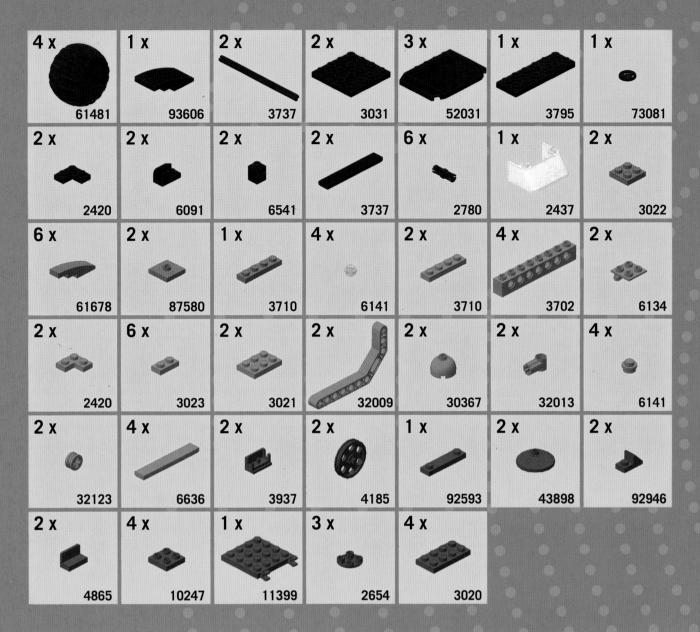

4 x 61481	1 x 93606	2 x 3737	2 x 3031	3 x 52031	1 x 3795	1 x 73081
2 x 2420	2 x 6091	2 x 6541	2 x 3737	6 x 2780	1 x 2437	2 x 3022
6 x 61678	2 x 87580	1 x 3710	4 x 6141	2 x 3710	4 x 3702	2 x 6134
2 x 2420	6 x 3023	2 x 3021	2 x 32009	2 x 30367	2 x 32013	4 x 6141
2 x 32123	4 x 6636	2 x 3937	2 x 4185	1 x 92593	2 x 43898	2 x 92946
2 x 4865	4 x 10247	1 x 11399	3 x 2654	4 x 3020		

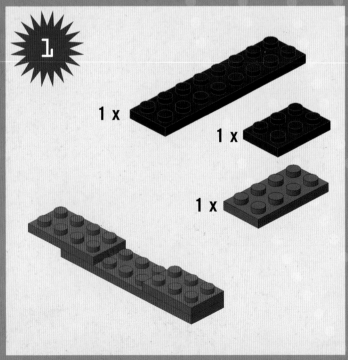

1

1 x
1 x
1 x

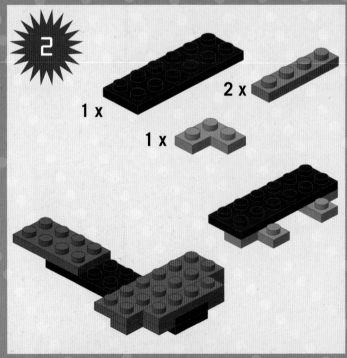

2

1 x
2 x
1 x

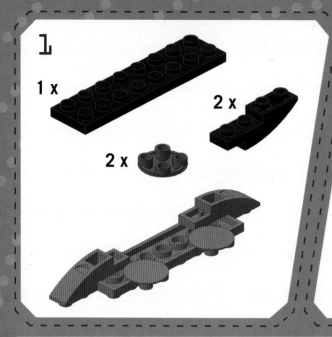

1

1 x

2 x

2 x

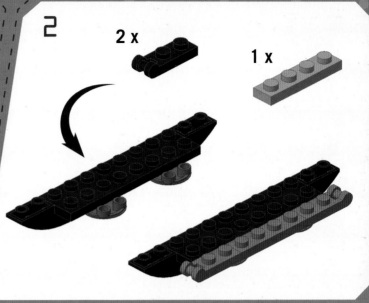

2

2 x

1 x

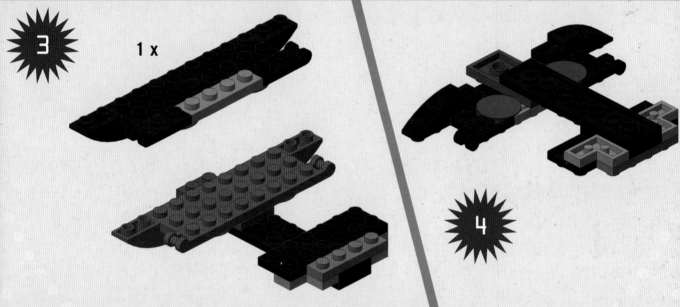

3

1 x

4

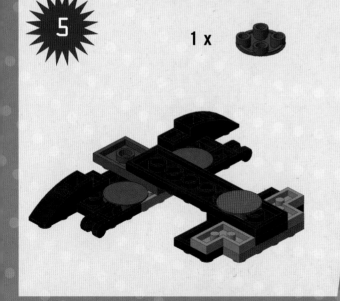

5

1 x

6

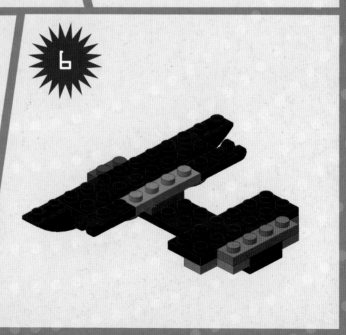

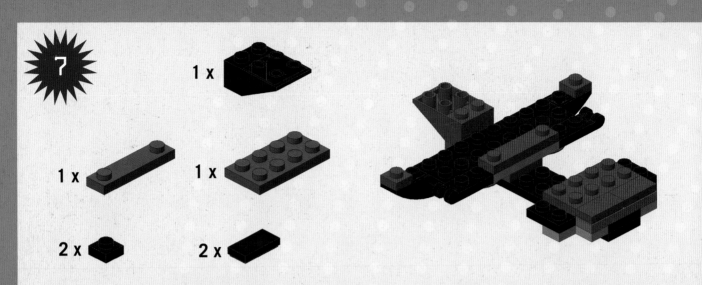

7

1 x

1 x 1 x

2 x 2 x

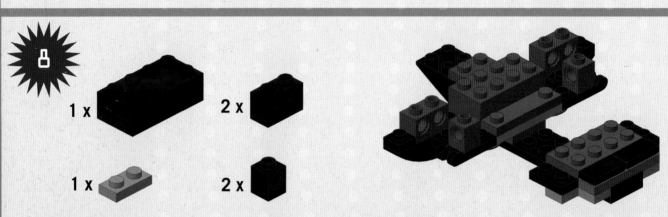

8

1 x 2 x

1 x 2 x

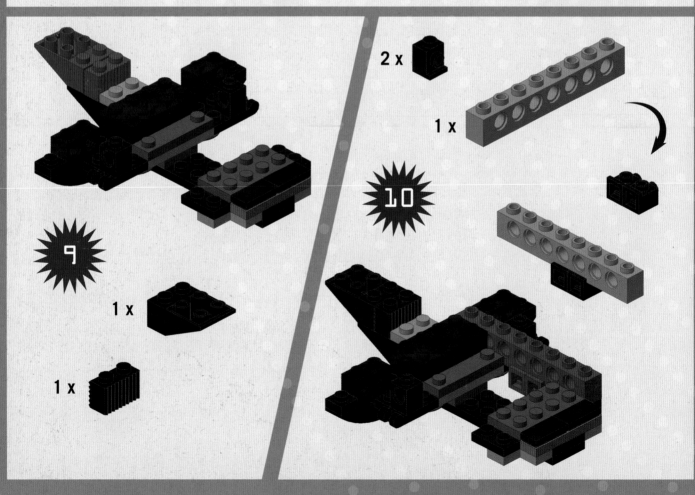

9

1 x

1 x

2 x

1 x

10

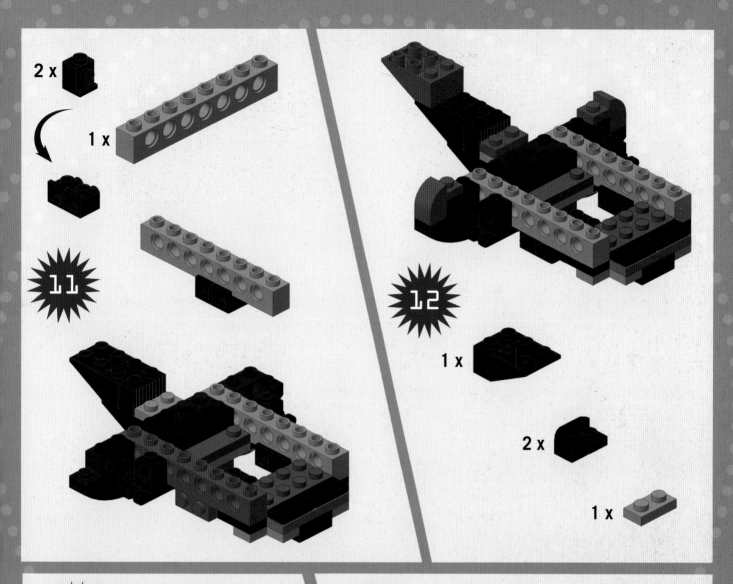

2 x

1 x

11

12

1 x

2 x

1 x

13

1 x

1 x 1 x

14

2 x

4 x

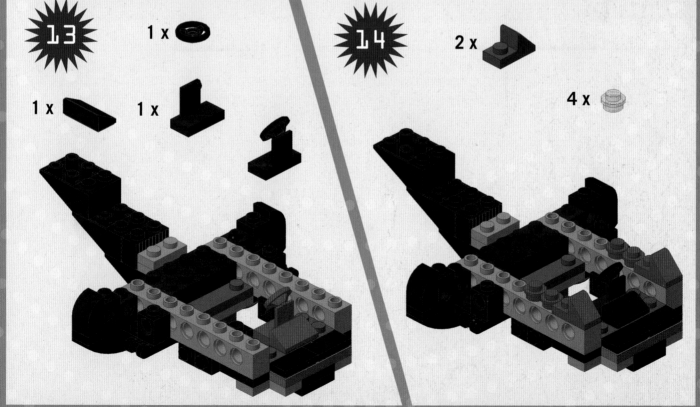

15

1 x

2 x

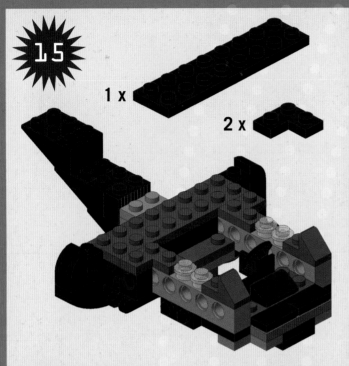

16

1 x

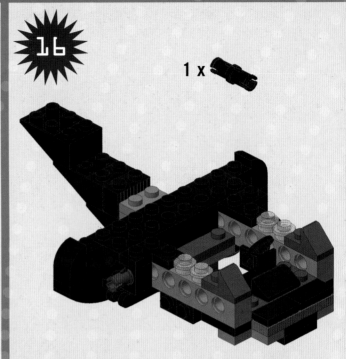

17

2 x

1 x

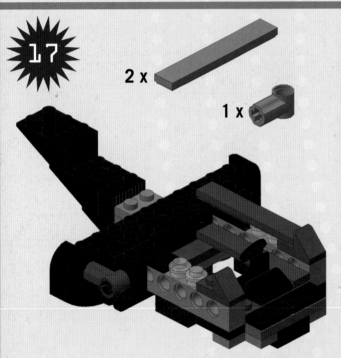

18

1 x

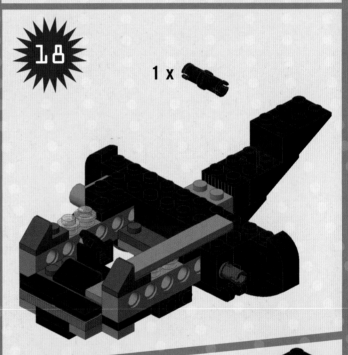

19

2 x

1 x

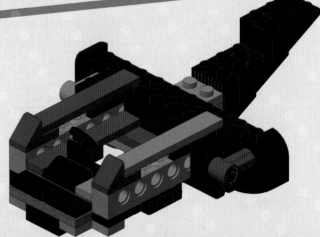

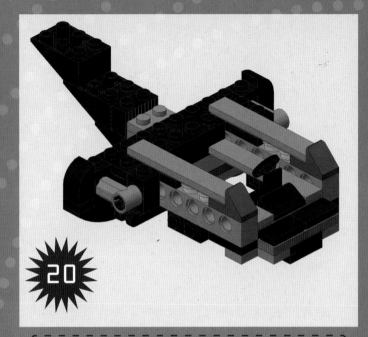

20

1

1 x

1 x

2 x

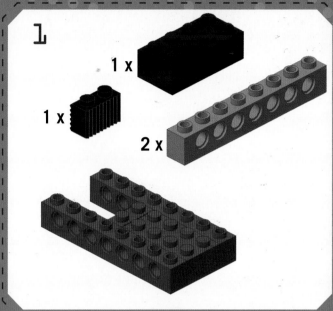

2

1 x

2 x

1 x

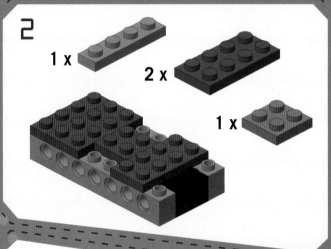

3

2 x

1 x

1 x

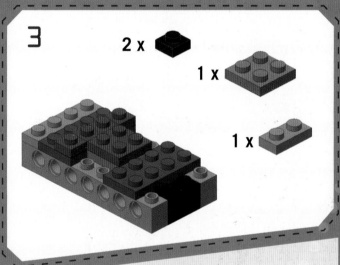

4

2 x

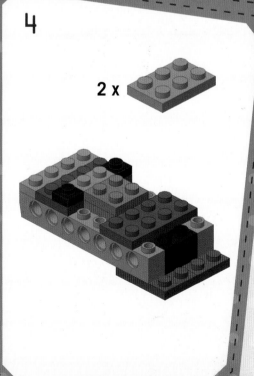

21

1 x

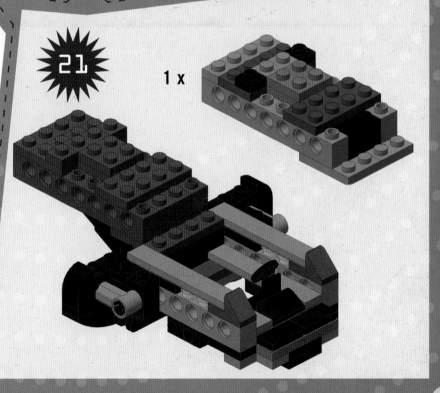

1

2 x

2 x

2 x

2

2 x

3

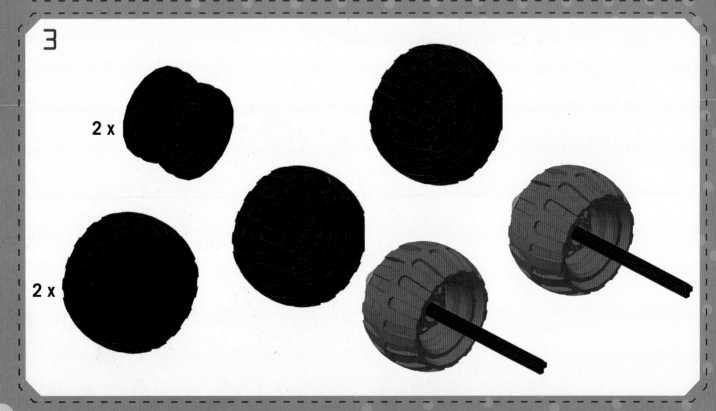

2 x

2 x

4

2 x

2 x

2 x

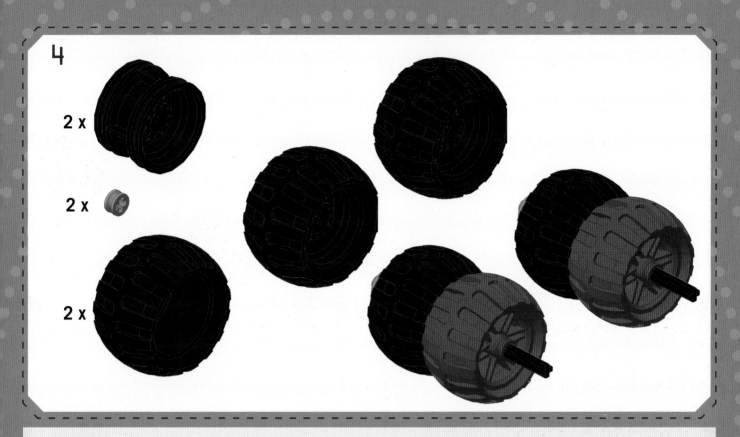

22

1 x

2 x

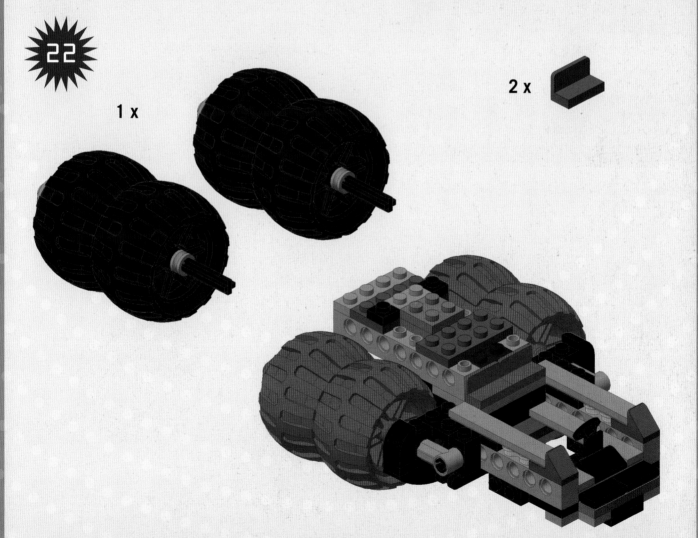

2 x

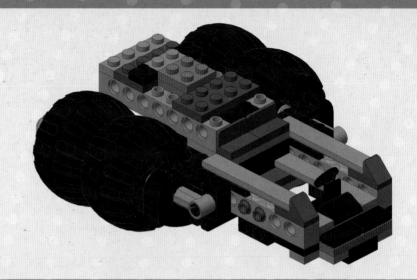

1
1 x
1 x

2
1 x

3
3 x

24

1 x

25

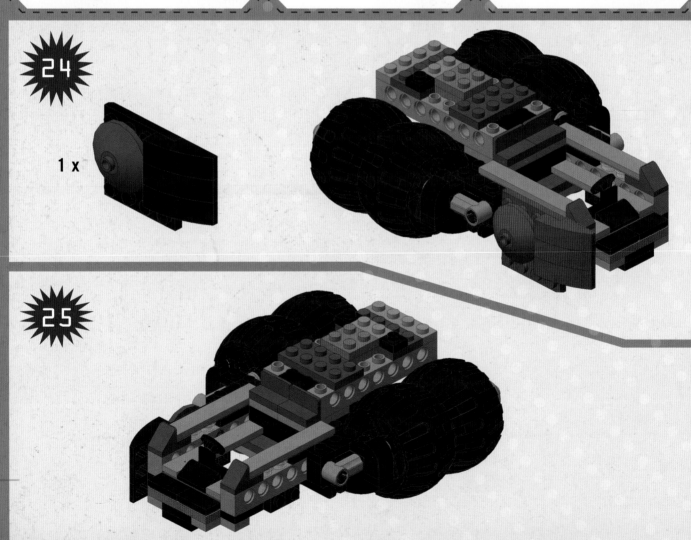

2 x

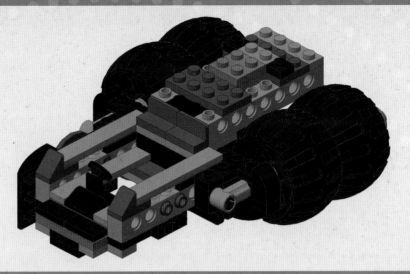

1
1 x
1 x

2
1 x

3
3 x

1 x

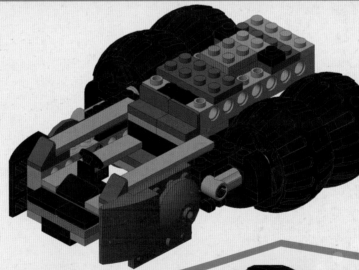

2 x

2 x

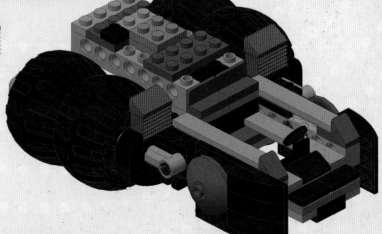

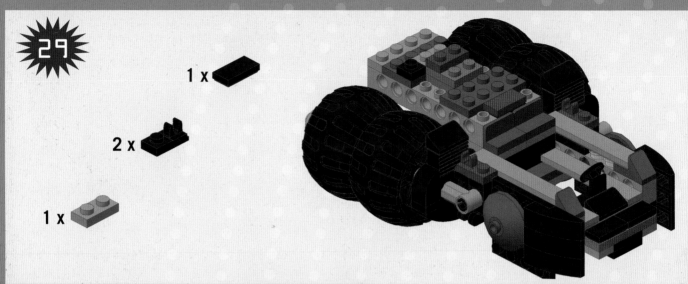

29

1 x

2 x

1 x

1

1 x

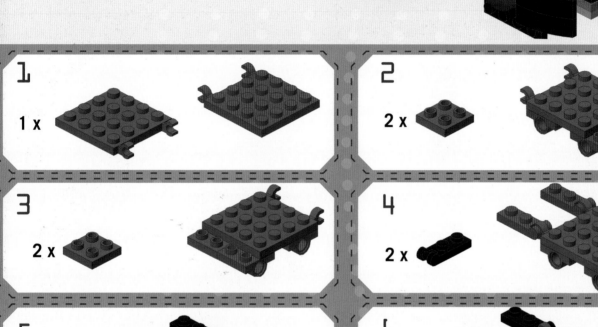

2

2 x

3

2 x

4

2 x

5

2 x

1 x

6

1 x

1 x

7

2 x

8

2 x

1 x

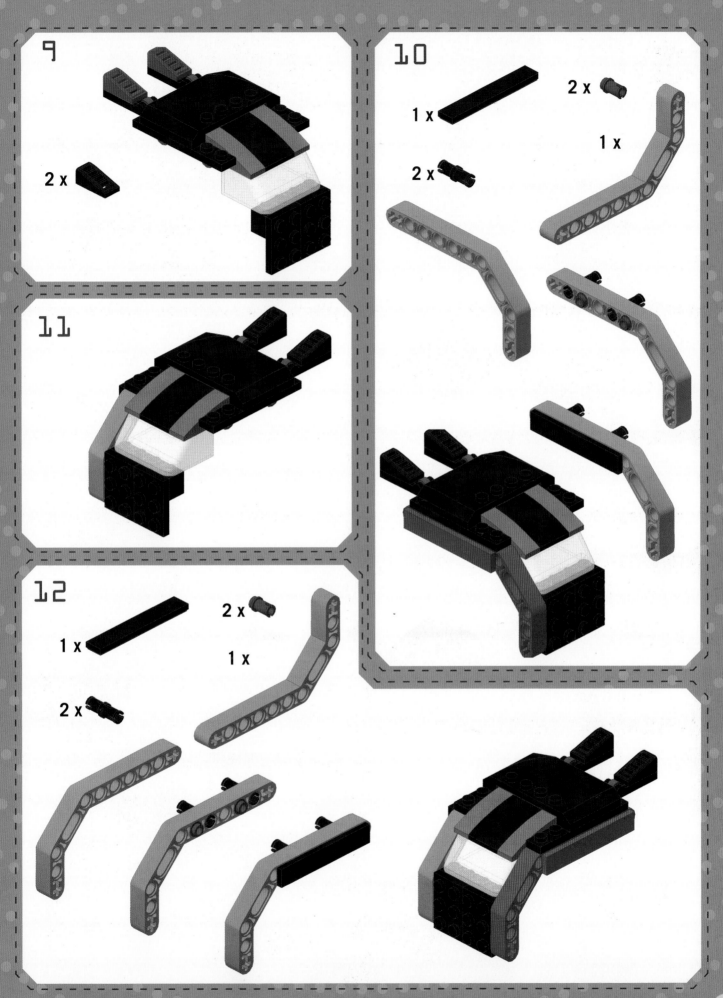

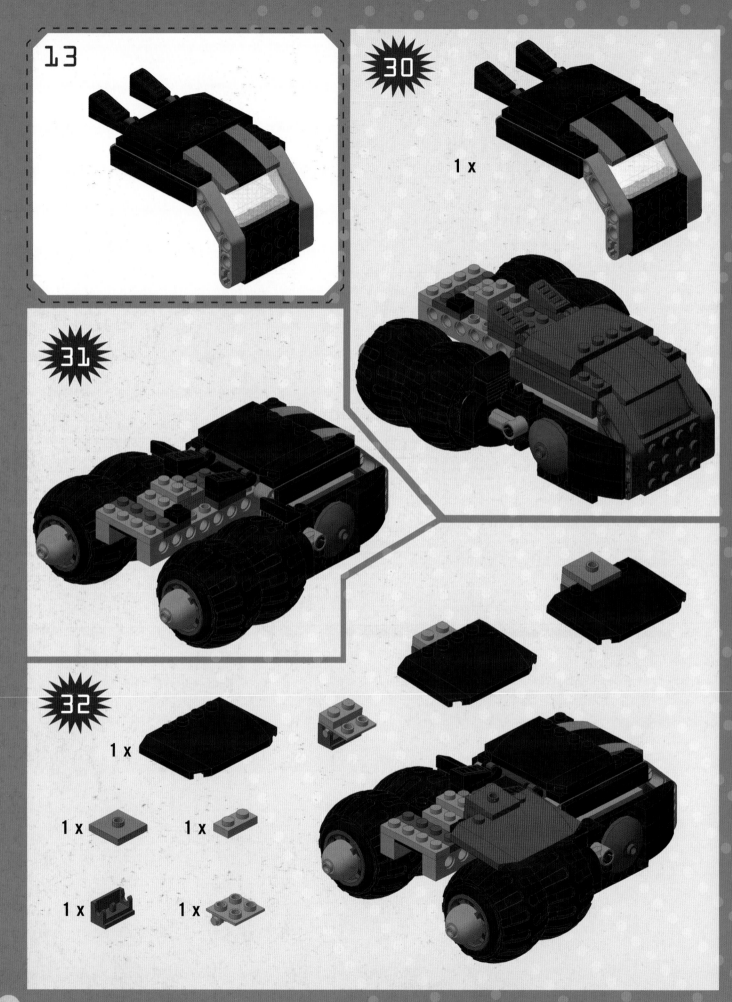

13

30

1 x

31

32

1 x

1 x 1 x

1 x 1 x

33

34

2 x

4 x

35

1 x

1 x 1 x

1 x 1 x

36

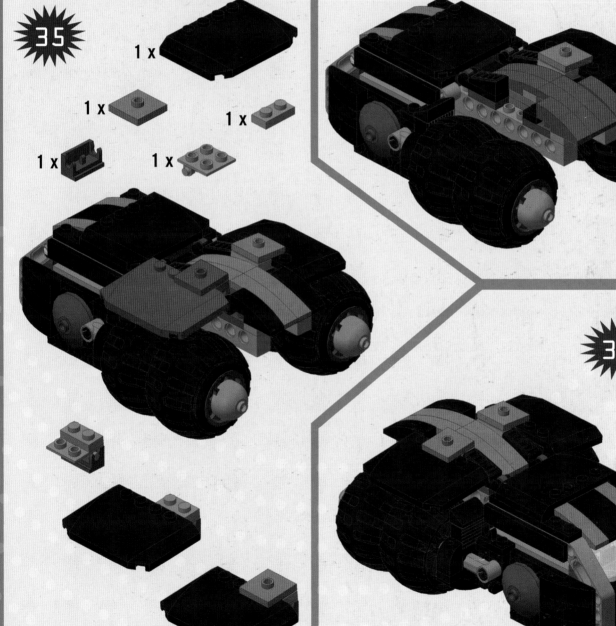

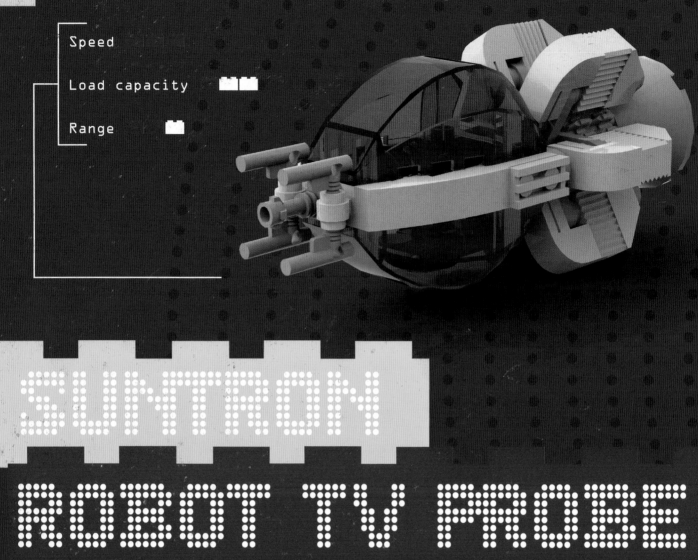

Speed

Load capacity

Range

SUNTRON
ROBOT TV PROBE

The Suntron was created to satisfy the whim of an ambitious but eccentric multibillionaire living on one of the planets most closely connected to the history of our dear Mother Earth. Its design was based on the so-called "star engines," which in the 1930s and 1940s were used on various kinds of airplanes. Because the designers required an engine that could voyage to the farthest reaches of space, they had to limit themselves to making their new engine resemble its predecessor, and they succeeded rather well. The structure of the particle generators, positioned in the arched walls of the cockpit, allowed them to provide energy to the pulse-driven engine, recalling the structure of the good old "star engines."

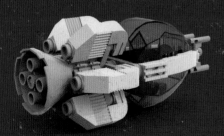

Creator/Designer: David Roberts

David is (coincidentally) an aeronautical engineer with an enormous passion for space science fiction. He reports in one of his many online profiles that one of his major influences as a child was the Terran Trade Authority book series (which he found in his school library), illustrated by Peter Elson. Don't bother him in the winter, though, because as soon as snow begins to appear, David goes off to Switzerland (he's an excellent skiing instructor, including extreme skiing), where he lives and works "as long as there's snow on the ground." This love for the snow led him to write a tourist guide for expert skiers, published in Kindle format.

CHARACTERISTICS

- compact in shape and agile in the most complex maneuvers
- can accommodate a minifigure

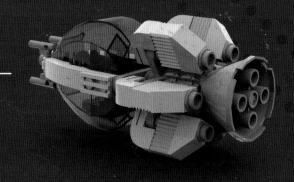

Author's note

The following element is used inside this model:
Brick 1x1 W. 4 KNOBS

(Element ID: 473324 – Part ID: 4733)

If you have trouble acquiring the 3 elements above, you can substitute the black versions:

(Element ID: 473326 – Part ID: 4733)

PIECES REQUIRED

2 x 4081	4 x 3024	6 x 3070	6 x 3665	2 x 3023	2 x 2412	6 x 6091
2 x 61678	3 x 4733	4 x 6141	6 x 2877	1 x 30374	1 x 60470	2 x 41883
1 x 32124	1 x 3023	1 x 30663	2 x 32269	1 x 2654	2 x 98138	12 x 6141
1 x 44294	2 x 32123	2 x 32125	4 x 60849	2 x 3794	1 x 64567	
1 x 99207	1 x 3943					

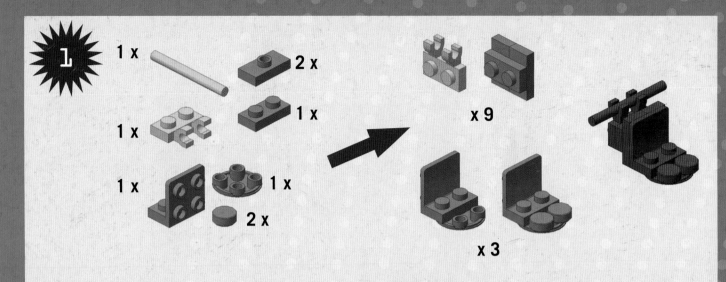

1
1 x
2 x
1 x
1 x
1 x
2 x
x 9
x 3

2
2 x
4 x
x 2
x 2

3
1 x

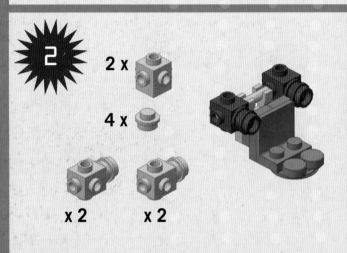

4
2 x
2 x

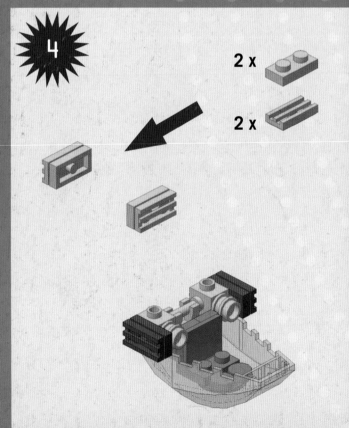

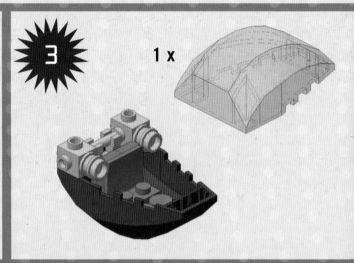

5
2 x
1 x
2 x
2 x

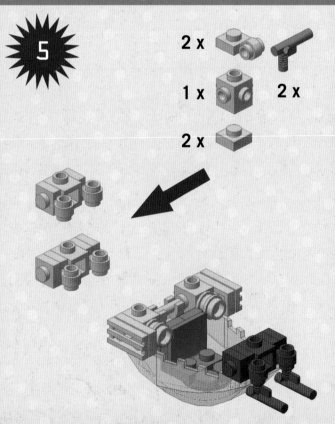

6

2 x
2 x

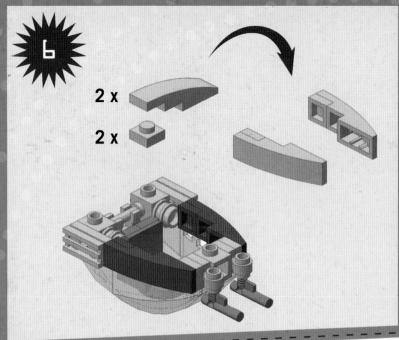

7

1 x

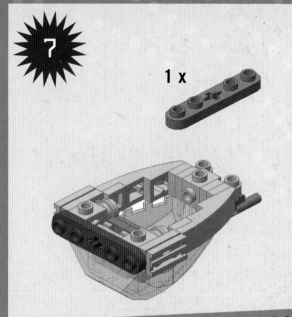

1

3 x
1 x
1 x
2 x

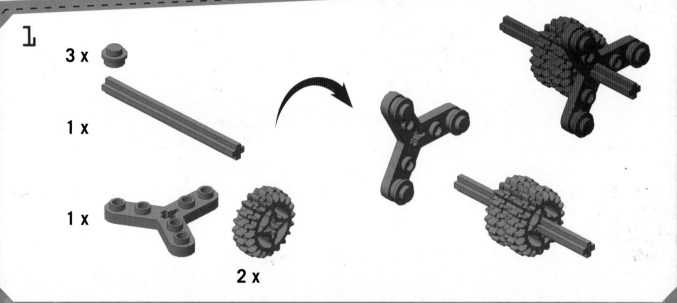

2

3 x
2 x
1 x

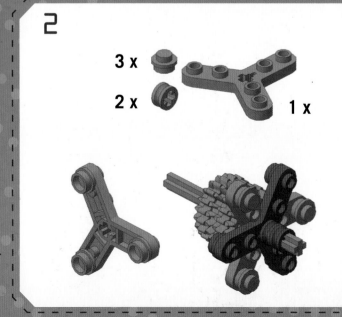

3

3 x

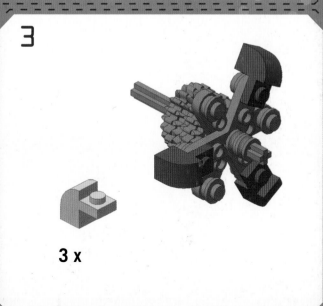

65

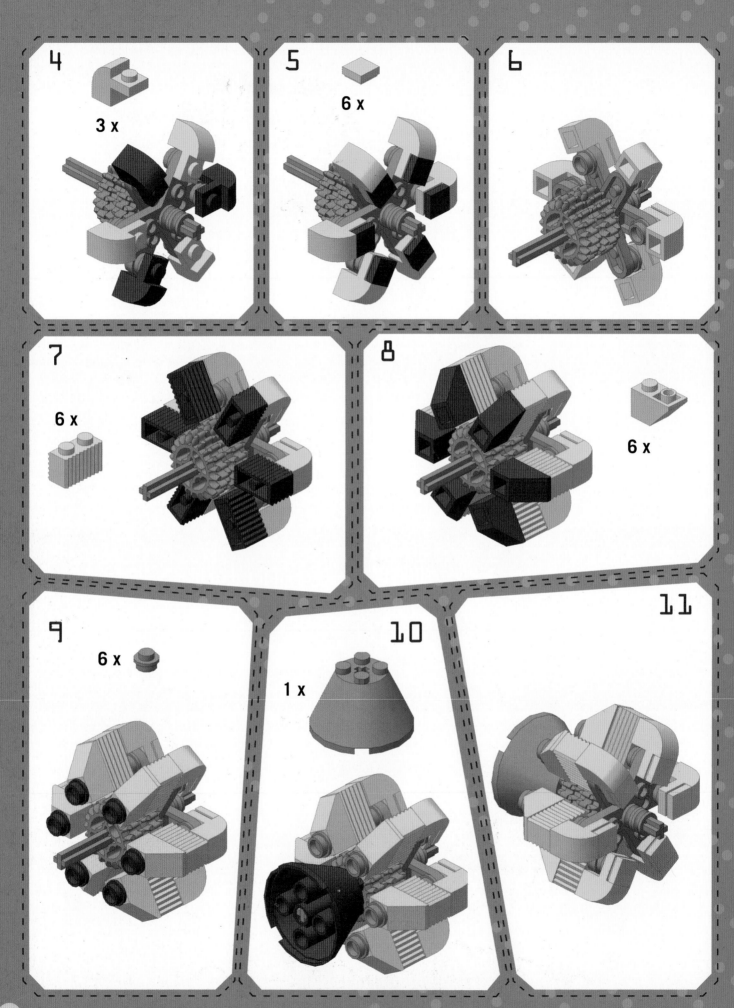

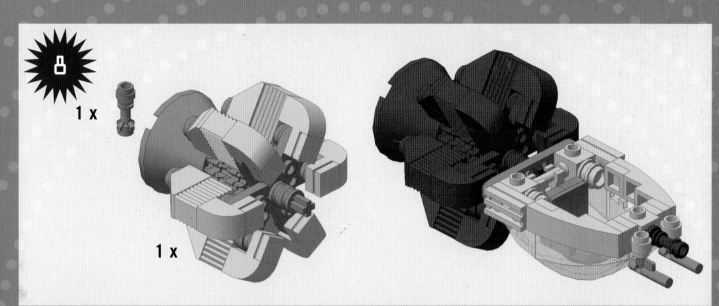

8

1 x

1 x

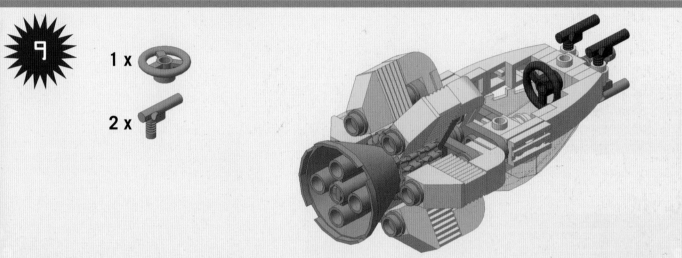

9

1 x

2 x

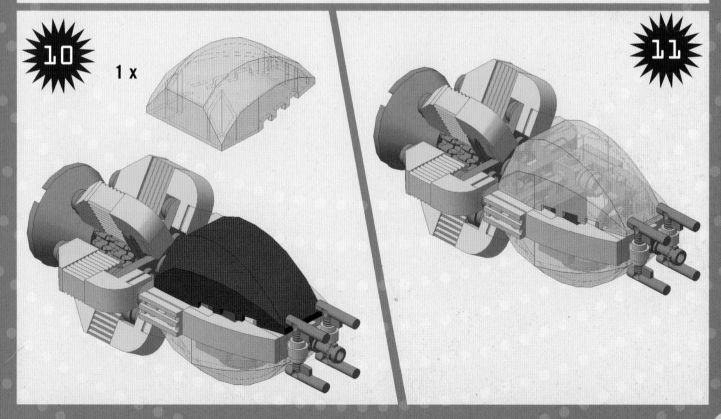

10

1 x

11

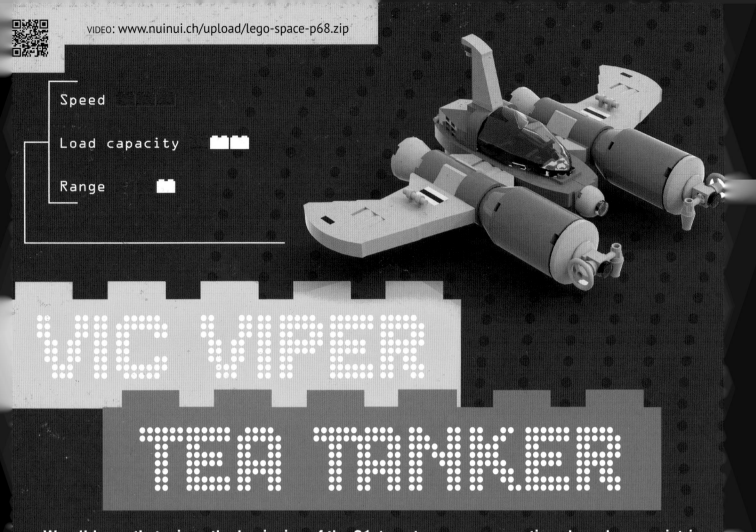

Speed

Load capacity

Range

VIC VIPER
TEA TANKER

We all know that, since the beginning of the 21st century, new generations have become intrigued by the digital world, by video games, and by virtual reality in general. We live in a universe that is no longer unknown, in which we can imagine contacting other civilizations, often more advanced than ours, and in which science makes steps forward every day that were unthinkable in the past. It is easy to imagine, then, that this fascination with the digital and the virtual can be taken to extremes. This premise is necessary to help understand how, in a time of such technological progress, engineers and designers, working on vehicles to participate in the J.U.P.I.T.E.R. GAMES, seem almost to enjoy paying homage through their own creations to the "digital" myths of the past. This space shuttle, with the humorous name Vic Viper Tea Tanker, is a perfect example of this. It was designed and developed to participate in the first part of one of the J.U.P.I.T.E.R. GAMES dedicated to an "earthling" video game that for some strange reason became an interplanetary success when other civilizations throughout the universe learned about it.

The Vic Viper Tea Tanker honors the shapes and types of space shuttles in the video game. The particular shape of the front section is due to the fact that, since vehicles required a great deal of fuel to finish the race (we're speaking of times in which "wave engines" and other more advanced types of engines were not yet developed), designers couldn't be too concerned about aerodynamics (especially since in space there is no air to generate friction). The shuttle's design team placed the fuel tanks in front, connected to the engines they had to feed. The tanks were supplied with a discharge pump that allowed the pilot to release fuel in case he realized he would arrive at the finish line with too much. He could thus make the shuttle lighter if he needed to make a "final sprint."

CHARACTERISTICS

- shape recalls the spacecraft in many video games loved by inhabitants of Planet Earth
- able to accommodate a minifigure

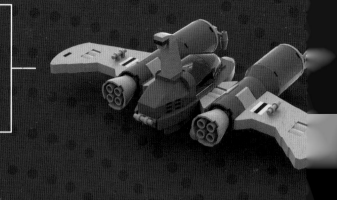

Creator/Designer: David Roberts

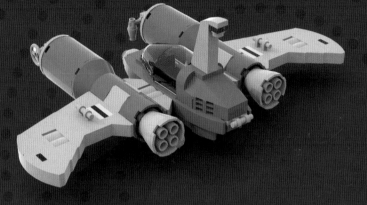

PIECES REQUIRED

10 x	3 x	4 x	2 x	1 x	2 x	4 x
3024	3020	85984	4742	3747	48183	3710
2 x	2 x	6 x	2 x		4 x	2 x
11477	3021	61678	3034		99780	3666
2 x	2 x	4 x	1 x	1 x	2 x	4 x
3070	3794	50746	48933	3022	93168	6218
4 x	2 x	1 x	4 x	6 x	2 x	2 x
3023	6091	3004	3023	4032	59443	3023
2 x	3 x	1 x	1 x		2 x	1 x
98138	3024	98138	30384		3040	2432

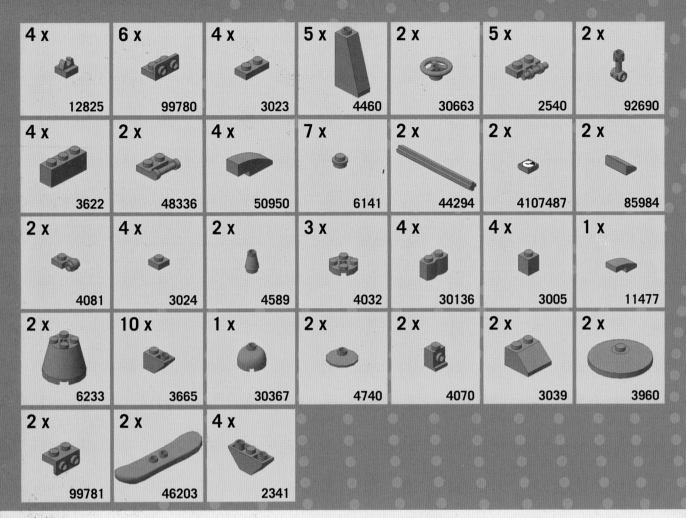

4 x 12825	6 x 99780	4 x 3023	5 x 4460	2 x 30663	5 x 2540	2 x 92690
4 x 3622	2 x 48336	4 x 50950	7 x 6141	2 x 44294	2 x 4107487	2 x 85984
2 x 4081	4 x 3024	2 x 4589	3 x 4032	4 x 30136	4 x 3005	1 x 11477
2 x 6233	10 x 3665	1 x 30367	2 x 4740	2 x 4070	2 x 3039	2 x 3960
2 x 99781	2 x 46203	4 x 2341				

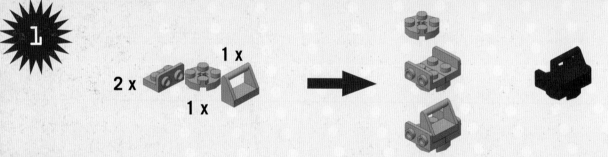

1

2 x 1 x 1 x

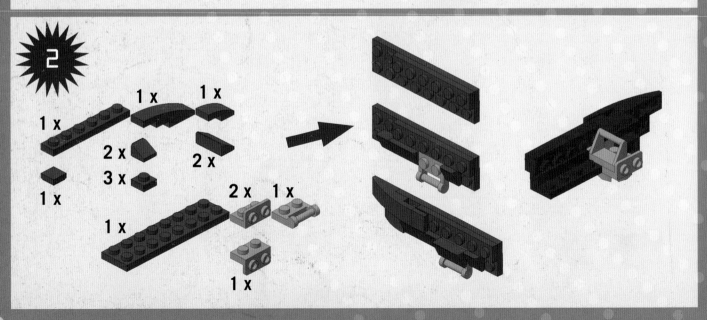

2

1 x 1 x 1 x

2 x 2 x

3 x

1 x

2 x 1 x

1 x

1 x

3

1 x 1 x 1 x 1 x
2 x 2 x
1 x 3 x
1 x 2 x 1 x
1 x

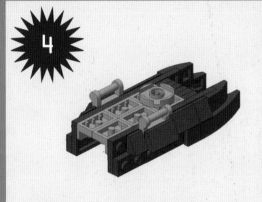

1

2

3

4

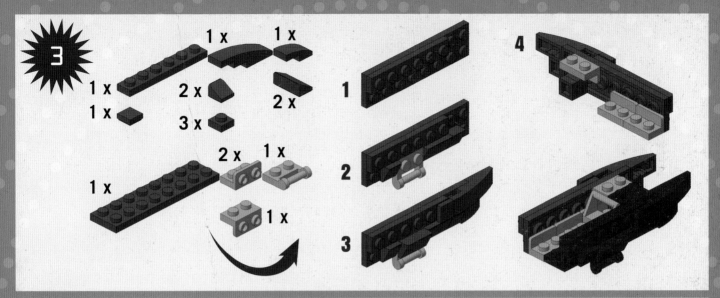

4

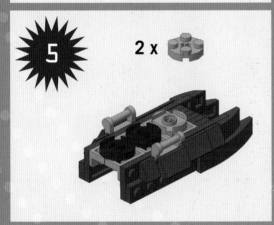

5

2 x

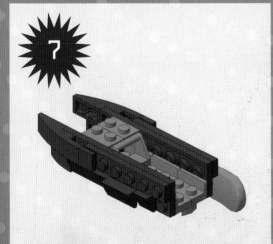

7

6

1

2

3

1 x 2 x
1 x
2 x

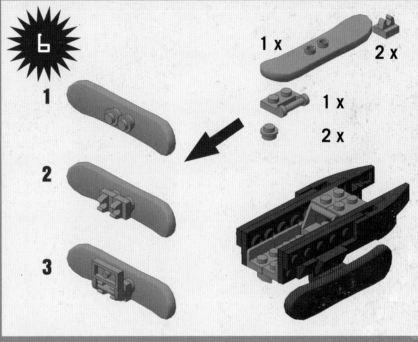

8

1 x 2 x
1 x
2 x

1

2

3

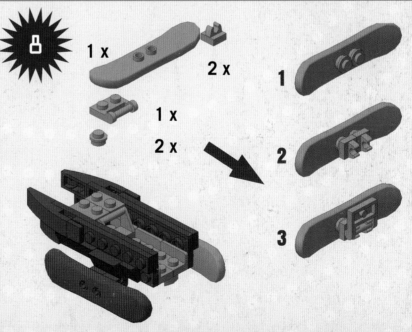

71

9

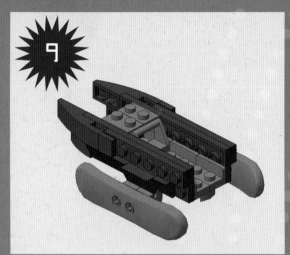

1

1 x 1 x 1 x

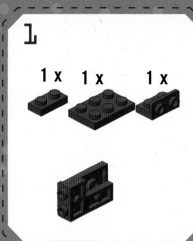

2

1 x

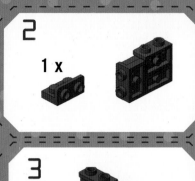

3

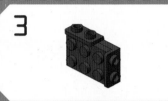

4

2 x

1 x

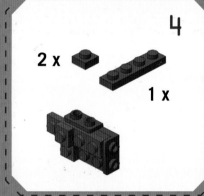

5

1 x
1 x 1 x

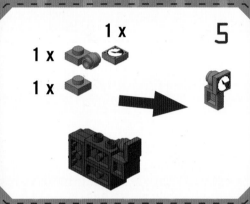

6

1 x

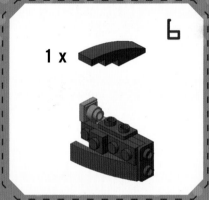

10

1 x

1 x

1 x

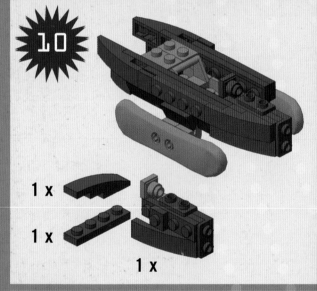

11

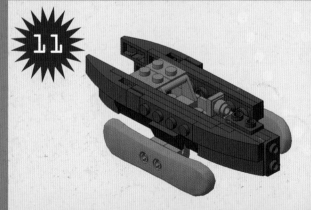

12

1 x
2 x
1 x
1 x 1 x 1 x
 2 x
 1 x
 1 x

1
2
3
4
5
6

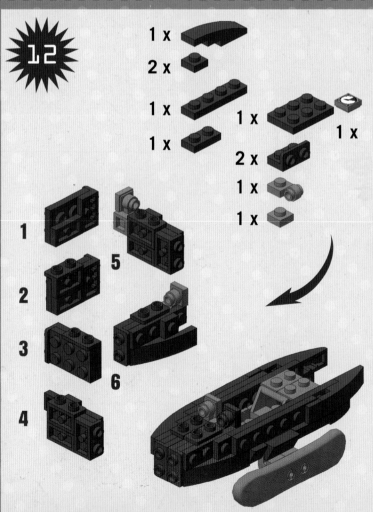

1 x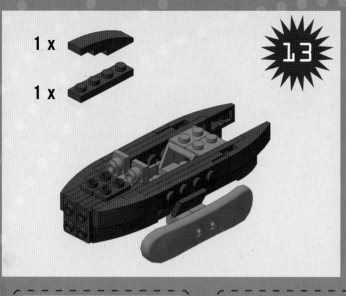

1 x

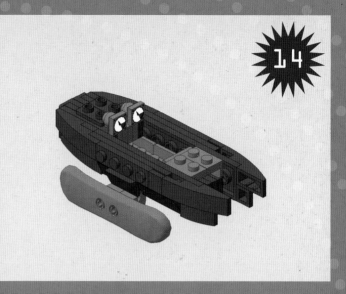

1

1 x

2

1 x **1 x** **1 x**

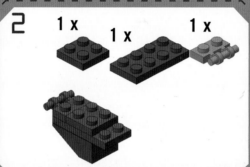

3

1 x

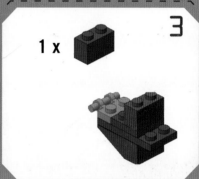

4

2 x

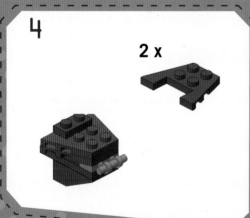

5

2 x

A

B

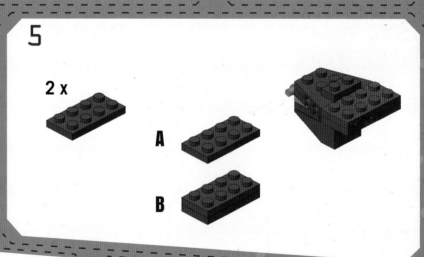

6

1 x

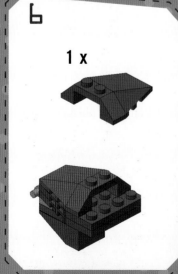

7

2 x

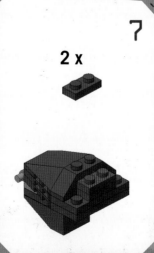

8

2 x

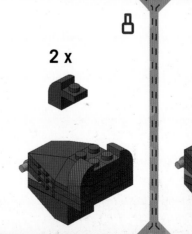

9

2 x

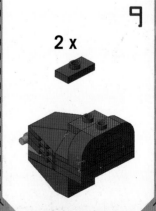

15

1 x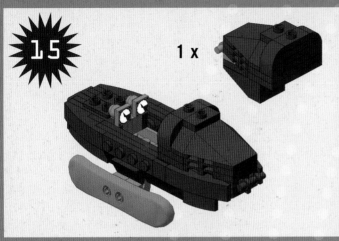

16

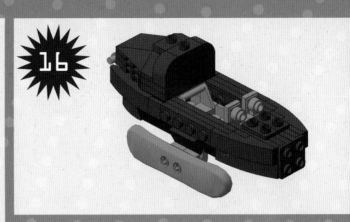

17

1 x
1 x

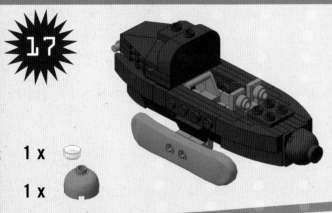

18

1 x
1 x
1 x
1 x
1 x

1
2

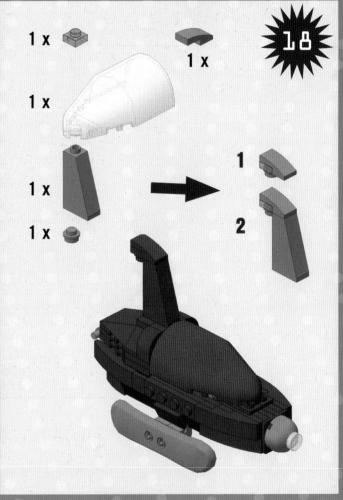

19

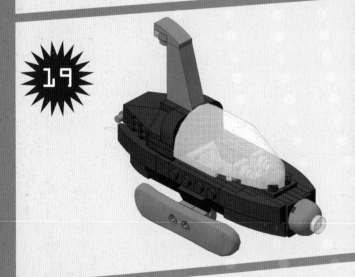

20

2 x
1 x

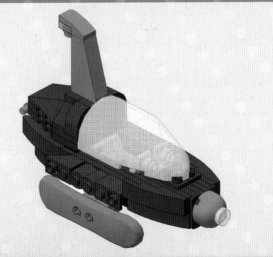

21

1 x

2 x

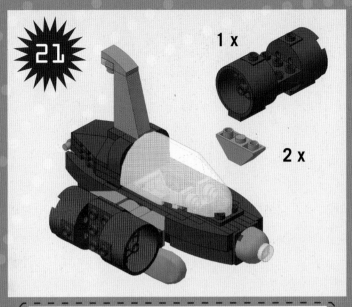

22

1 x
1 x

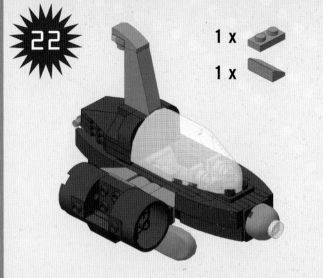

1

1 x
1 x
1 x

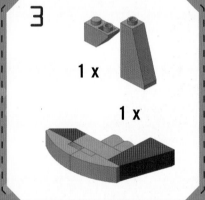

2

2 x
1 x

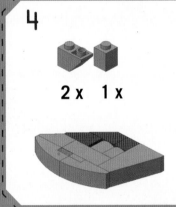

3

1 x
1 x

4

2 x 1 x

5

1 x
1 x

6

1 x
2 x
1 x
1 x 2 x

1
2
3

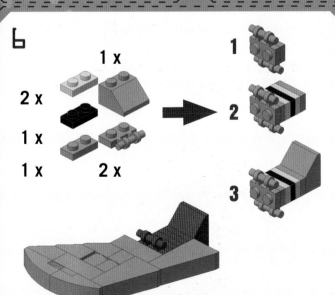

7

1 x
1 x

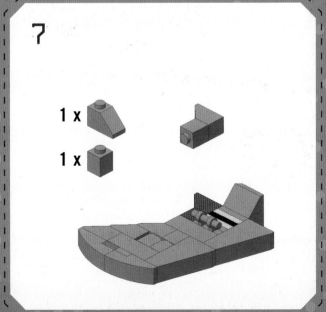

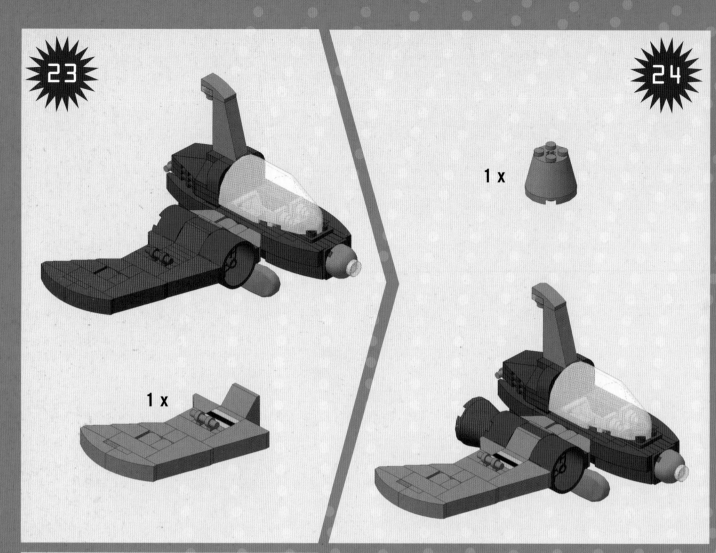

23

24

1 x

1 x

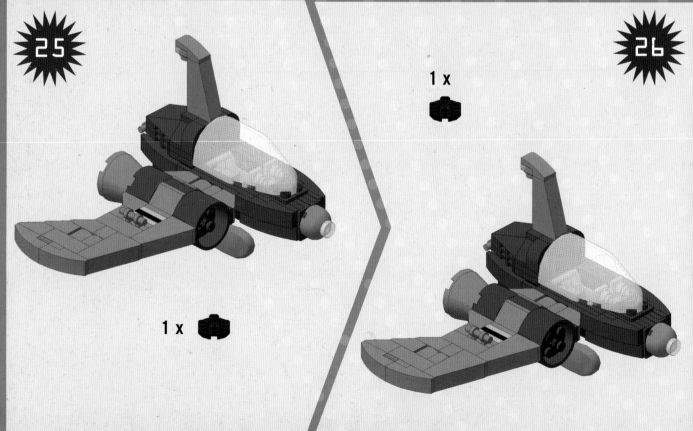

25

26

1 x

1 x

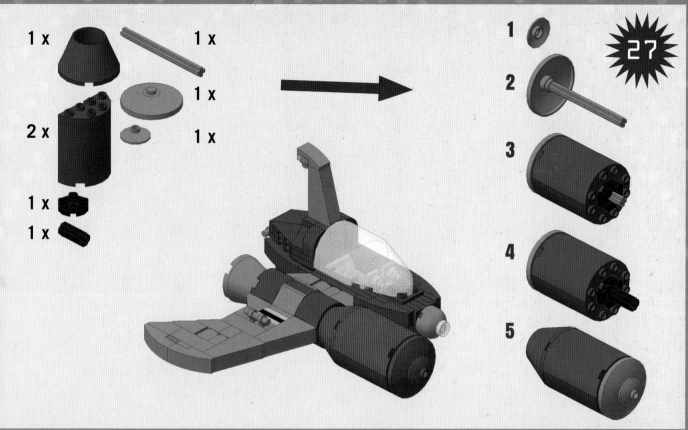

27

1 x
1 x
2 x
1 x
1 x

1 x
1 x
1 x

1
2
3
4
5

28

29

2 x
1 x

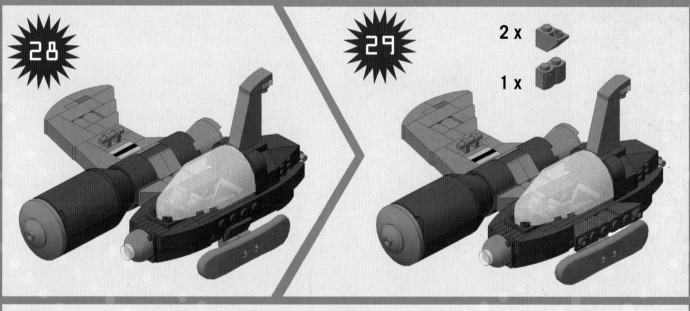

30

1 x
2 x

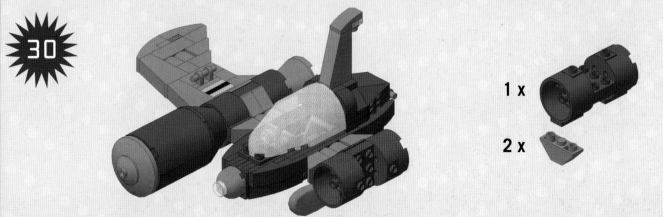

31

1 x
1 x

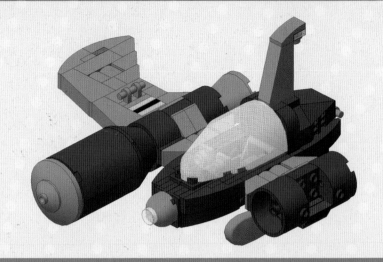

32

2 x
1 x
1 x
1 x

1 x
2 x

1 x

2 x
3 x
2 x

1 x

1 x

2 x

2 x

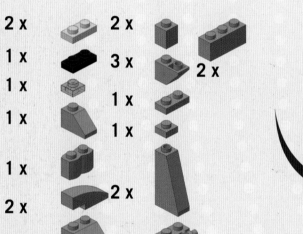

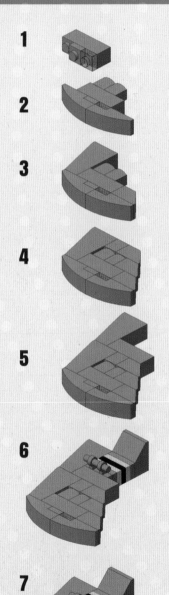

1

2

3

4

5

6

7

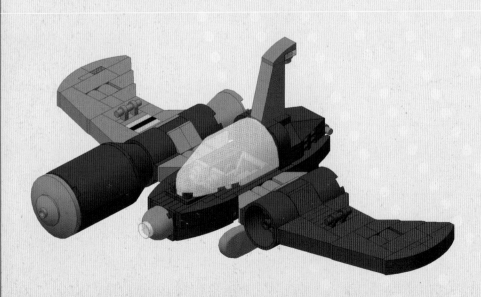

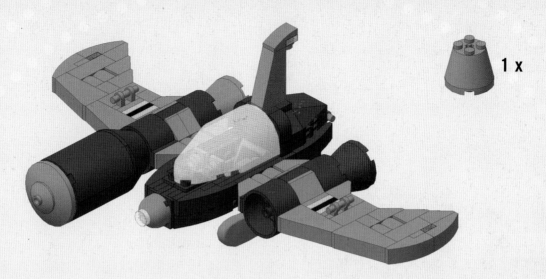

1 x

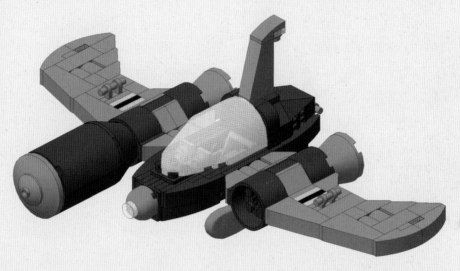

1 x

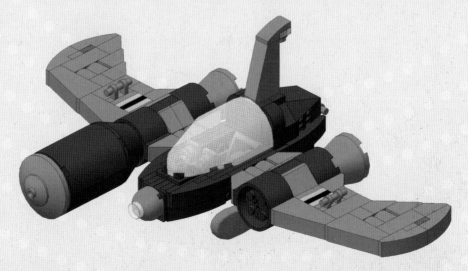

1 x

36

1 x
2 x
1 x
1 x

1 x
1 x
1 x

1
2
3
4
5

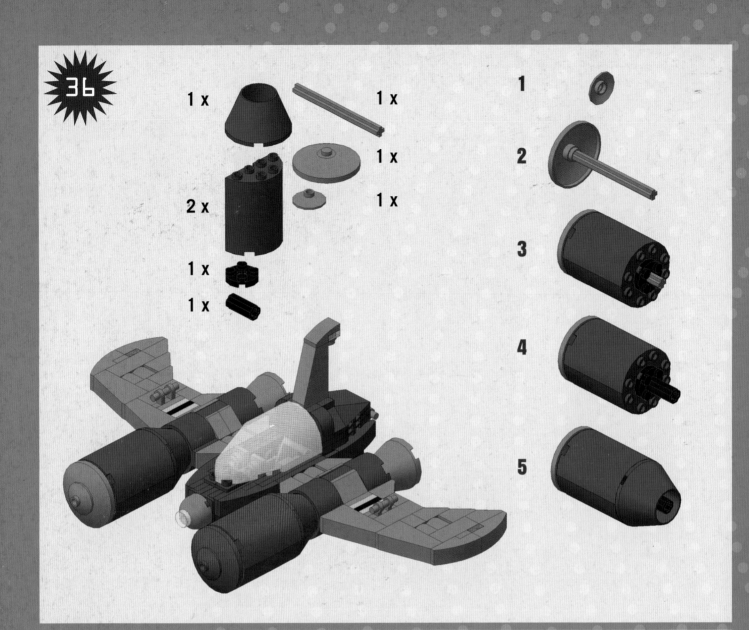

37

A
A
B

1 x
1 x
1 x
1 x
1 x
1 x

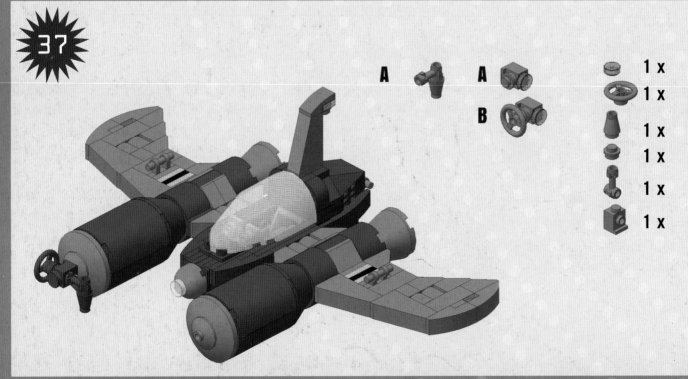

38

1 x
1 x
1 x
1 x
1 x
1 x

1
2
3

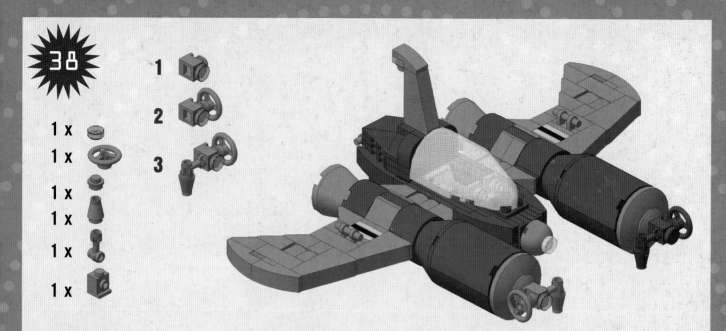

39

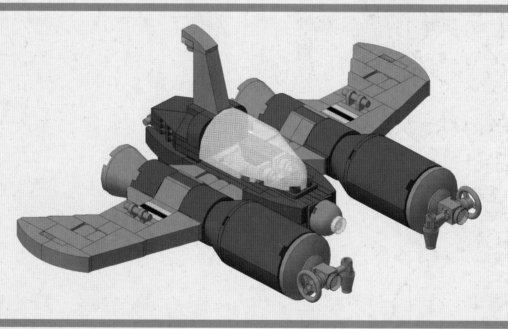

40

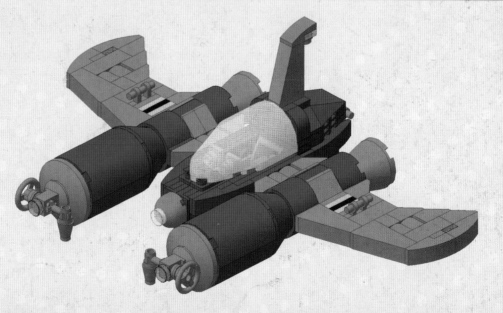

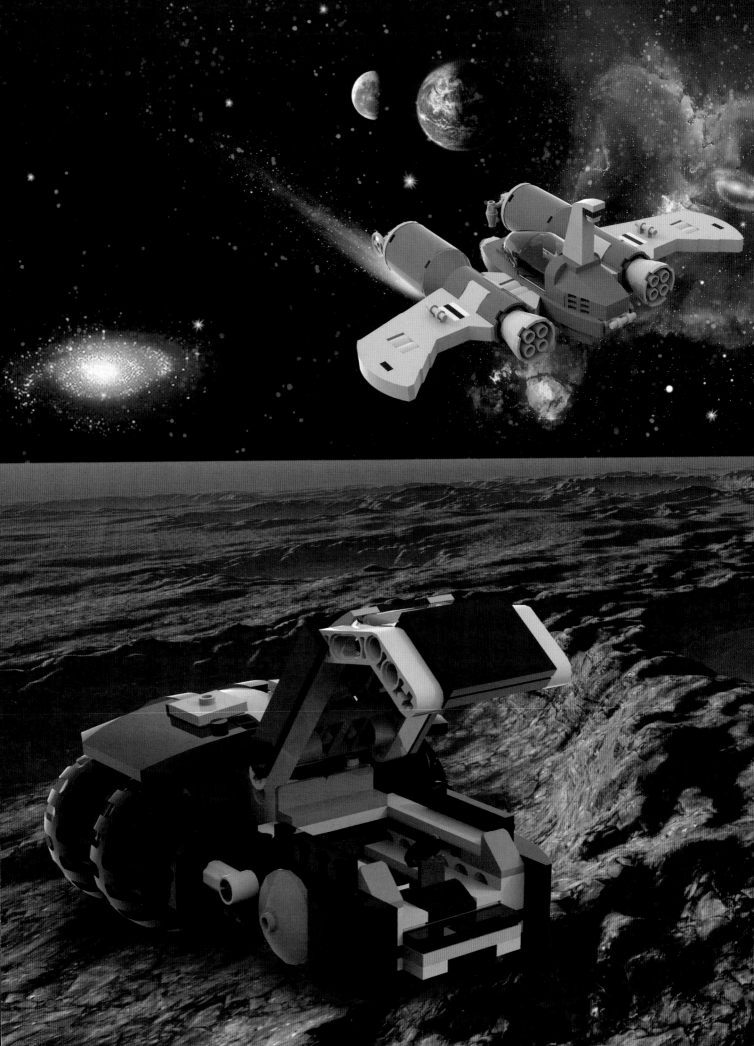

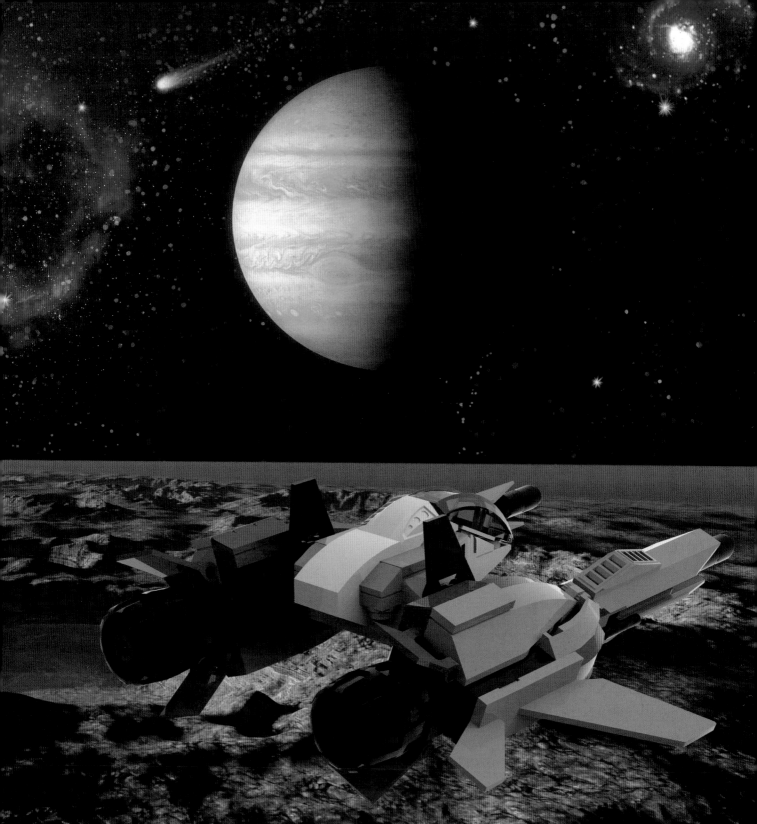

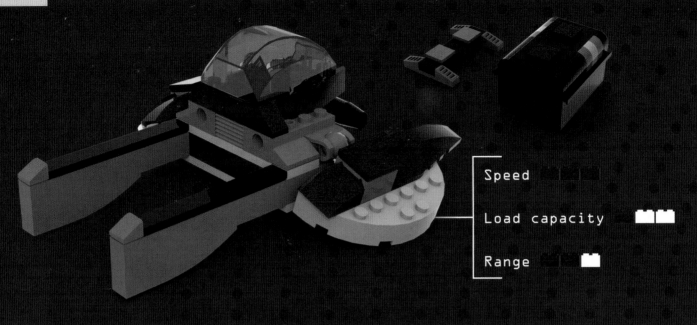

Speed	■■■■
Load capacity	■■
Range	■■■

ORBITAL HAULER
SUPER SPORT

Being a member of an advanced civilization means trying above all to obtain maximum results with minimal expense of power and resources. Some of the civilizations from the planets participating in the J.U.P.I.T.E.R. GAMES took this concept to extremes and created space shuttles that not only performed at a high level but were also ... useful. The representatives of these civilizations requested and were granted authorization by the J.U.P.I.T.E.R. GAMES Commission to devote one year's games to work vehicles. The following model is one of the best examples of a vehicle for both work and competition: a space shuttle for carrying loads (adapted for transporting space containers) but with a shape, propulsion, and piloting system designed for competition. In particular, this vehicle participated in an event in the J.U.P.I.T.E.R. GAMES whose objective was to transport the greatest possible number of space containers (which, as on earth, are of uniform size and weight) from one planet to another.

Creator/Designer: Nicola Lugato

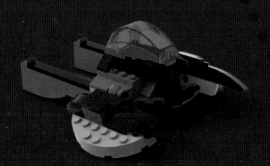

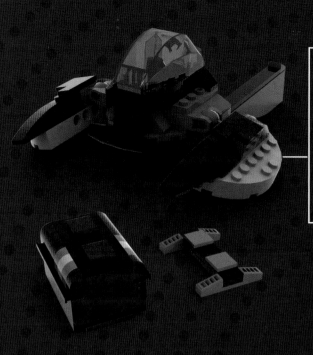

CHARACTERISTICS

- shape recalls the mythical forklift trucks used for many years on Planet Earth to move loads and merchandise

- able to accommodate a minifigure

- the container incudes its supporting base, which it rests on while waiting to be loaded onto its Orbital Hauler Super Sport

PIECES REQUIRED-SPACESHIP

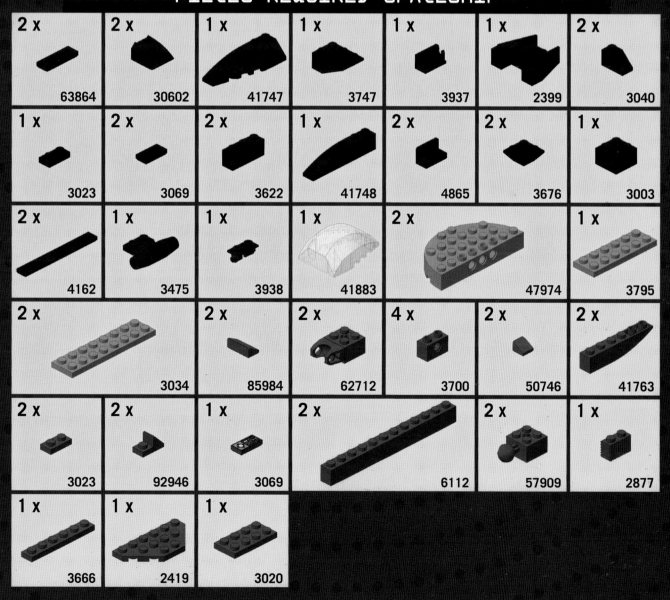

2 x 63864	2 x 30602	1 x 41747	1 x 3747	1 x 3937	1 x 2399	2 x 3040
1 x 3023	2 x 3069	2 x 3622	1 x 41748	2 x 4865	2 x 3676	1 x 3003
2 x 4162	1 x 3475	1 x 3938	1 x 41883	2 x 47974		1 x 3795
2 x 3034	2 x 85984	2 x 62712	4 x 3700	2 x 50746	2 x 41763	
2 x 3023	2 x 92946	1 x 3069	2 x 6112	2 x 57909	1 x 2877	
1 x 3666	1 x 2419	1 x 3020				

1

1 x

2

1 x　　　1 x
2 x　　　2 x

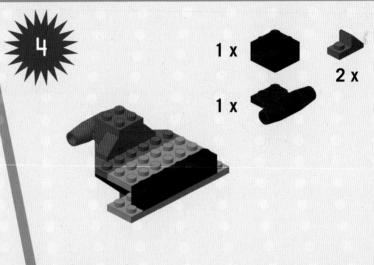

3

1 x　　　1 x

4

1 x　　　2 x
1 x

5

2 x
2 x

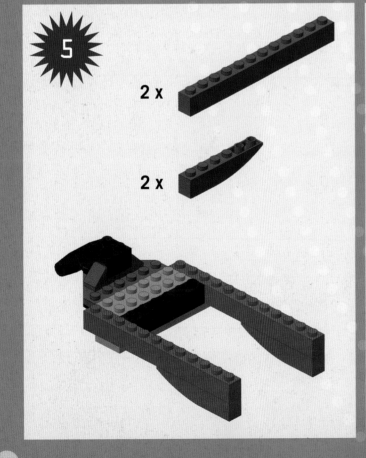

6

2 x
2 x
2 x

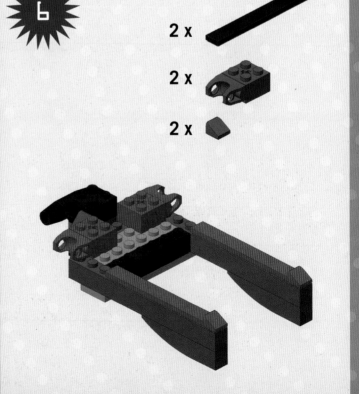

7

1 x

1 x

2 x

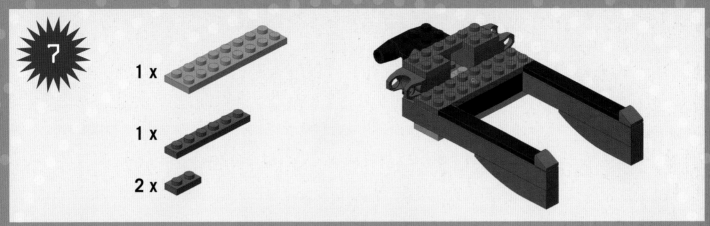

8

2 x

2 x

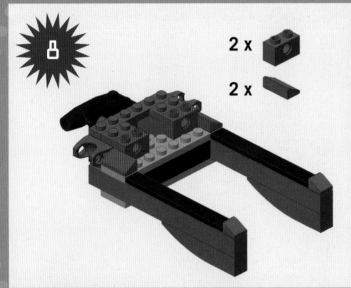

9

2 x

1 x

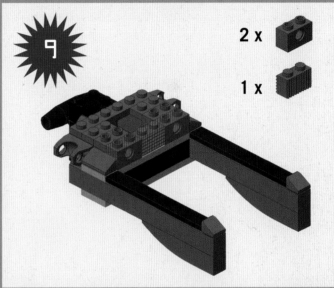

10

2 x

2 x

1 x

1 x

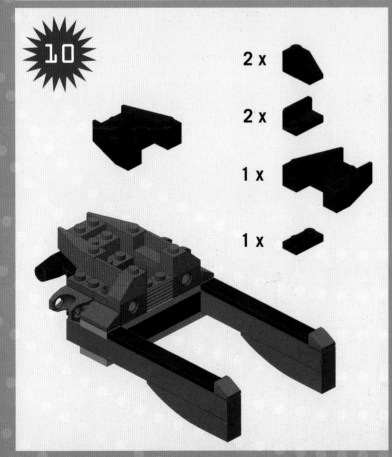

11

1 x

1 x

1 x

1

2

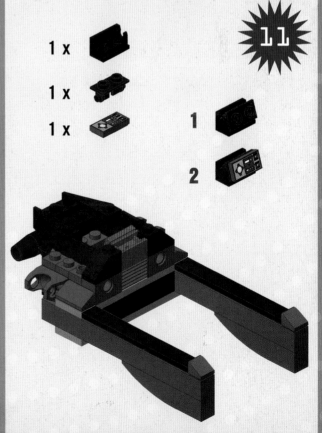

1

1 x

1 x

2

1 x

1 x

3

1 x

1 x

12

1 x

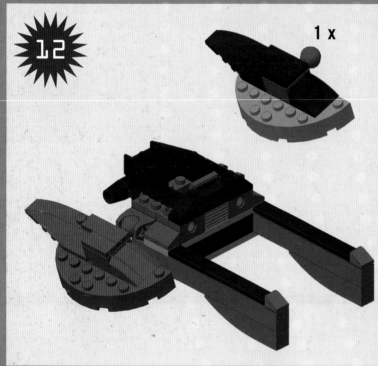

13

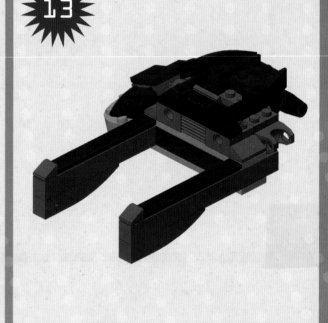

1

1 x

1 x

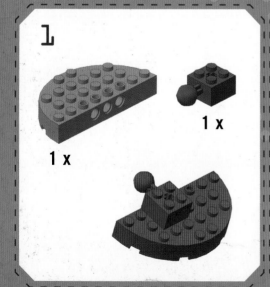

2

1 x

1 x

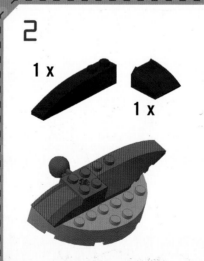

3

1 x

1 x

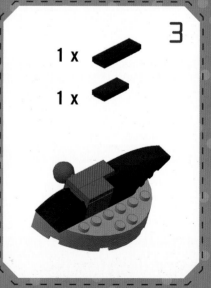

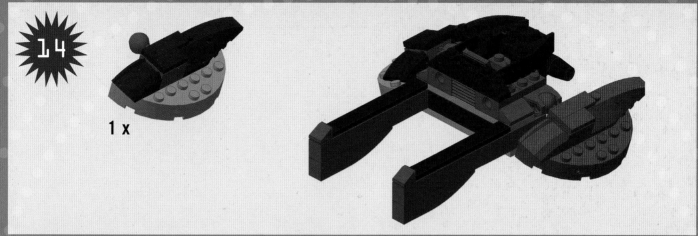

14 1 x

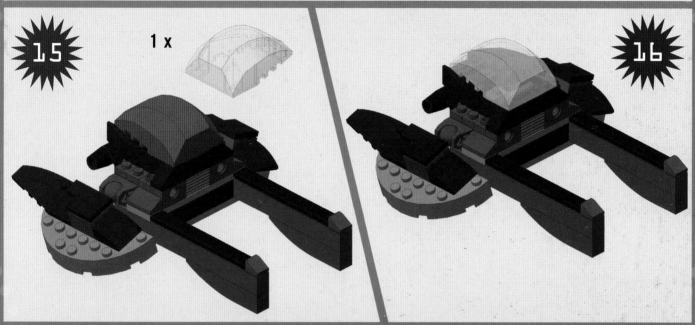

15 1 x **16**

PIECES REQUIRED-CONTAINER

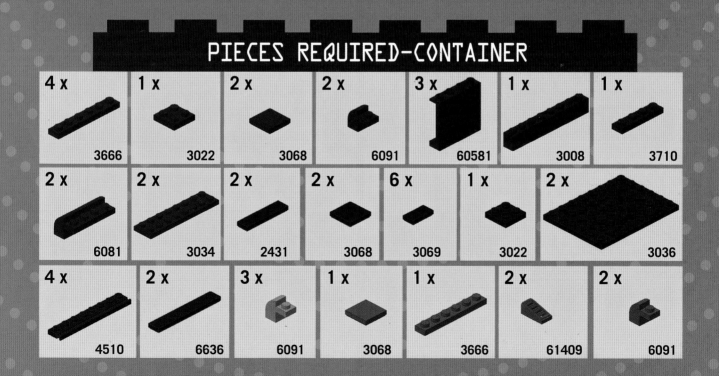

4 x	1 x	2 x	2 x	3 x	1 x	1 x
3666	3022	3068	6091	60581	3008	3710

2 x	2 x	2 x	2 x	6 x	1 x	2 x
6081	3034	2431	3068	3069	3022	3036

4 x	2 x	3 x	1 x	1 x	2 x	2 x
4510	6636	6091	3068	3666	61409	6091

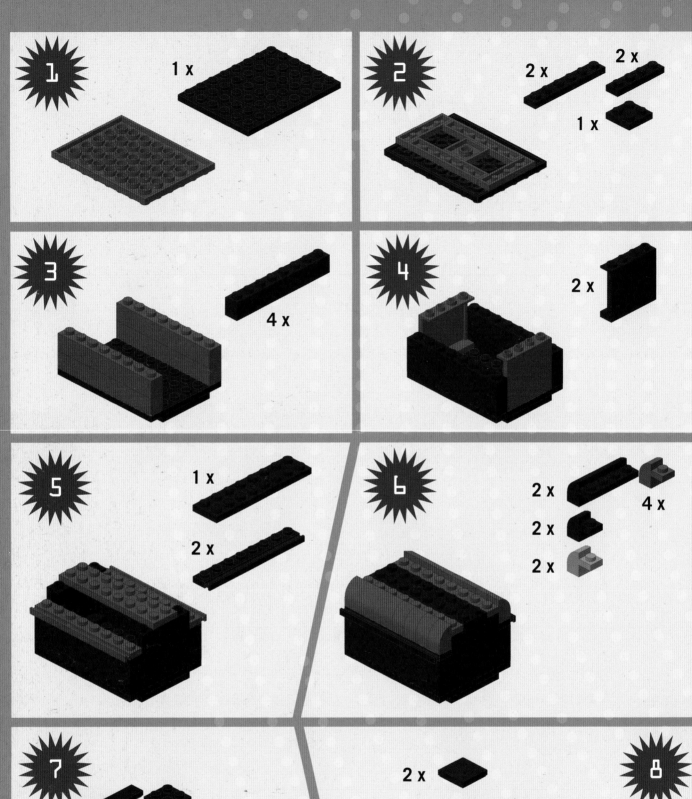

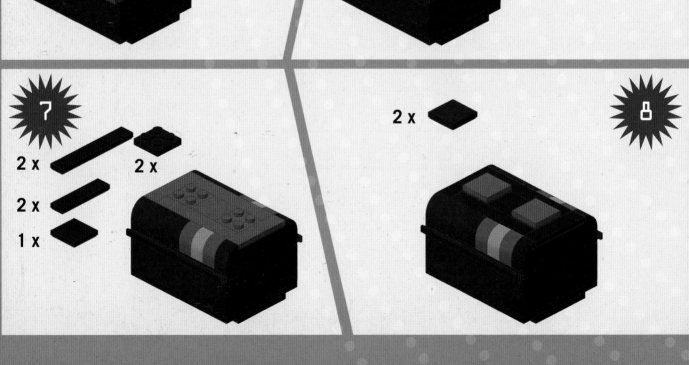

9

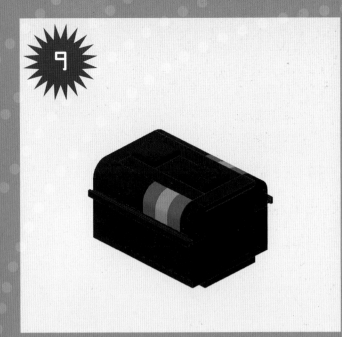

10

1 x

2 x

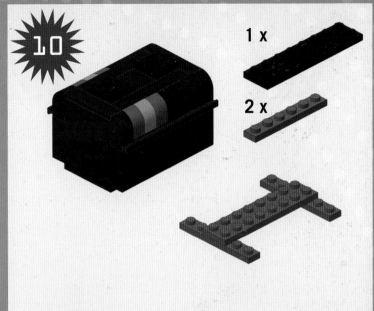

11

4 x

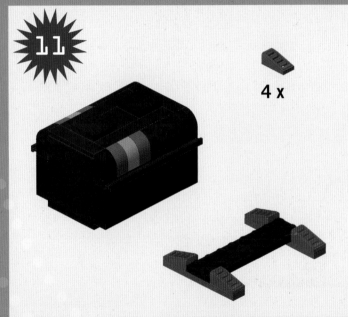

12

1 x

2 x

2 x

13

2 x

14

In this chapter you can find LEGO® reproductions of the best wheeled (or in some cases tracked) vehicles that have participated in (and often won) Part 2 of the **J.U.P.I.T.E.R. GAMES**.

Some models are one-seaters, while others have two seats, because some of the events of Part 2 of the **Games** require a co-pilot or navigator, as in races on faraway Planet Earth called "rallies."

The pieces used to create the models are a combination of those used for cars, trucks, and other forms of transport and those used to build airplanes and other "flying machines" (wings, tails, jet engines, etc.).

For example, combine some slope pieces (see chapter 2), and you can make an excellent car body. Or combine them with plate wedges and rudders to create futuristic vehicles.

Take tracks, wheel rims, and a windshield of the appropriate dimensions ... and you have a beautiful tracked vehicle.

Or use a combination of curved slopes, cockpits, and air vents and you can construct a cabin, and the air vents will give your model an aggressive look.

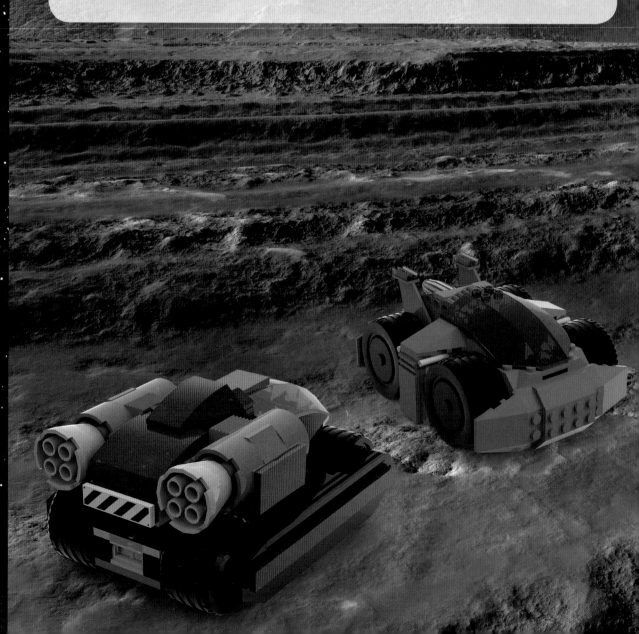

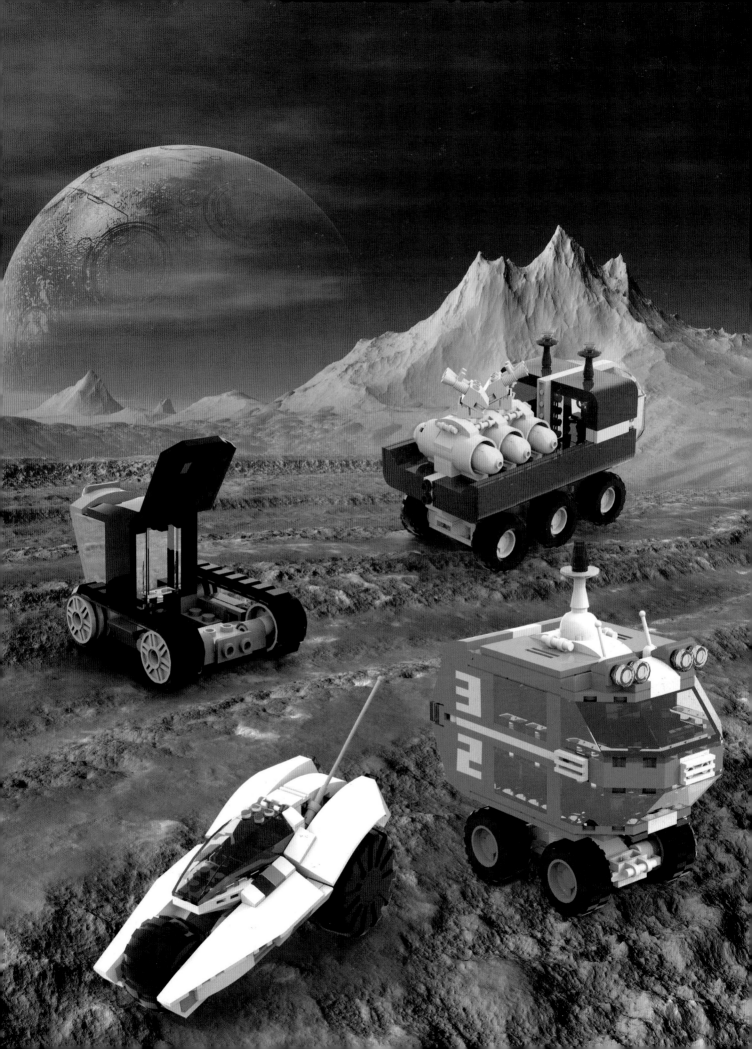

Speed

Load capacity

Range

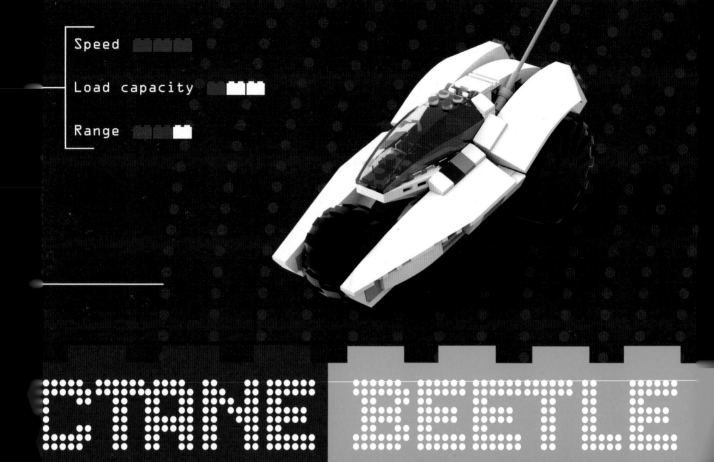

CTANE BEETLE

...ned and built by Team Octane, one of the most historic teams that has ever participated in ...U.P.I.T.E.R. GAMES, the ultra speedy Octane Beetle has always achieved extraordinary re-... even on the most demanding terrain. Its powerful impulse engine, capable of harnessing the ...austible magnetic energy emitted by the planet on which it is racing and transforming it into ...ional power, allows it to speed across almost any type of terrain.

CHARACTERISTICS

- able to accommodate a minifigure in the driver's seat
- adapted to any kind of course

Creator/Designer: Bob De Quatre

Bob De Quatre is a great builder of space models.

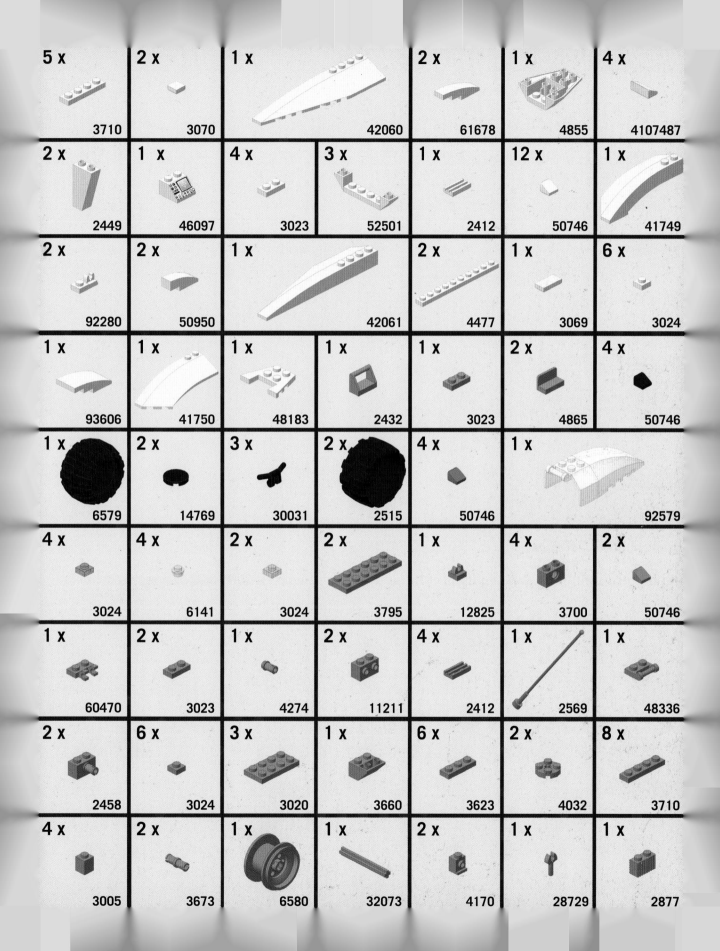

5 x 3710	2 x 3070	1 x 42060	2 x 61678	1 x 4855	4 x 4107487	
2 x 2449	1 x 46097	4 x 3023	3 x 52501	1 x 2412	12 x 50746	1 x 41749
2 x 92280	2 x 50950	1 x 42061	2 x 4477	1 x 3069	6 x 3024	
1 x 93606	1 x 41750	1 x 48183	1 x 2432	1 x 3023	2 x 4865	4 x 50746
1 x 6579	2 x 14769	3 x 30031	2 x 2515	4 x 50746	1 x 92579	
4 x 3024	4 x 6141	2 x 3024	2 x 3795	1 x 12825	4 x 3700	2 x 50746
1 x 60470	2 x 3023	1 x 4274	2 x 11211	4 x 2412	1 x 2569	1 x 48336
2 x 2458	6 x 3024	3 x 3020	1 x 3660	6 x 3623	2 x 4032	8 x 3710
4 x 3005	2 x 3673	1 x 6580	1 x 32073	2 x 4170	1 x 28729	1 x 2877

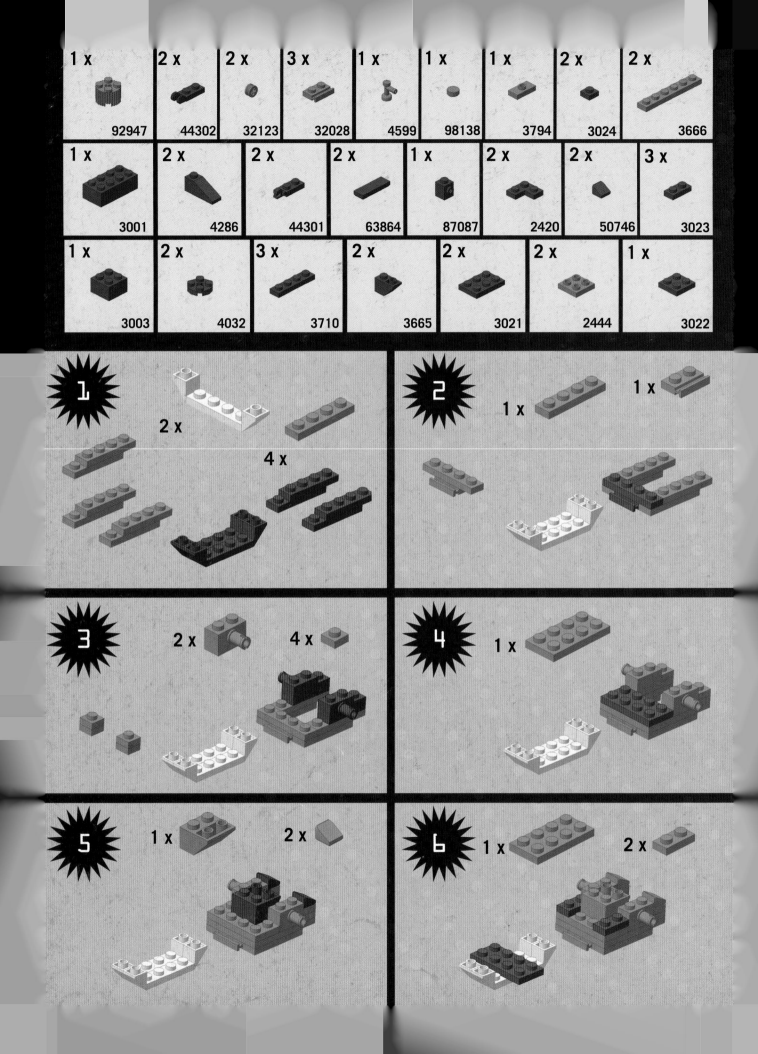

7

1 x

2 x

8

9

1 x

2 x

2 x

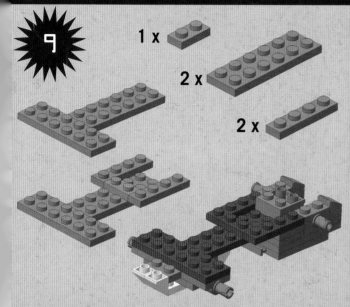

10

2 x

1 x

1 x

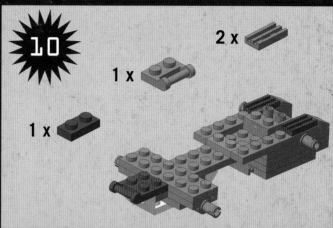

11

2 x

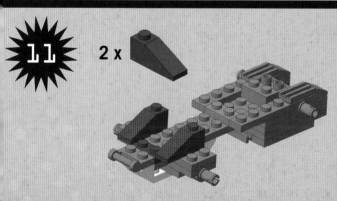

12

2 x 1 x

1 x

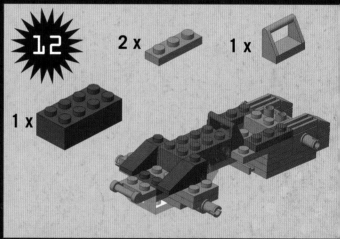

13

1 x

2 x

2 x

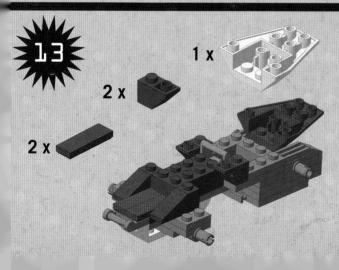

14

1 x

1 x

2 x

1 x

1 x

2 x

1 x

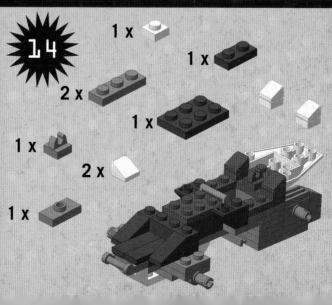

15
1 x
2 x
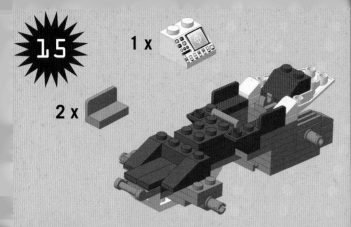

16
2 x
2 x
1 x
1 x
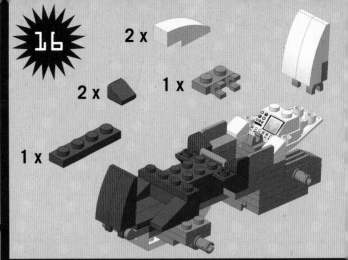

17
1 x
1 x
1 x
2 x
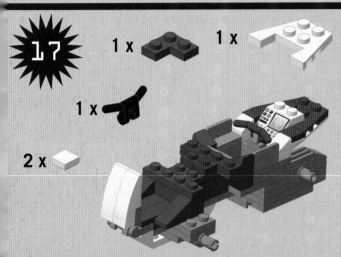

18
1 x
2 x
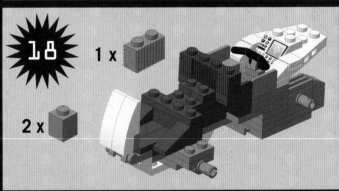

19
1 x
1 x
1 x
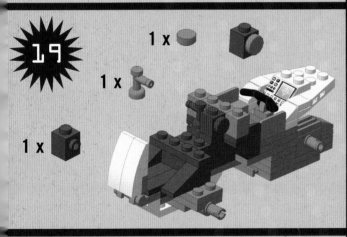

20
1 x
1 x
1 x
1 x
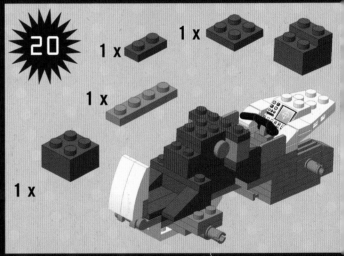

21
1 x
1 x
2 x
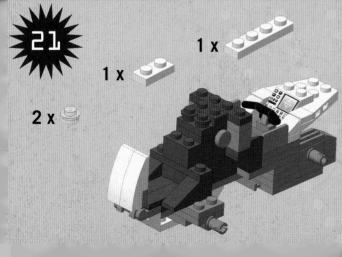

22
1 x
2 x
1 x
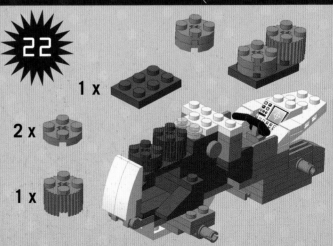

23

2 x

24

2 x

1 x

2 x

1 x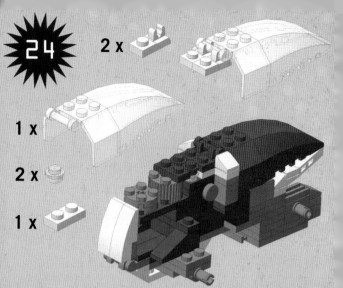

25

1 x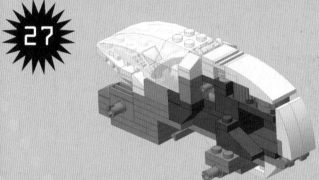

26

1 x

1 x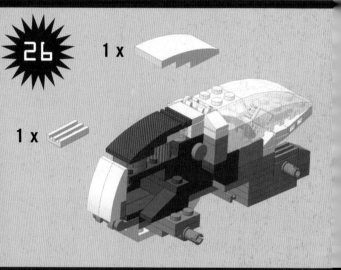

27

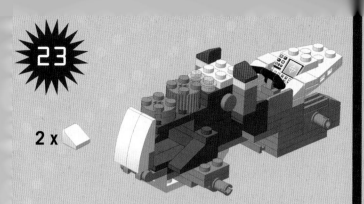

28

1 x

1 x

1 x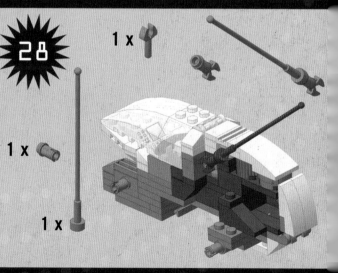

29

1 x

1 x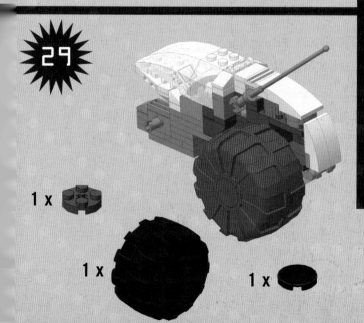

1 x 1 x **1** **2** **3**

30

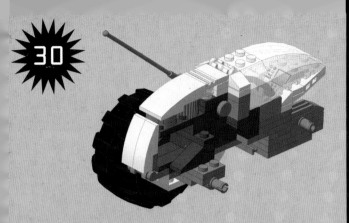

31

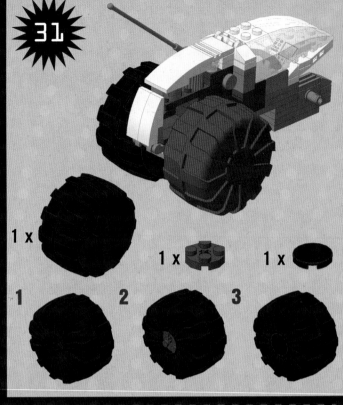

1 x

1 x 1 x

1 2 3

32

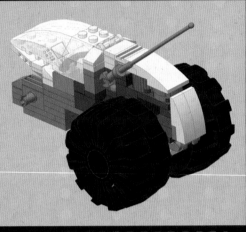

1

1 x 1 x 1 x

1 x 1 x 1 x

1 x 2 x

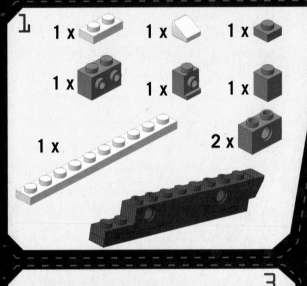

2

1 x

1 x 1 x

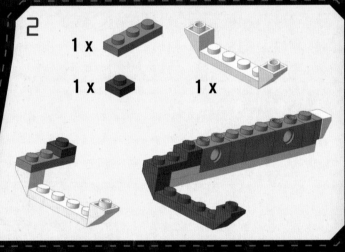

3

4 1 x

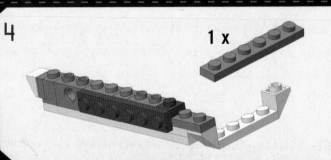

5

1 x 1 x a

1 x 1 x b

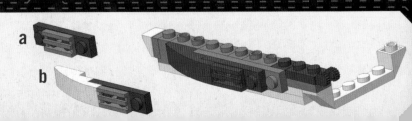

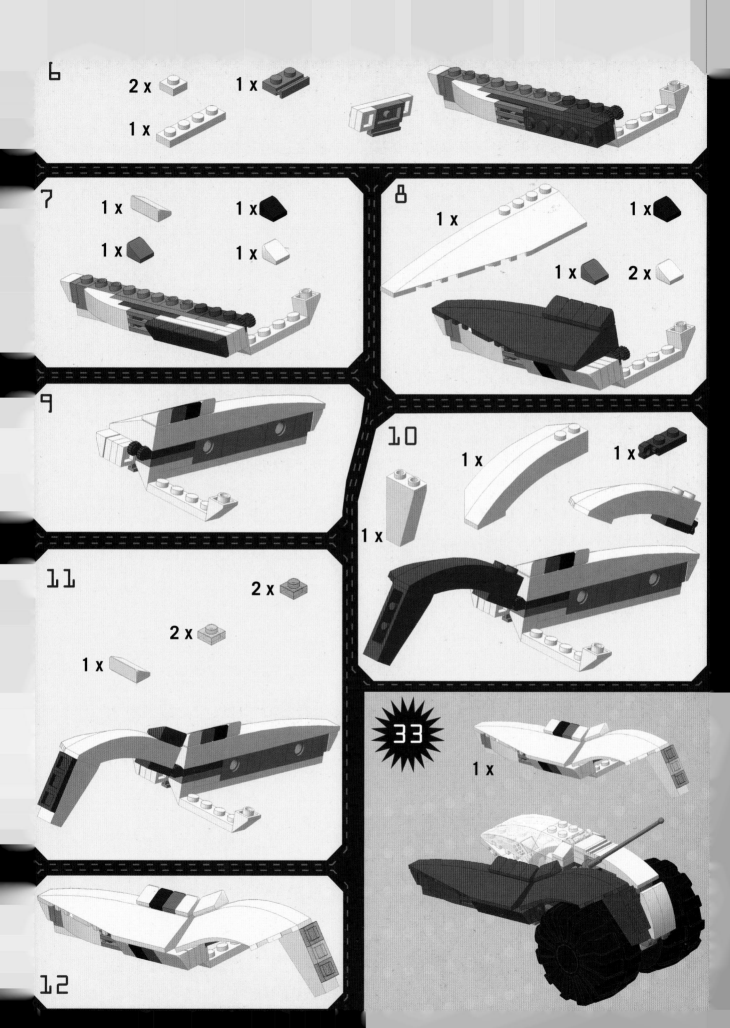

6

2 x 1 x

1 x

7

1 x 1 x

1 x 1 x

8

1 x

1 x 2 x

9

10

1 x 1 x

1 x

11

2 x

2 x

1 x

33

1 x

12

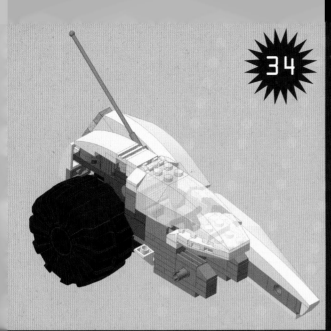

34

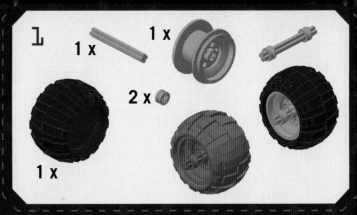

1

1 x 1 x 2 x 1 x

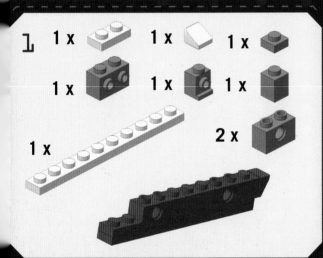

1

1 x 1 x 1 x

1 x 1 x 1 x

1 x 2 x

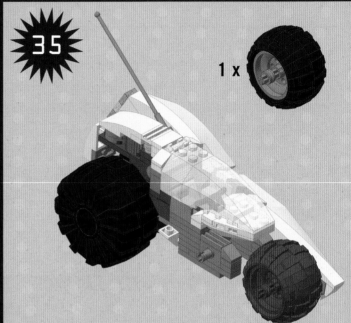

35

1 x

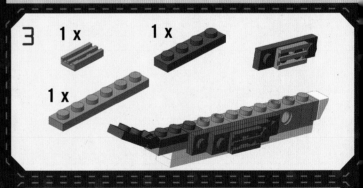

2

1 x 1 x 1 x

1 x

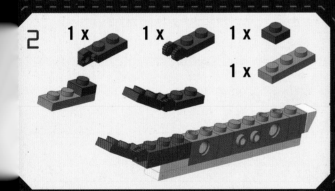

3

1 x 1 x

1 x

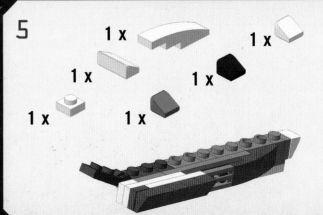

4

2 x 1 x

1 x

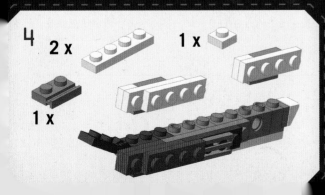

5

1 x 1 x

1 x 1 x

1 x 1 x

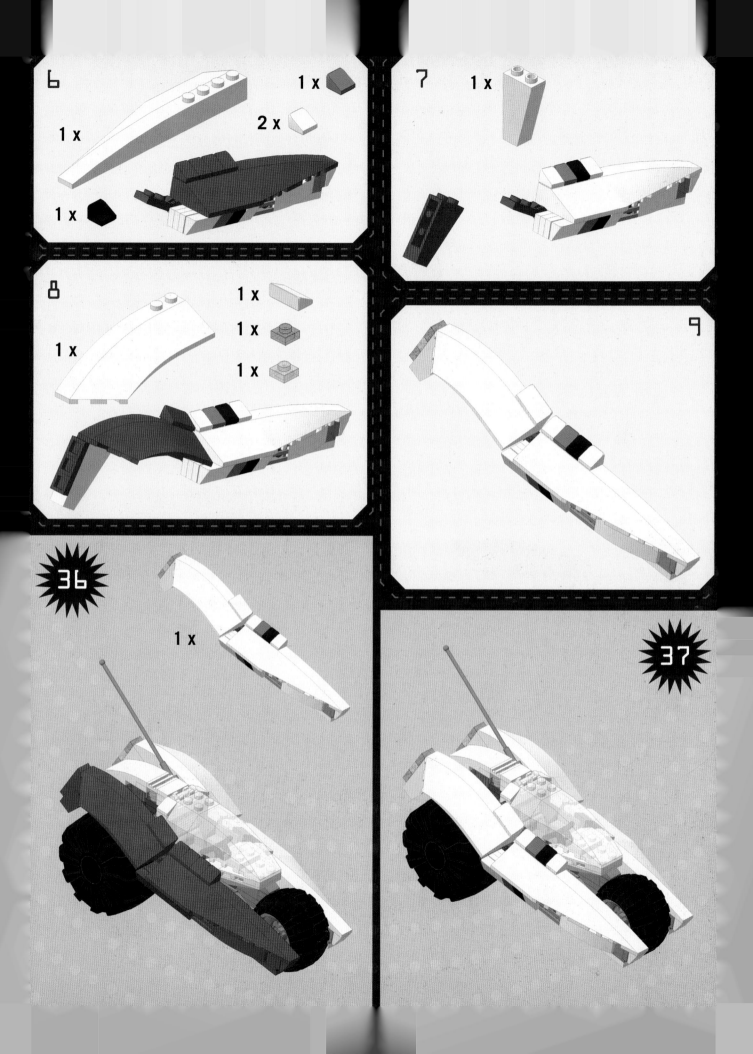

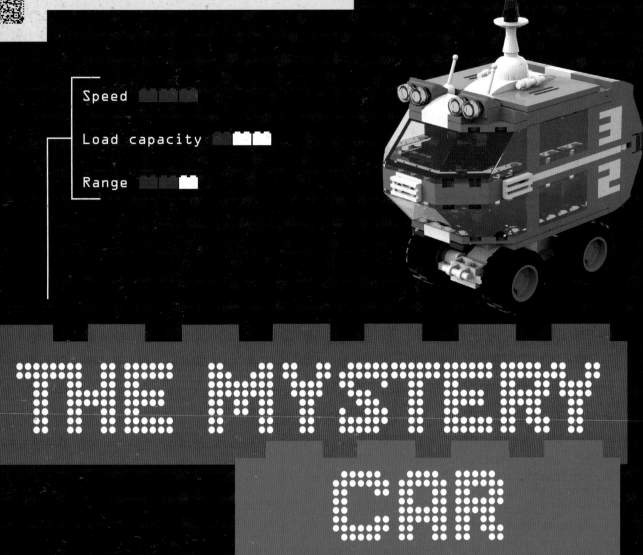

Speed ▪▪▪▪

Load capacity ▪▪□□

Range ▪▪▪□

THE MYSTERY CAR

Honoring an extremely popular twentieth-century animated cartoon series on Planet Earth (Scoo-by-Doo, Where Are You?), its name emphasizes the fact that besides being a vehicle designed for competition, it is also a sophisticated mobile research laboratory. The Second J.U.P.I.T.E.R. GAMES, in which it participated, were in fact devoted to the research and study of new materials extracted from rocks, soil, and minerals sampled on a recently discovered planet. The J.U.P.I.T.E.R. GAMES Commission decided that the participants in these games would be only space shuttles, wheeled vehicles, and robots that, besides being designed for competition, were primarily mobile laborato-ries capable of analyzing gases, materials, soils, rocks, and whatever else revealed itself to be a potentially useful natural resource.

Creator/Designer: David Roberts

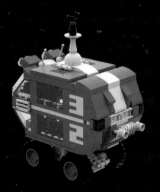

- able to accommodate two minifigures, one in the driver's seat and one in charge of the "mobile laboratory"
- capable of adapting to any kind of course

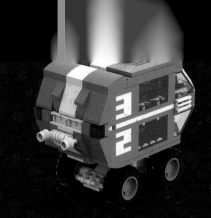

PIECES REQUIRED

2 x	2 x	1 x	2 x	2 x	12 x	2 x	4 x	2 x
4032	3937	3710	98138	30363	11477	3021	92593	44728

4 x	2 x	1 x	2 x	4 x	2 x	3 x	3 x	2 x
3022	3938	4479	2654	2555	3959	3022	3068	3460

1 x	1 x	2 x	1 x	1 x	5 x	1 x	2 x
4360	4740	4162	3039	3832	85984	3039	11211

2 x	11 x	4 x	5 x	5 x	2 x	3 x	4 x	1 x	4 x
3678	3023	2540	2412	85861	47905	47905	50746	87994	73587

1 x	2 x	4 x	2 x	9 x	8 x	4 x	2 x	1 x	1 x
30367	4349	6141	48336	3024	4081	73587	64567	3020	4589

2 x	4 x	1 x	5 x	2 x	16 x	2 x	4 x
3747	30391	3036	2431	4213	3005	4081	2450

12 x	4 x	1 x	4 x	10 x	2 x	4 x	2 x	4 x
3024	3678	3710	30285	11477	3021	6636	99780	3040

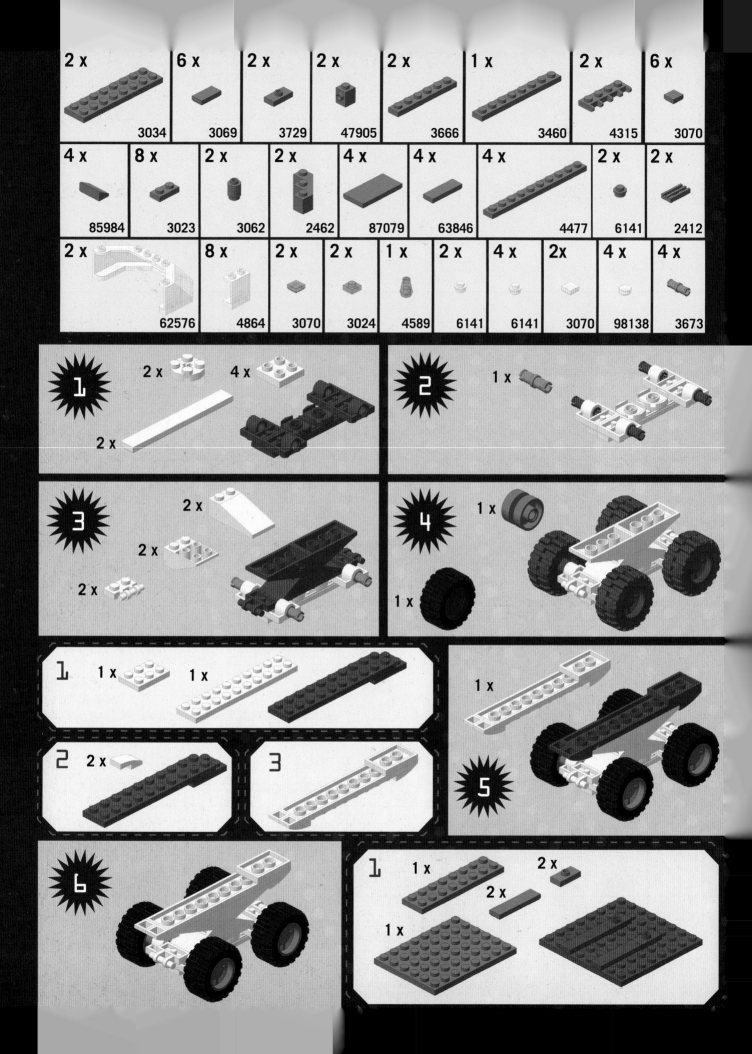

2 x 3034	6 x 3069	2 x 3729	2 x 47905	2 x 3666	1 x 3460	2 x 4315	6 x 3070		
4 x 85984	8 x 3023	2 x 3062	2 x 2462	4 x 87079	4 x 63846	4 x 4477	2 x 6141	2 x 2412	
2 x 62576	8 x 4864	2 x 3070	2 x 3024	1 x 4589	2 x 6141	4 x 6141	2 x 3070	4 x 98138	4 x 3673

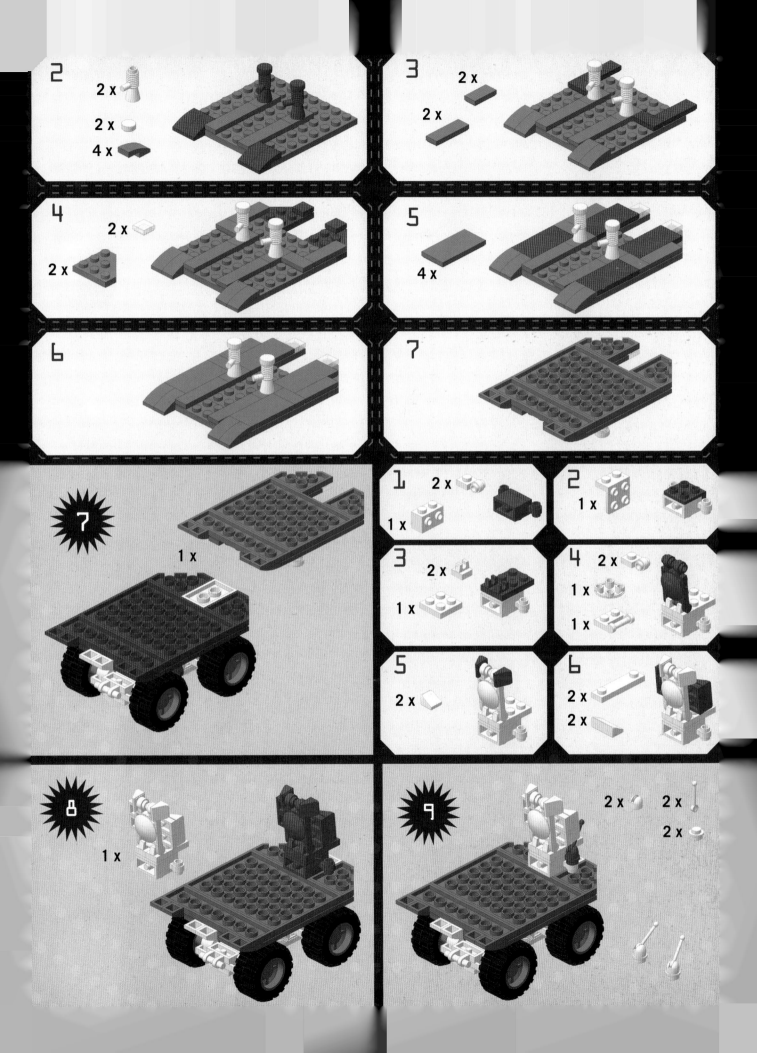

10

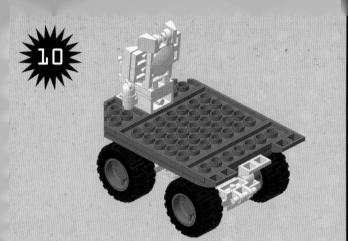

1 1 x 1 x

2 2 x 1 x

3 2 x

4 2 x 1 x 1 x

5 2 x

6 2 x 2 x

11

1 x

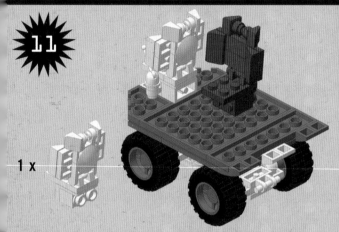

12

8 x

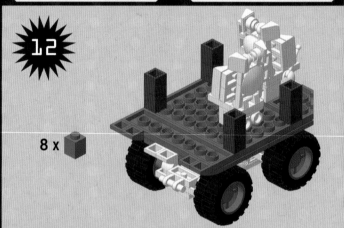

13

4 x

1 x

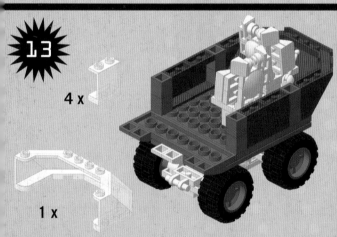

14 1 x 2 x

2 x

2 x

1 x

1 x 2 x

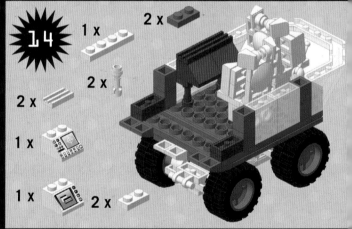

15

4 x

5 x

2 x

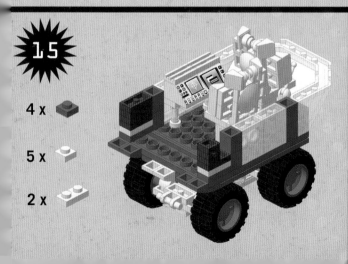

16

1 x

1 x

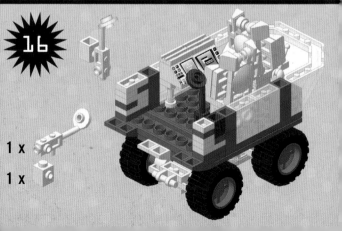

17

2 x

2 x

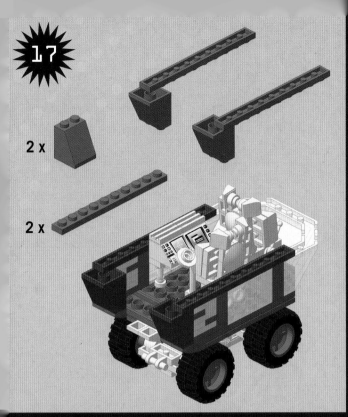

18

2 x

2 x

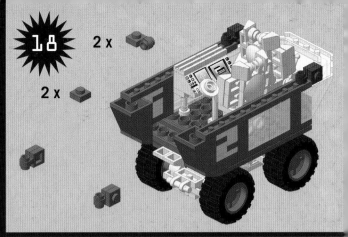

19

2 x

1 x

2 x

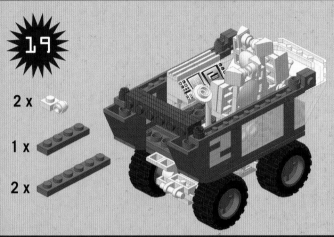

20

2 x

2 x

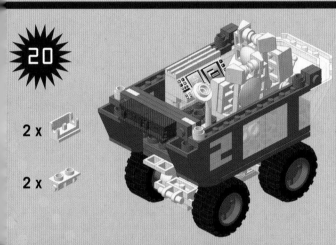

22

2 x

2 x

2 x

2 x

2 x

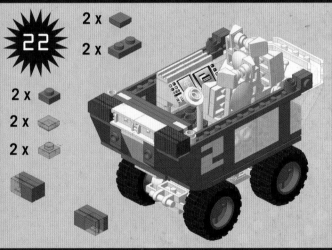

21

1 x

2 x

2 x

2 x

1 x

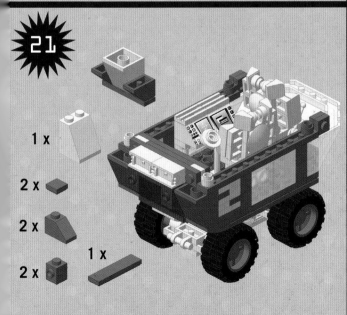

23

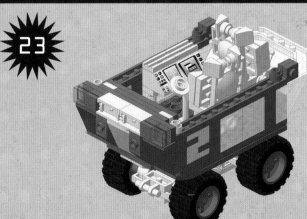

24

3 x

1 x

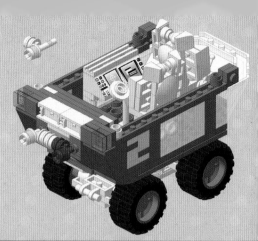

25

3 x

1 x

26

2 x

2 x

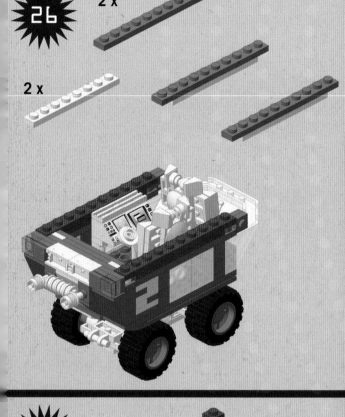

27

2 x

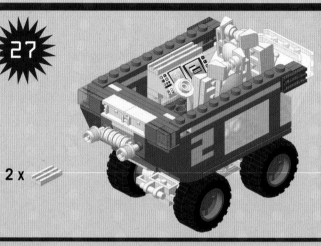

28

2 x

2 x

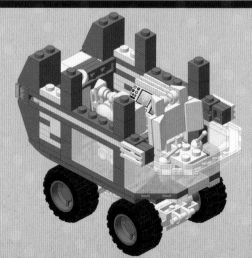

29

8 x

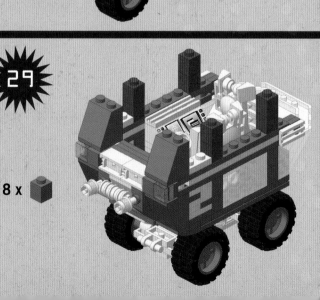

30

31

2 x

2 x

1 x

1 x

1

2

3

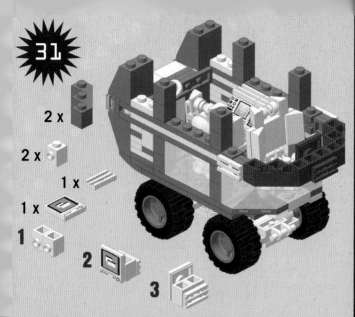

32

4 x

2 x

4 x

4 x

1

2

4

3

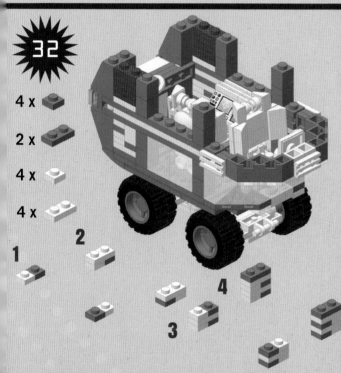

36

2 x

2 x

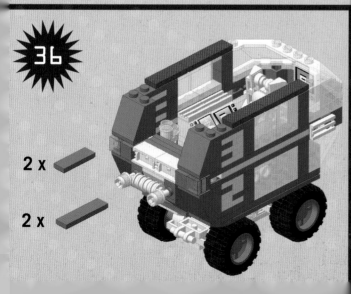

33

1 x

2 x

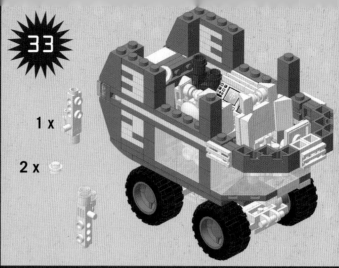

34

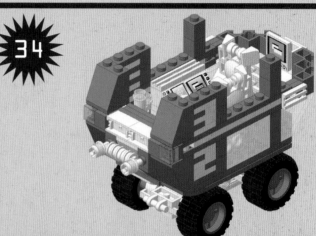

35

4 x

1 x

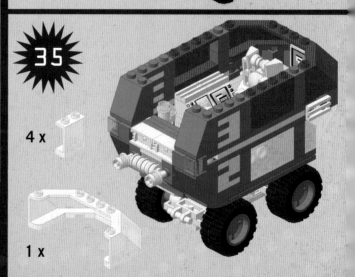

1

1 x 2 x

2

1 x 2 x

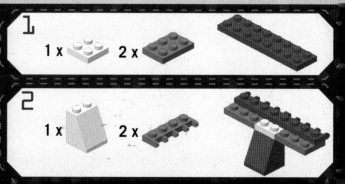

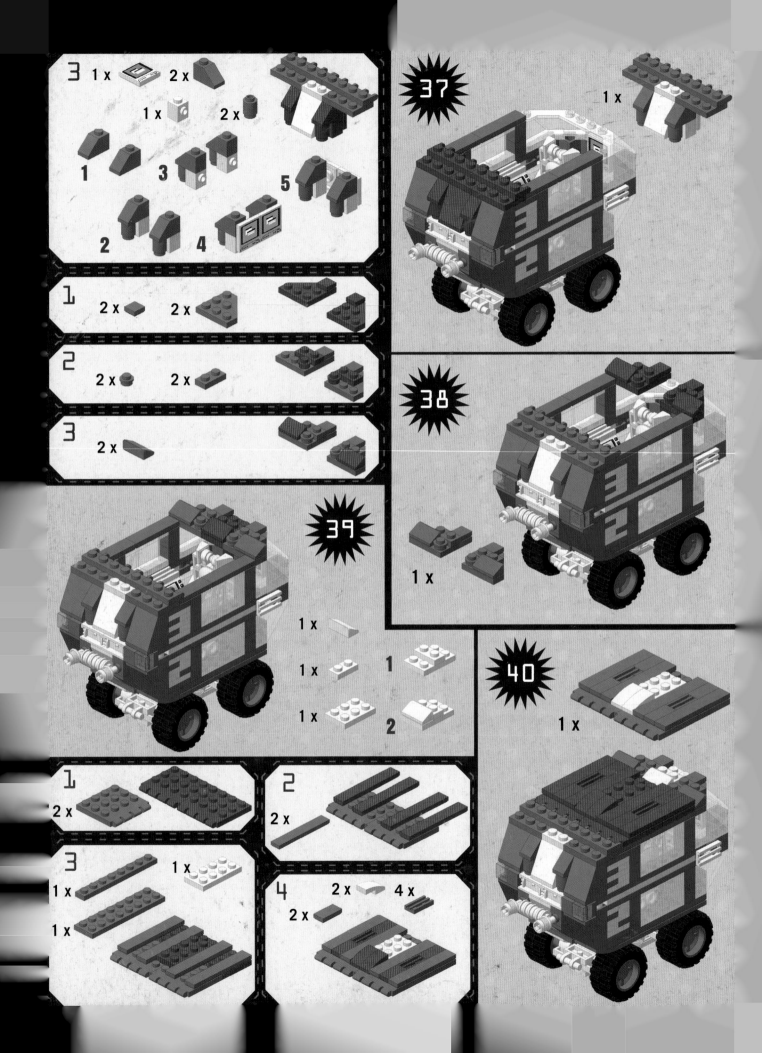

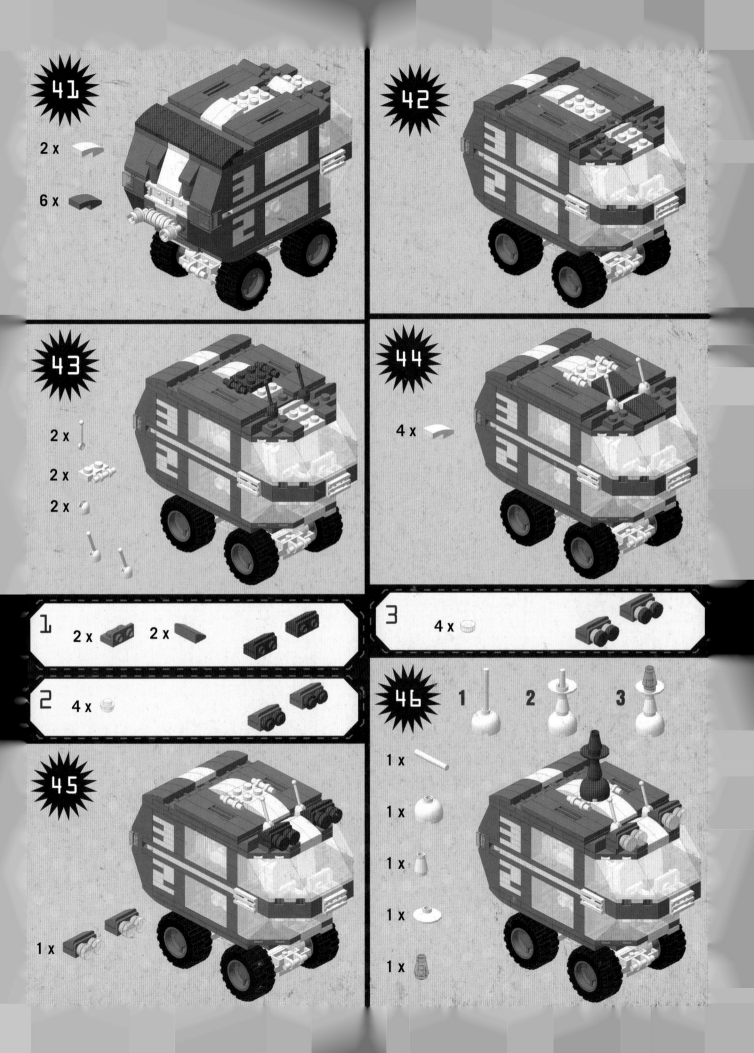

41
2 x
6 x

42

43
2 x
2 x
2 x

44
4 x

1
2 x 2 x

2
4 x

3
4 x

46
1 2 3
1 x
1 x
1 x
1 x
1 x

45
1 x

VIDEO: www.nuinui.ch/upload/lego-space-p114.zip

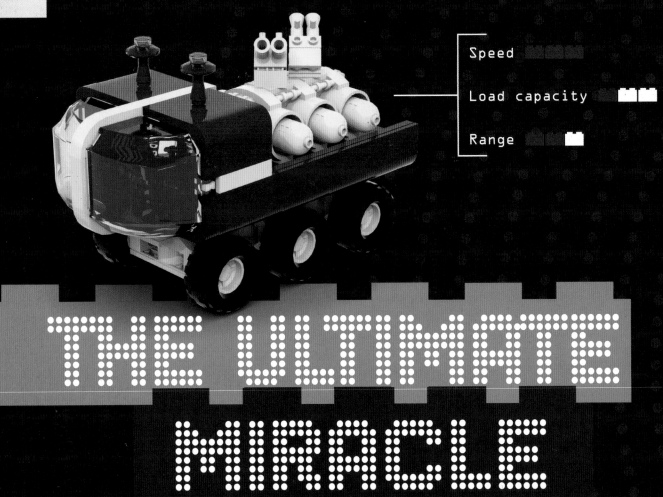

Speed	
Load capacity	■■
Range	■

THE ULTIMATE
MIRACLE

Although science and the latest technology have always made it possible for engineers and designers to create vehicles that can take part safely in Part 2 of the J.U.P.I.T.E.R. GAMES, unforeseen events are always waiting in the wings, and even the most experienced drivers are capable of finding themselves in trouble with damaged vehicles that can catch on fire. If you think about the fuels used and the power produced by the vehicles that participate in a one-of-a-kind competition like the J.U.P.I.T.E.R. GAMES, it's easy to understand that rescue vehicles must always be up to dealing with any situation. They need to rush as fast as the competitors (and sometimes faster) in order to arrive at the scene of an accident as quickly as possible, and they need to be able to put out even the most aggressive fires. The decision to include a model of one of the rescue vehicles used in the Games was made to pay homage to the courageous firefighters who so often have rescued drivers from truly dangerous situations.

Creator/Designer: David Roberts

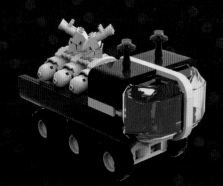

- able to accommodate one minifigure in the driver's seat and another to control the equipment to put out fires

- adapted to any kind of course

- 3 axles, all with moving wheels

- tires able to stand up to very high temperatures and any kind of terrain

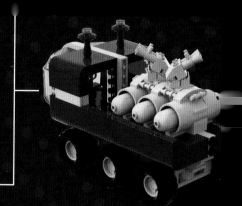

PIECES REQUIRED

16 x — 3024	4 x — 3020	12 x — 3660
2 x — 3937	6 x — 3623	4 x — 3010
6 x — 3710	2 x — 3665	8 x — 3005
2 x — 3021	4 x — 87087	10 x — 6081
4 x — 3001	2 x — 4740	2 x — 3068
10 x — 87079	4 x — 3006	
3 x — 32062	1 x — 3035	4 x — 3832
4 x — 3004	1 x — 3795	2 x — 3023
2 x — 3069		
6 x — 6091	2 x — 60479	4 x — 3622
2 x — 4477	2 x — 6005	1 x — 3069
1 x — 3039		
1 x — 73081	5 x — 2431	2 x — 3005
2 x — 30383	16 x — 3024	1 x — 3660
4 x — 3623	6 x — 3747	2 x — 87580
2 x — 3937	6 x — 4032	2 x — 3838
2 x — 48336	6 x — 87087	2 x — 6134
8 x — 3039	6 x — 30285	1 x — 3004

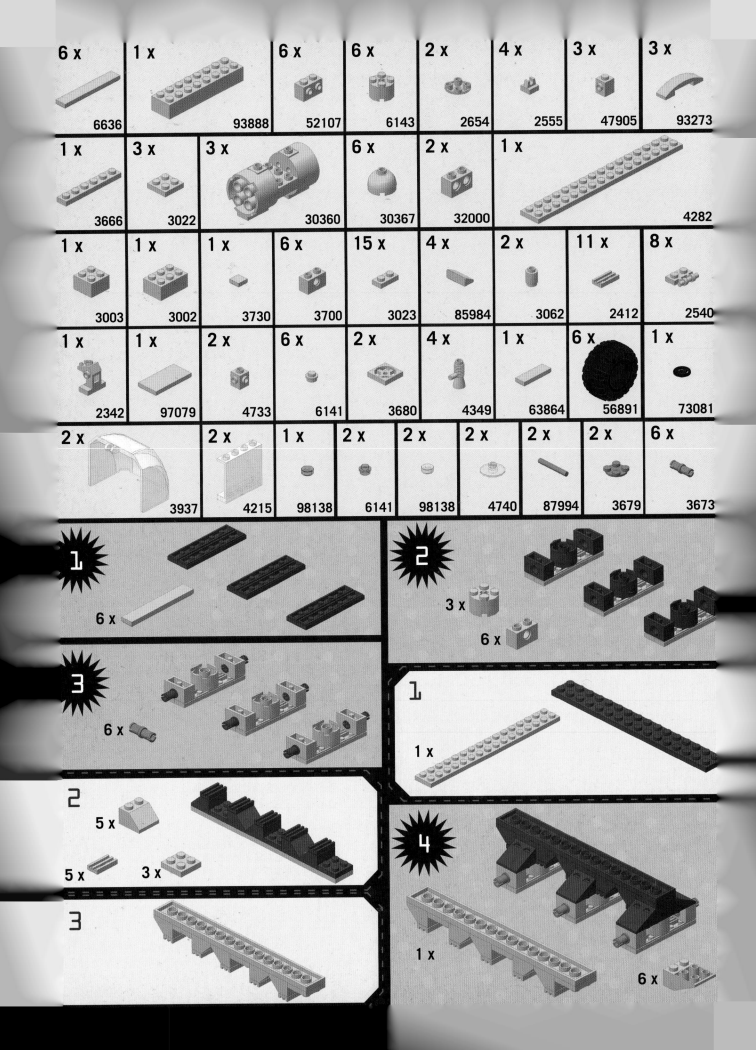

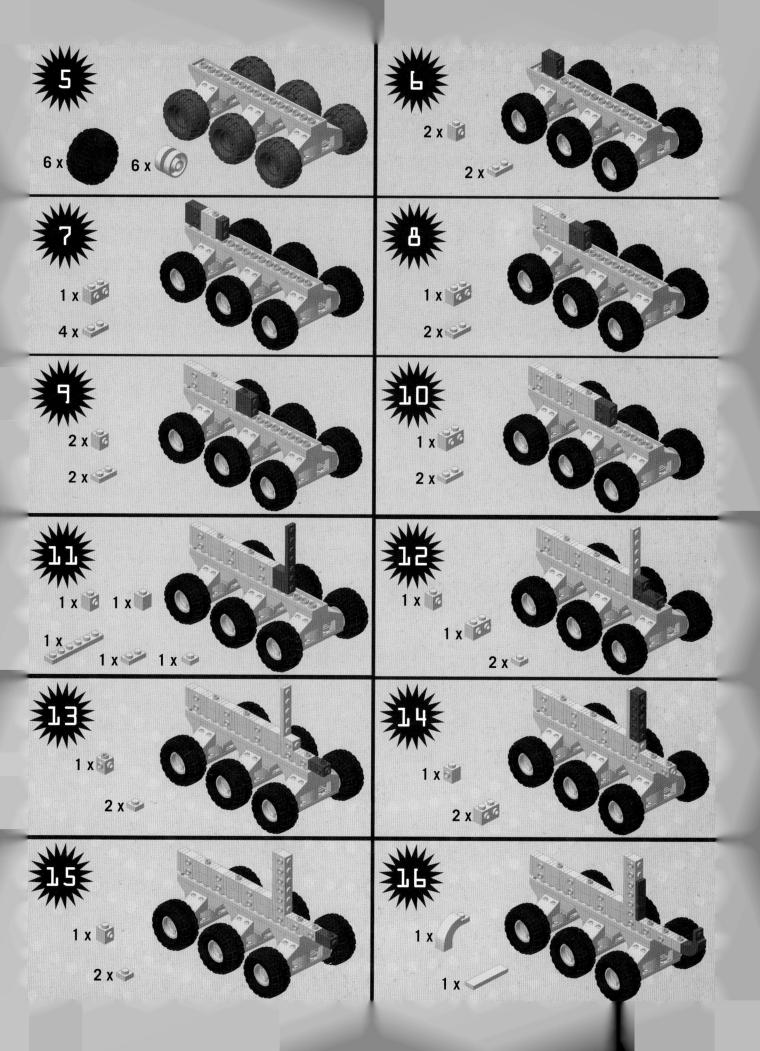

17

1 x

1 x

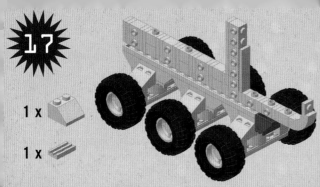

18

1 x

1 x

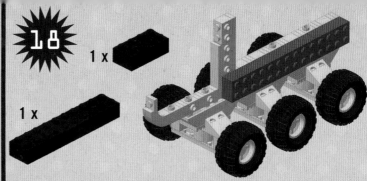

19

1 x

1 x

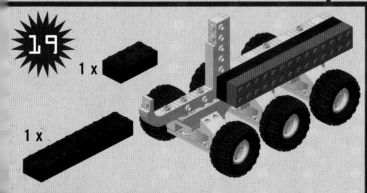

20

1 x

1 x

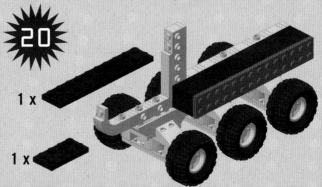

21

1 x

1 x

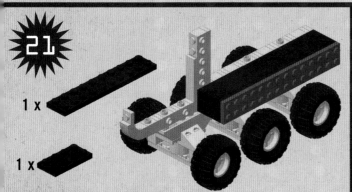

22

1 x

1 x

2 x

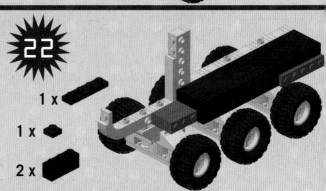

23

1 x

2 x

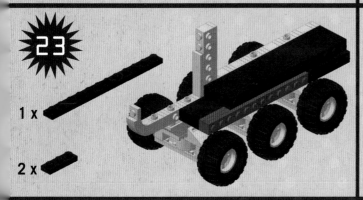

24

3 x

1 x

1 x

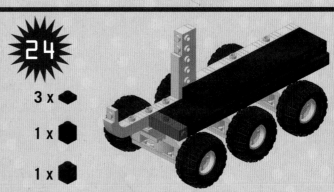

25

1 x

1 x

6 x

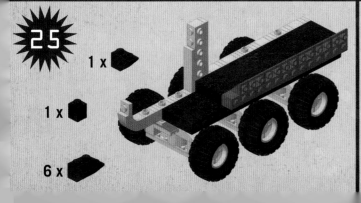

26

4 x

2 x

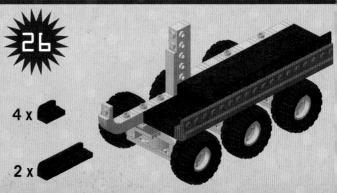

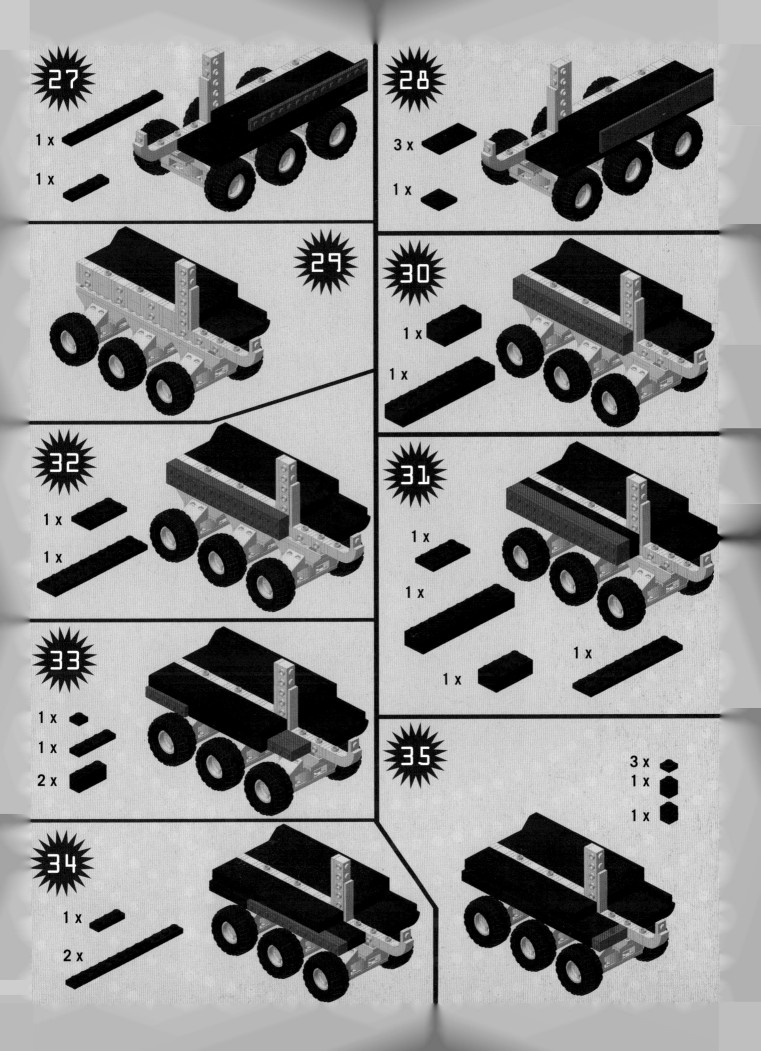

27
1 x
1 x

28
3 x
1 x

29

30
1 x
1 x

32
1 x
1 x

31
1 x
1 x
1 x
1 x

33
1 x
1 x
2 x

35
3 x
1 x
1 x

34
1 x
2 x

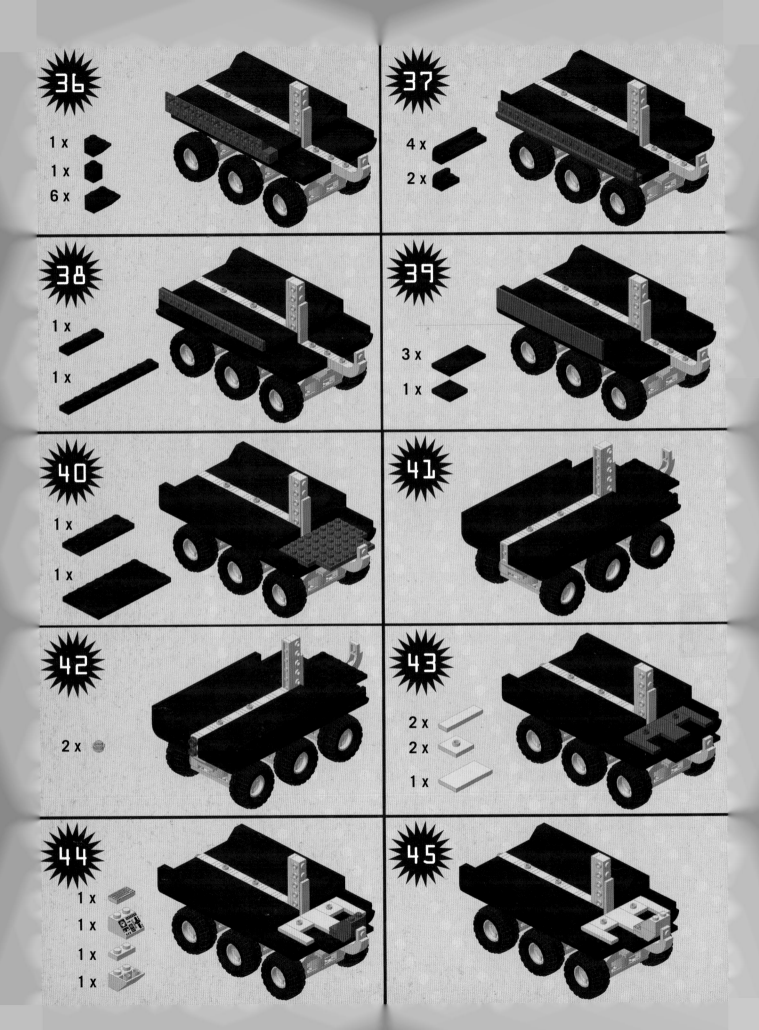

46

4 x

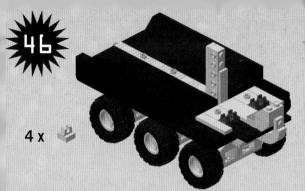

47

1

2 x
2 x
4 x
2 x

2
3

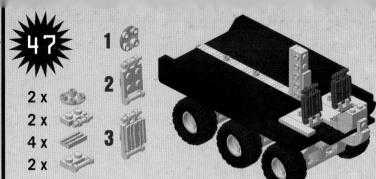

48

2 x
2 x

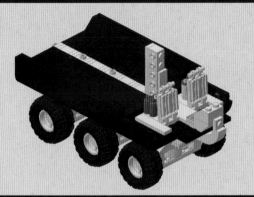

49

2 x

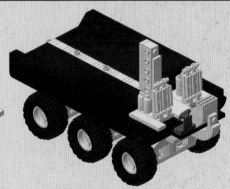

50

1 x
1 x

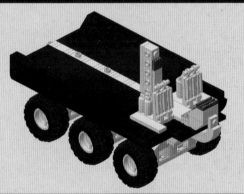

51

1 x
1 x

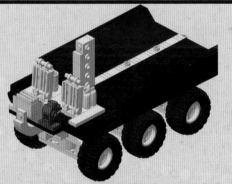

52

1 x
1 x

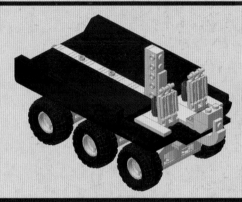

53

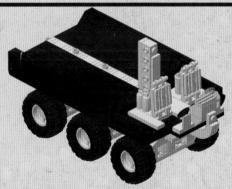

54

1 x
4 x

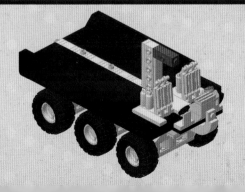

55

1 x
1 x
1 x

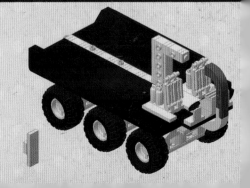

56

1 x
1 x
2 x

57

2 x
1 x
1 x
1 x

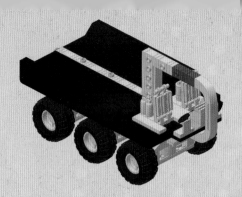

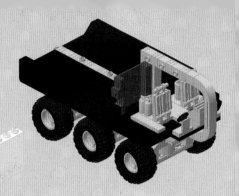

58

1 x
1 x
2 x 2 x
2 x 1 x
1 x 1 x 1 x
1 x 1 x

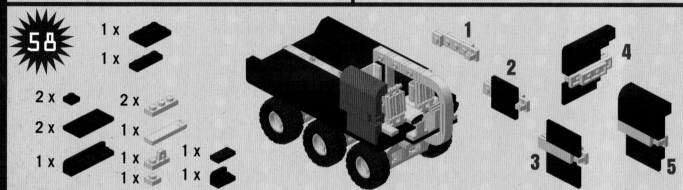

1
2
4
3
5

59

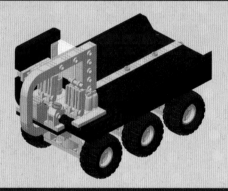

60

2 x
1 x
1 x
1 x

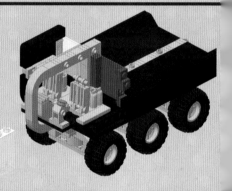

61

1 x
1 x
2 x 2 x
2 x 1 x
1 x 1 x 1 x
1 x 1 x

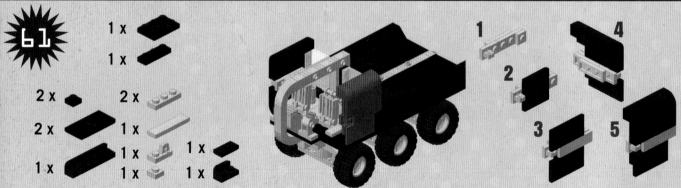

1
2
4
3
5

62

1 x
1 x

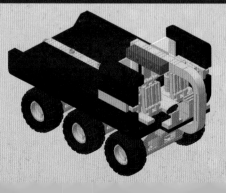

63

2 x
1 x

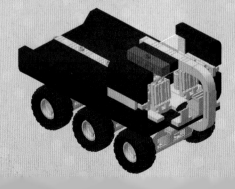

64

1 x
1 x

65

66

1 x
1 x

67

2 x
1 x

68

1 x
1 x

69

70

1 x
1 x

71

3 x

72

2 x
1 x
1 x

73

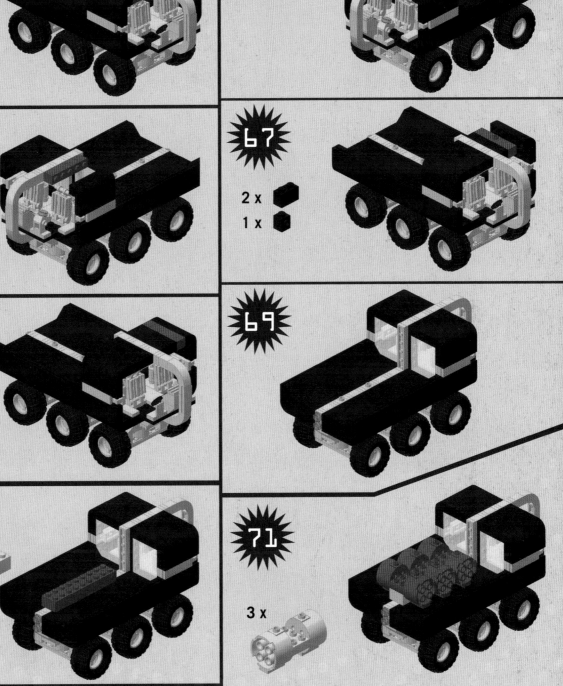
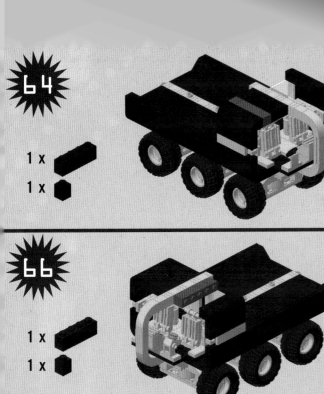
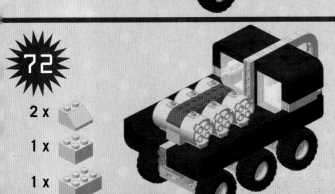
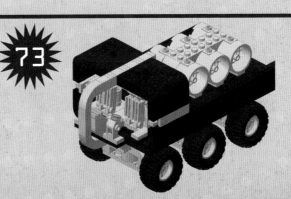

74

1 x
1 x

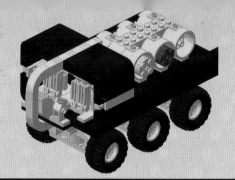

75

1 x
1 x

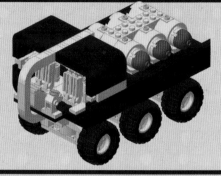

76

1 x
1 x

77

3 x

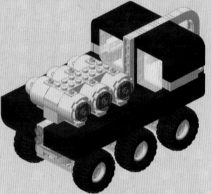

78

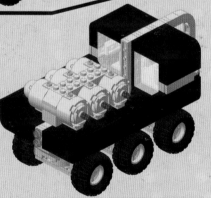

79

3 x

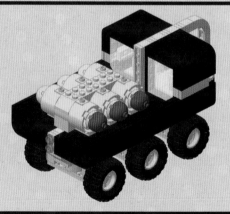

80

3 x

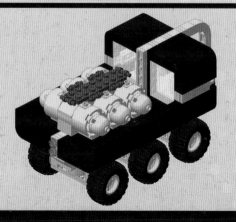

81

3 x

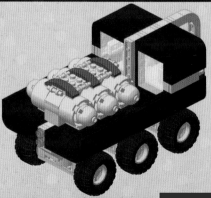

82

1 x
6 x

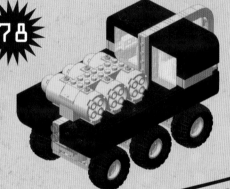

83

3 x

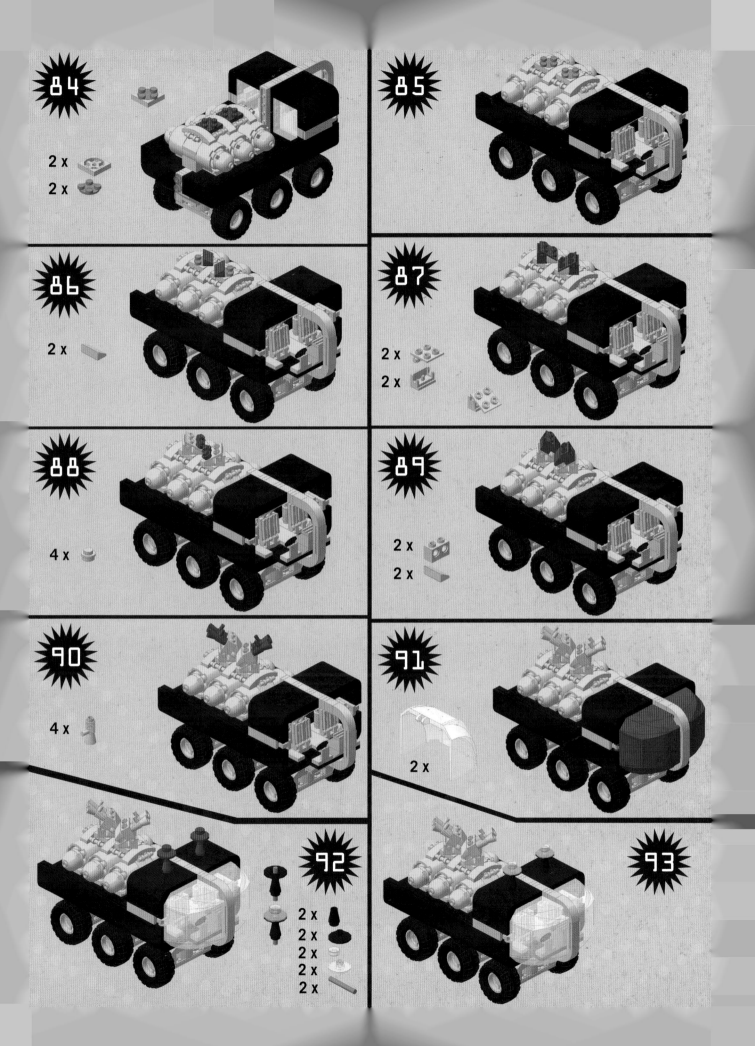

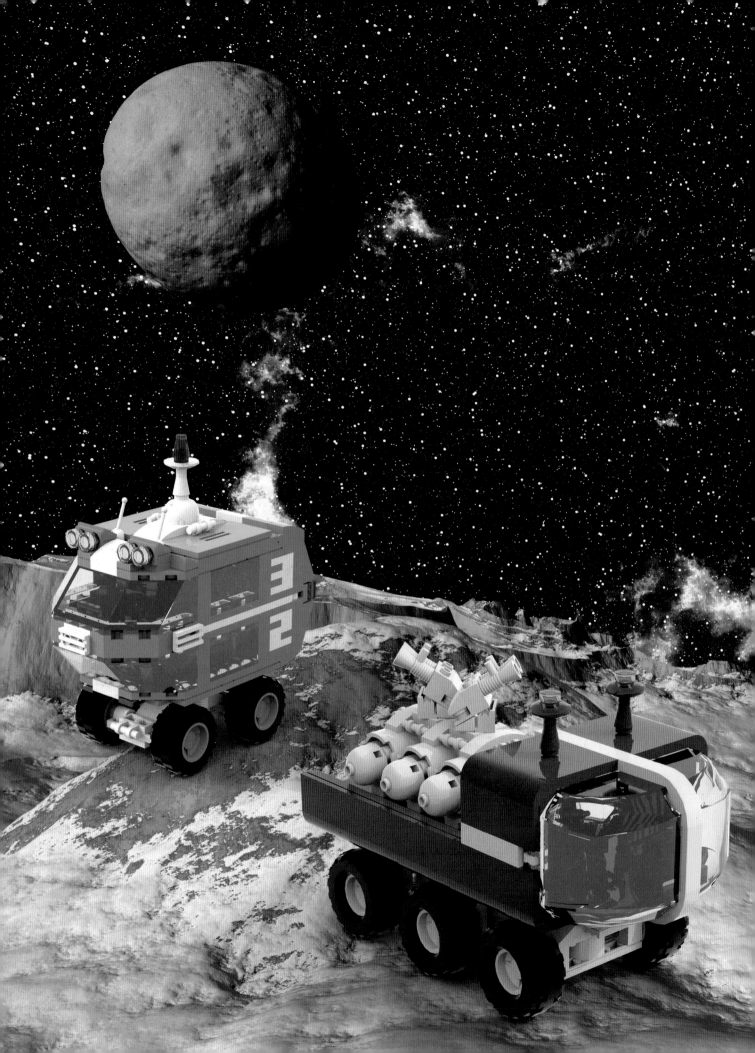

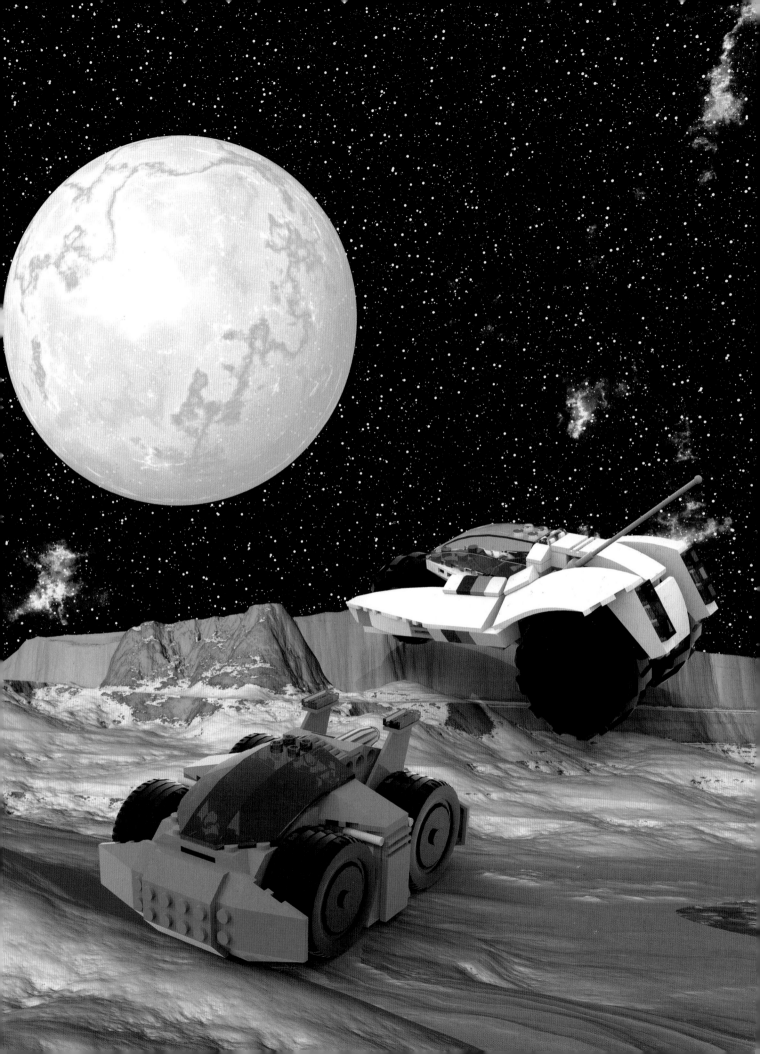

Speed ▪▪▪▪▪

Load capacity ▪▪▪▫▫

Range ▪▪▫▫▫

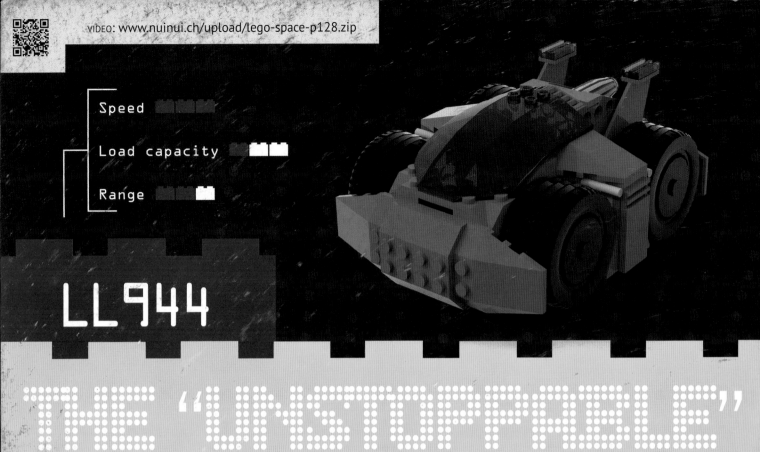

LL944

THE "UNSTOPPABLE"

The "Unstoppable" was designed and built by the Space Classic Team, one of the most recognizable teams participating in the J.U.P.I.T.E.R. GAMES because its members' outfits recall the color scheme of the LEGOLAND® Classic Space team, of which they are all huge fans. The LL944 was designed to drive quickly on a sandy, dusty course on a planet similar to "our" Mars. Such a planet has very long, flat areas and very wide plains where vehicles have the possibility of going extremely fast for miles and miles, as long as they have wheels and gears equipped for driving on terrain that is soft and unstable, composed mostly of soil, sand, and tiny bits of gravel. It's highly likely that some of the designers of this race course for Part 2 of the J.U.P.I.T.E.R. GAMES loved the old endurance cars that sped along on Planet Earth in the 20th and 21st centuries, for example in the famous "Paris-Dakar."

Creator/Designer: Nicola Lugato

CHARACTERISTICS

- able to accommodate a minifigure in the driver's seat
- adapted to any kind of sandy course or on soft ground

4 x 6590	3 x 3701	2 x 51739	2 x 61409	1 x	10 x 3710	1 x
4 x 4315	2 x 2744	1 x 4598	2 x 3665	2 x 3021	2 x 3046	2 x 2340
1 x	1 x	4 x 63864	3 x 3666	2 x 3070	6 x 48933	2 x 44676
4 x 3022	2 x 3062	1 x	1 x	2 x 4286	1 x 41769	1 x 2431
1 x	3 x 3023	3 x 2412	2 x	2 x 3622	1 x	1 x 41770
2 x 87552	1 x	4 x 32123	4 x 2723	2 x 4032	4 x 56145	4 x 99206
2 x 3034	2 x 30414	2 x 3708	4 x 2420	1 x	6 x 3023	
4 x 44309	2 x 2412	3 x 6141	1 x 41751		4 x 3062	1 x 4740
1 x 92593	2 x 99206	3 x 3023	2 x 11211	1 x 4229	2 x 4697	2 x 3009

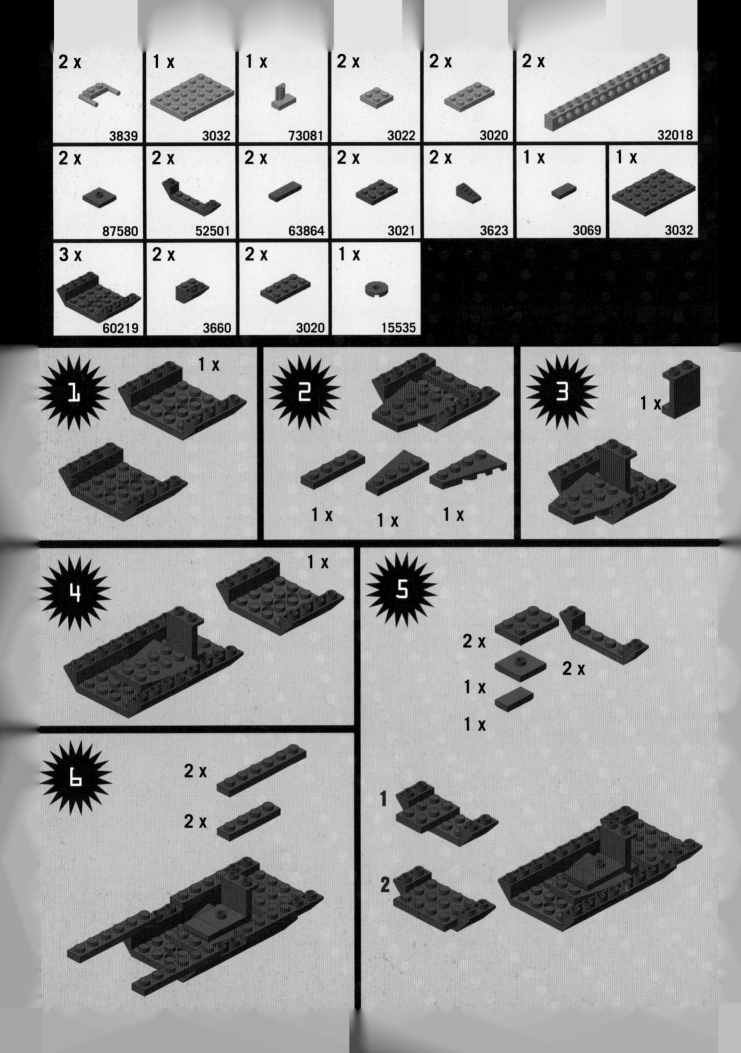

7 1 x 2 x 2 x 1 1

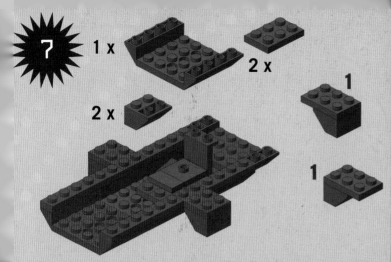

8 2 x

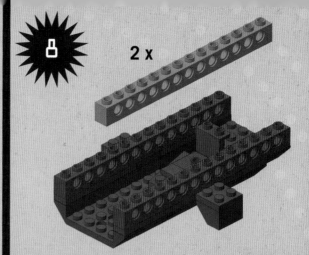

9 2 x

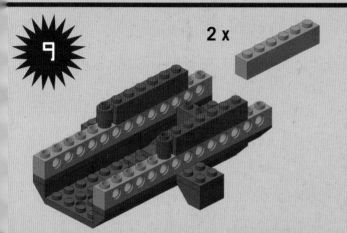

10 2 x

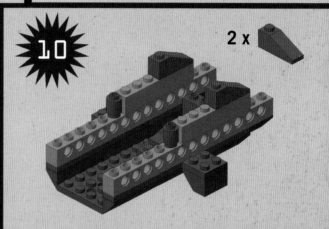

1 2 x 1 x

2 1 x 1 x

1 2 x 1 x

2 1 x 1 x

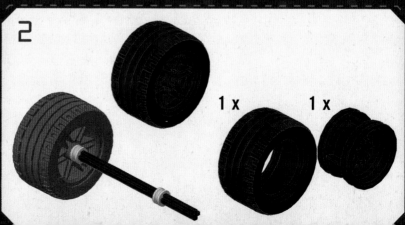

11

1 x

1 x

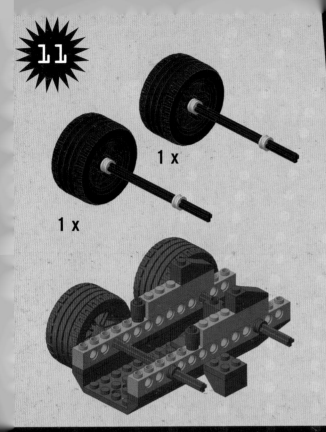

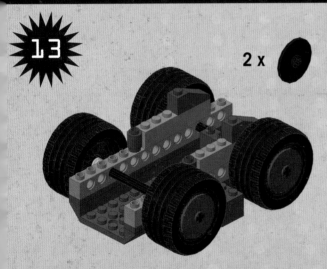

12

2 x

2 x

2 x

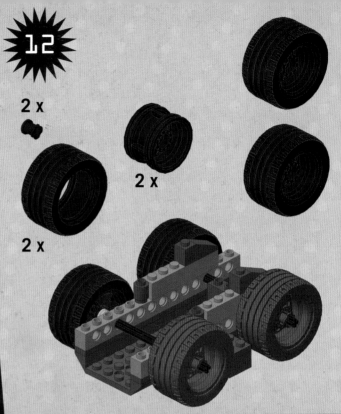

13

2 x

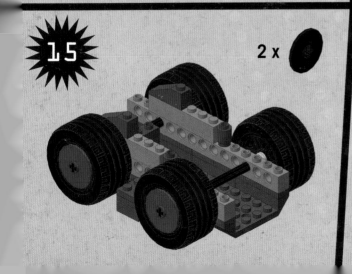

14

2 x

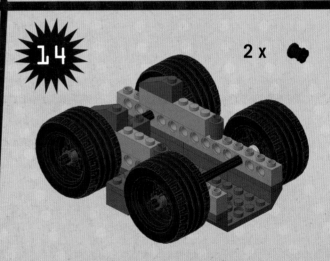

15

2 x

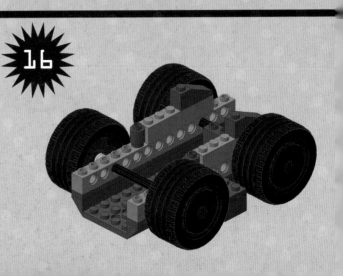

16

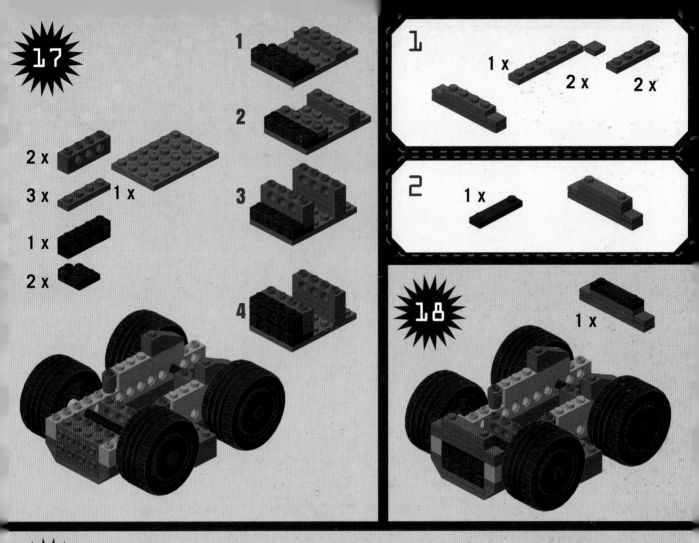

17

2 x
3 x 1 x
1 x
2 x

1
2
3
4

1

1 x 2 x 2 x

2

1 x

18

1 x

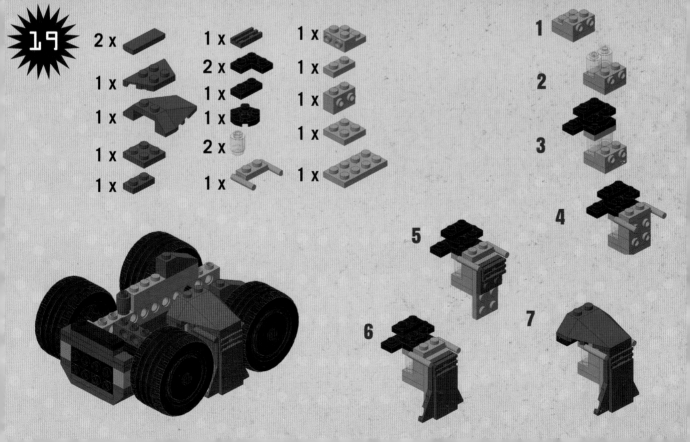

19

2 x 1 x 1 x
1 x 2 x 1 x
1 x 1 x 1 x
1 x 1 x 1 x
1 x 2 x
1 x 1 x

1
2
3
4
5
6 7

20

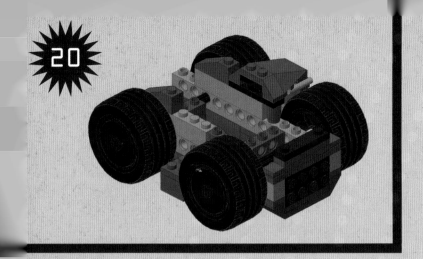

1

2

3

4

5

6

21

2 x
1 x
1 x
1 x
1 x

1 x
2 x
1 x
1 x
2 x
1 x

1 x
1 x
1 x
1 x
1 x

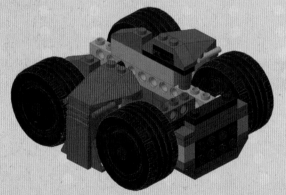

22

2 x
1 x
1 x
2 x
2 x

1

2

3

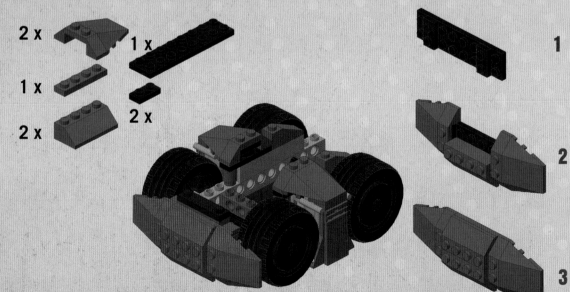

23

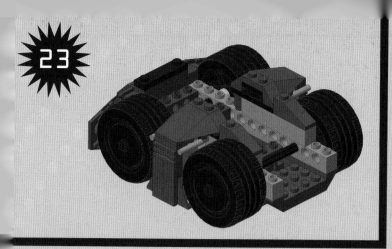

1
2
3
4
5
6 7
8
9

24

2 x
1 x
2 x
1 x

1 x
1 x
2 x
1 x
2 x

2 x
2 x

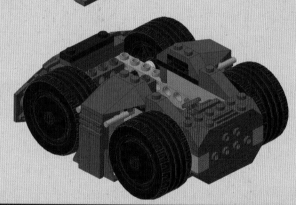

25

2 x 1 x
1 x
2 x 2 x

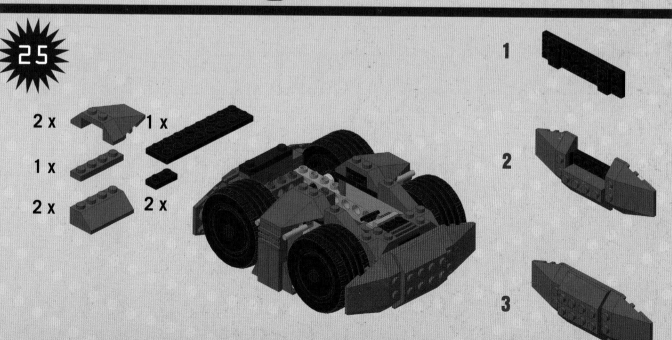

1

2

3

26

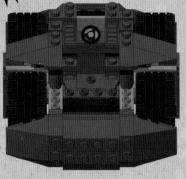

27

1 x

2 x
1 x
2 x

1

2

3

4

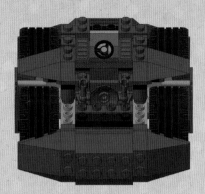

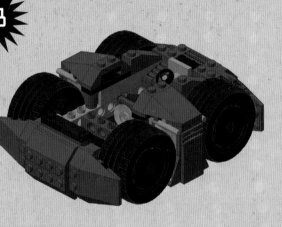

1

2

3

28

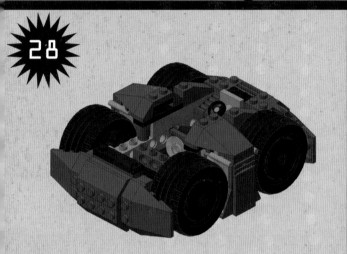

4

5

29

1 x

1 x
2 x

1 x
2 x

2 x

1 x

1 x
2 x

1 x
1 x
1 x

3 x

1 x

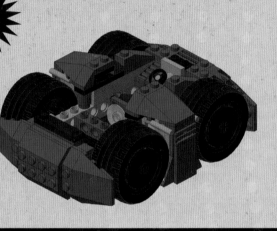

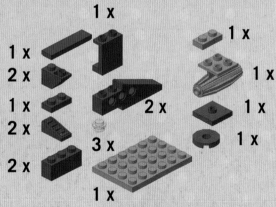

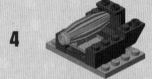

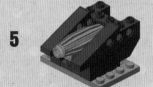

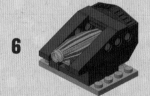

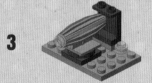

6

7

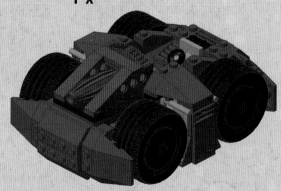

30

2 x

2 x

1 x

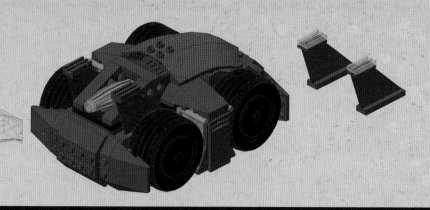

31

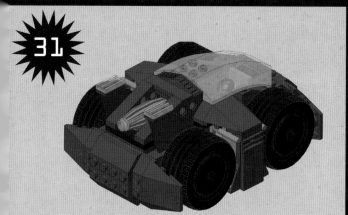

32

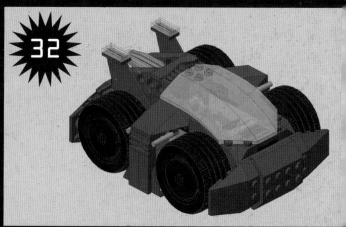

33

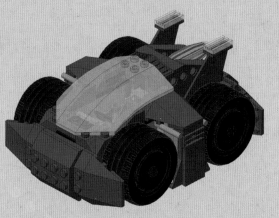

1

1 x 1 x 1 x 1 x

1 x ⬛ ⬛ ⬛ ⬛ ⬛ ⬛ 1 x

1 x ⬛ ⬛ 1 x

1 x ⬛

2 x

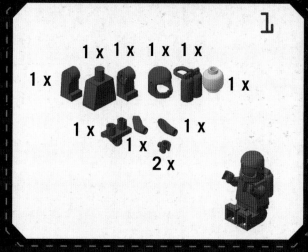

34

1 x

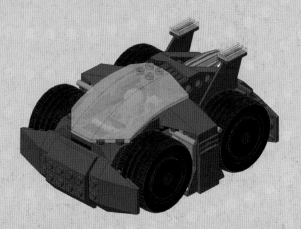

VIDEO: www.nuinui.ch/upload/lego-space-p138.zip

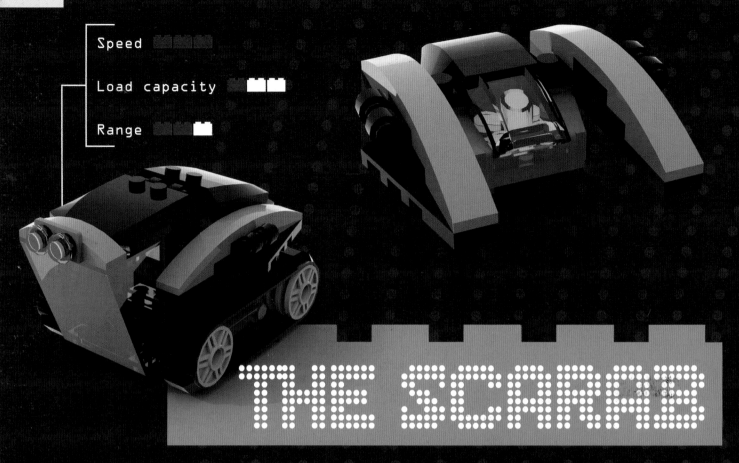

Speed ■■■■

Load capacity ■■

Range ■■■

THE SCARAB

Designed by the team from the planet Kashyyyndor, the Scarab is a tracked vehicle created to race on the surface of a planet chosen for one particular year's J.U.P.I.T.E.R. GAMES. The uniqueness of this strange Part 2 was that, for reasons now lost in the mists of time, the Games Commission decided that the drivers wouldn't have a route or a map for the race but only the coordinates of the starting and finish lines. Each one would have to determine his own fastest and most practical route. A later complication for the drivers was that a series of drones piloted by the Commission would try to intercept their vehicles and shoot "projectiles" containing an electromagnetic impulse at them. If they were struck, the vehicles would stop running and be eliminated from the race. The designers of the Scarab had the idea of providing it with two important means of protection. The first was camouflage paint able to hide it from the drones' cameras, thanks to its resemblance to the vegetation of the planet on which the race would take place. The second was a detachable drone that could fly above and ahead of the Scarab to allow the pilot-navigator to choose the optimal course to avoid obstacles or other environmental factors capable of slowing it down (besides pinpointing the Commission's drones).

Creator/Designer: Nicola Lugato

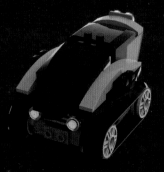

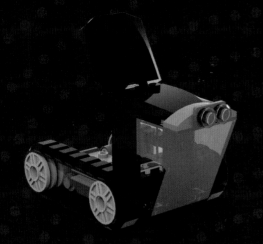

CHARACTERISTICS

- able to accommodate a minifigure in the driver's seat
- adapted to any kind of race
- the rear platform accommodates a remote-controlled drone used to determine the vehicle's course and alert it to obstacles

PIECES REQUIRED

1 x 3023	2 x 41769	2 x 45677	1 x 64225	1 x 3069	4 x 4081	2 x 13547
1 x 3666	2 x 87544	2 x 3623	1 x 48336	1 x 3035		2 x 41770
1 x 10201	2 x 43903		1 x 32028	1 x 4871	1 x 3176	1 x 60470
1 x 2877	2 x 6141	1 x 74968	4 x 6141	1 x 30602	2 x 3023	1 x 72475
4 x 3673	2 x 15573	4 x 55981	2 x 11458	2 x 3623	2 x 32000	1 x 3710
2 x 85984	2 x 11477	1 x 3023	2 x 61409	2 x 6141	6 x 99780	1 x 3660
1 x 2412	4 x 93273					

1 1 x

2 1 x 1 x 2 x

3 3 x

4 2 x

5 1 x 1 x

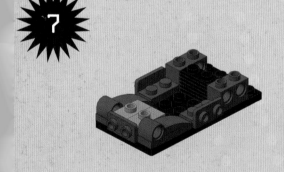

6 1 x 1 x

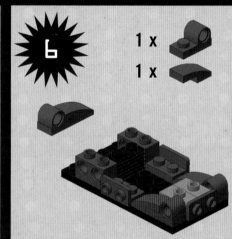

7

8 1 x 1 x 1 x

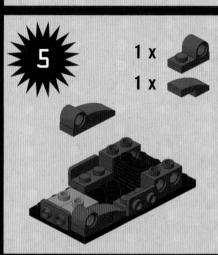

9 1 x 1 x 1 x

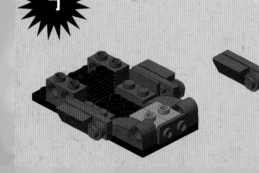

10

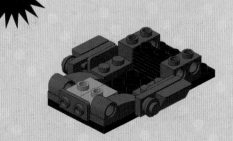

11

4 x

12

1 x

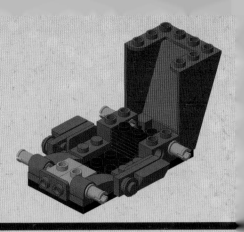

13

2 x

1 x

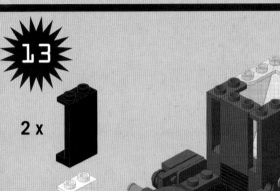

14

2 x

1 x

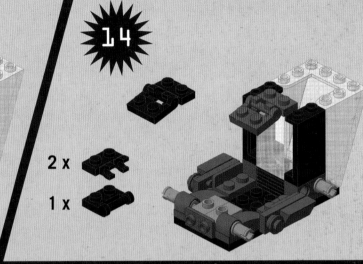

15

2 x

1 x

1 x

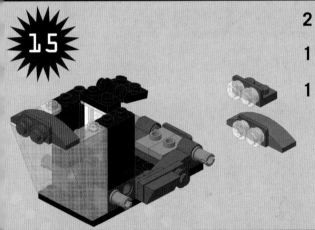

16

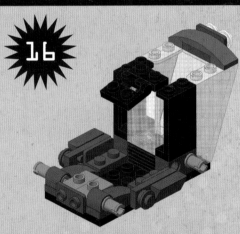

17

1 x

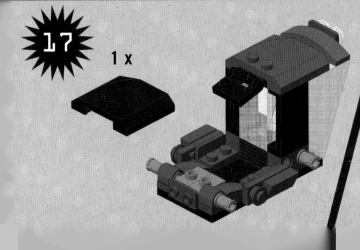

18

1 x

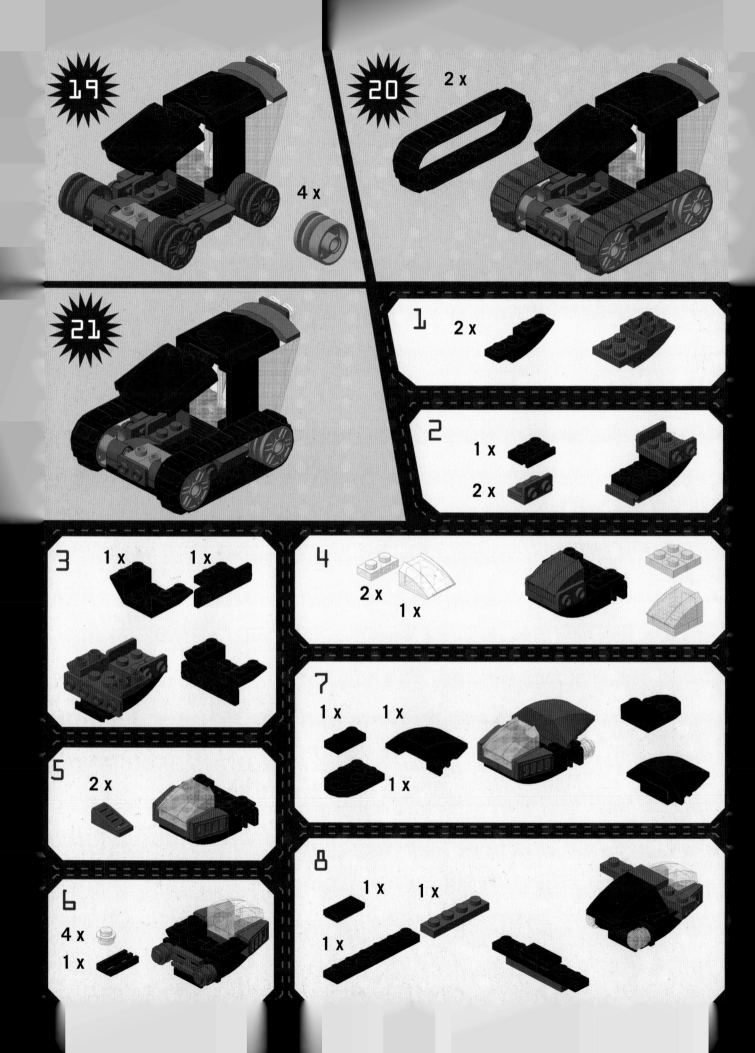

9

2 x 2 x

4 x

2 x

1

2

3

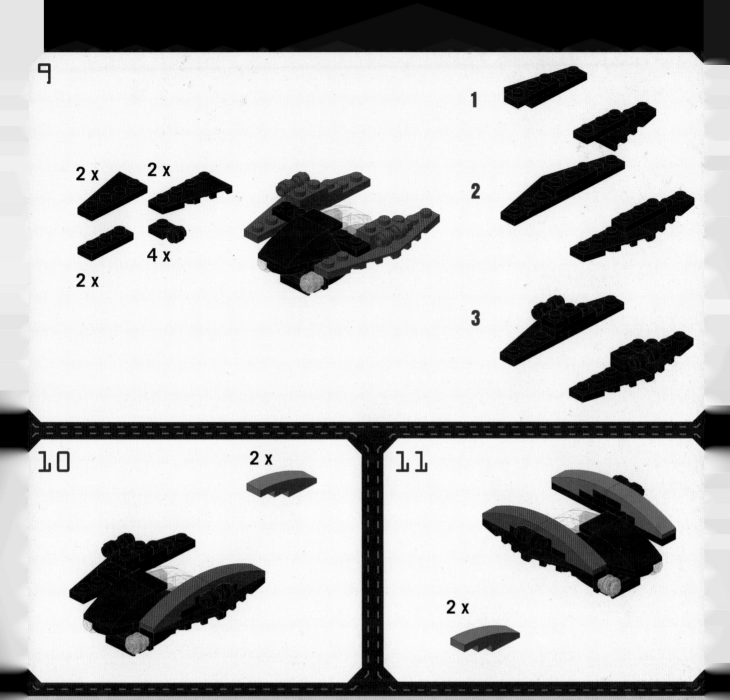

10

2 x

11

2 x

22

1 x

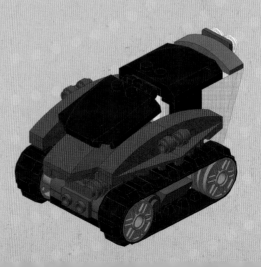

VIDEO: www.nuinui.ch/upload/lego-space-p144.zip

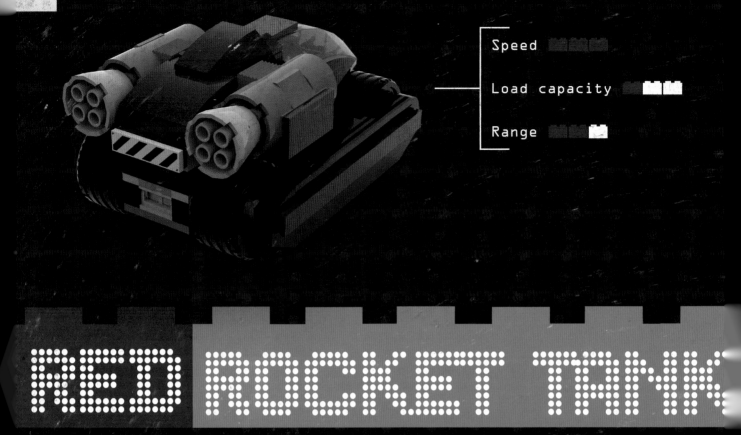

Speed

Load capacity

Range

RED ROCKET TANK

Designed to zoom across the surface of the planet chosen for the most competitive J.U.P.I.T.E.R. GAMES ever, the Red Rocket Tank employs three different systems for thrust, steering, and traction. The thrust truly impressive for a wheeled vehicle, is supplied by two rocket engines located in the rear section. Steering is controlled by the same system used on hovercraft, which for a time were often used on Planet Earth. By means of controls in the cockpit, it is possible to direct the jets of gas shooting out of the rear rocket engines to steer the vehicle left or right. It's a system that works very well on fast courses without big curves. In the particular case of the J.U.P.I.T.E.R. GAMES on Planet Earth in which the Red Rocket Tank took part, the racecourse was a kind of "ring" composed of two very long straight lines connected to two long curves. With the problem of thrust resolved, the designers faced one last challenge: how to keep such a powerful vehicle on the ground. By creating greater lift, it was possible (as in the Formula 1 cars that participated in championship races on Planet Earth in the 20th and 21st centuries) for the jet engines to produce so much energy that the prototypes of this vehicle literally took off.

You might not believe this, but it was while watching an old Japanese cartoon, broadcast on Planet Earth toward the end of the 20th century, that one of the designers was struck by a flash of inspiration. The power generated by the jet engines was so strong that the engineers had to limit how much they could use in the race. The cartoon-watching designer had the brilliant idea of removing this limit and redirecting the excess power to turbines directed upward, located beyond the wheels. The thrust generated by these turbines pushed the vehicle toward the ground, improving traction and ingeniously resolving the problem of undesired "take-off." That is why on the tubular structures found on the side walls of the vehicle you can observe what looks like a long series of air vents: the jets of gas that keep

CHARACTERISTICS

- able to accommodate a minifigure in the driver's seat
- adapted to any kind of course

Creator/Designer: Nicola Lugato

PIECES REQUIRED

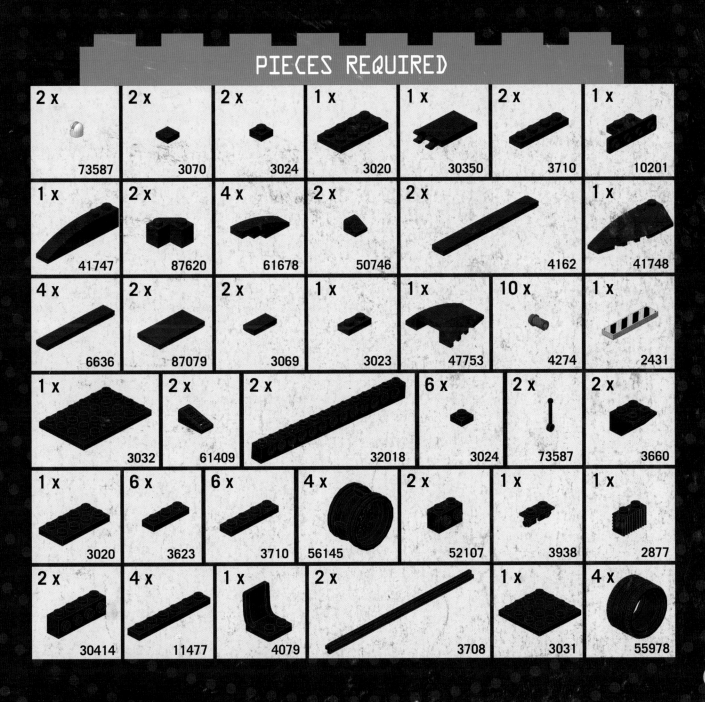

2 x 73587	2 x 3070	2 x 3024	1 x 3020	1 x 30350	2 x 3710	1 x 10201
1 x 41747	2 x 87620	4 x 61678	2 x 50746	2 x 4162		1 x 41748
4 x 6636	2 x 87079	2 x 3069	1 x 3023	1 x 47753	10 x 4274	1 x 2431
1 x 3032	2 x 61409	2 x 32018		6 x 3024	2 x 73587	2 x 3660
1 x 3020	6 x 3623	6 x 3710	4 x 56145	2 x 52107	1 x 3938	1 x 2877
2 x 30414	4 x 11477	1 x 4079	2 x 3708		1 x 3031	4 x 55978

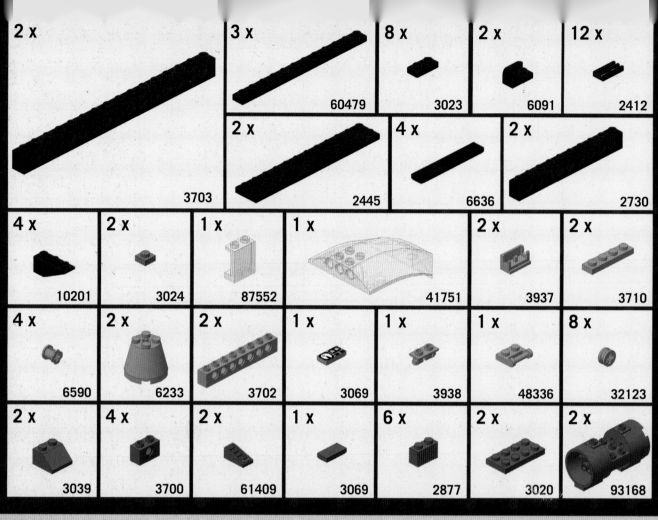

2 x

3 x 60479

8 x 3023

2 x 6091

12 x 2412

3703

2 x 2445

4 x 6636

2 x 2730

4 x 10201

2 x 3024

1 x 87552

1 x 41751

2 x 3937

2 x 3710

4 x 6590

2 x 6233

2 x 3702

1 x 3069

1 x 3938

1 x 48336

8 x 32123

2 x 3039

4 x 3700

2 x 61409

1 x 3069

6 x 2877

2 x 3020

2 x 93168

1

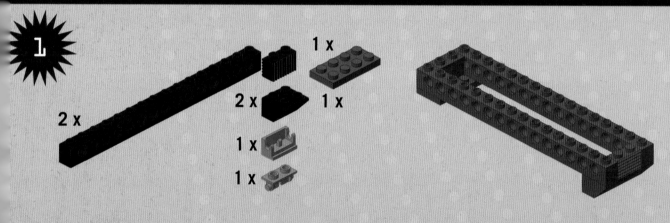

2 x

1 x

2 x 1 x

1 x

1 x

2

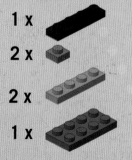

1 x

2 x

2 x

1 x

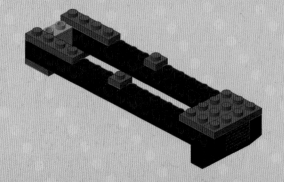

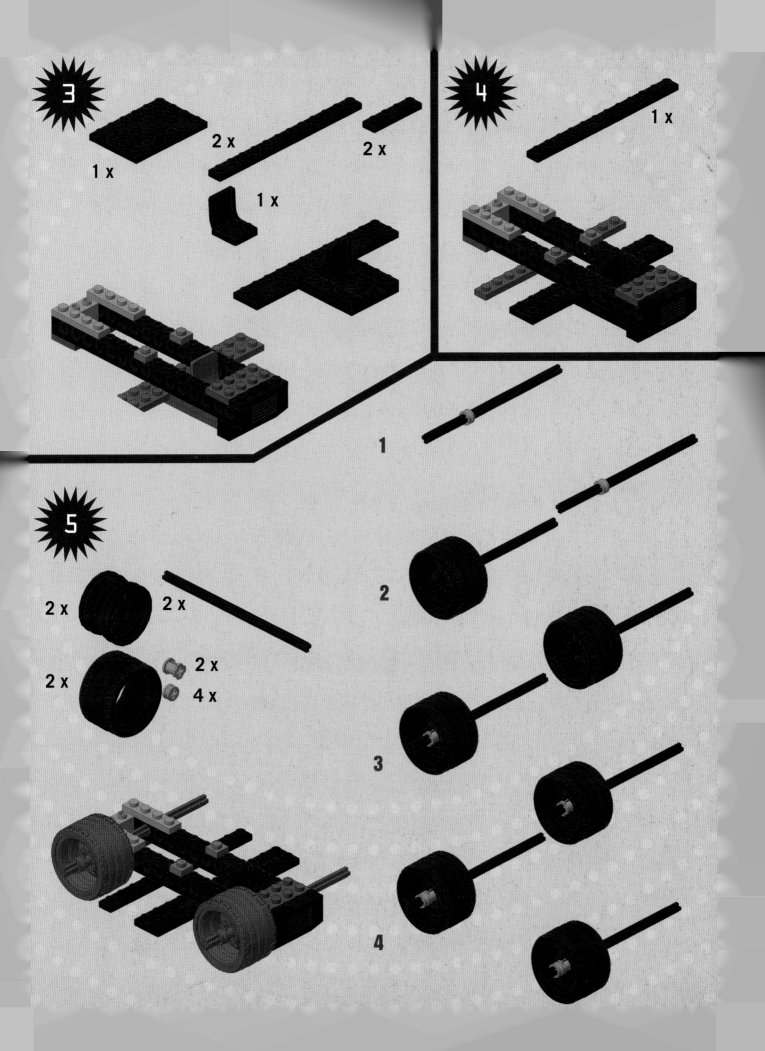

6

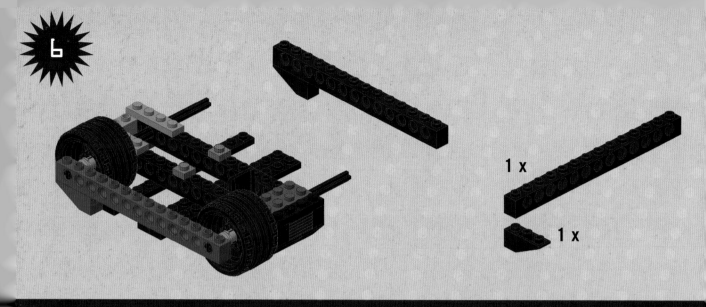

1 x

1 x

7

1

3 x

2 x 2

1 x

1 x 3

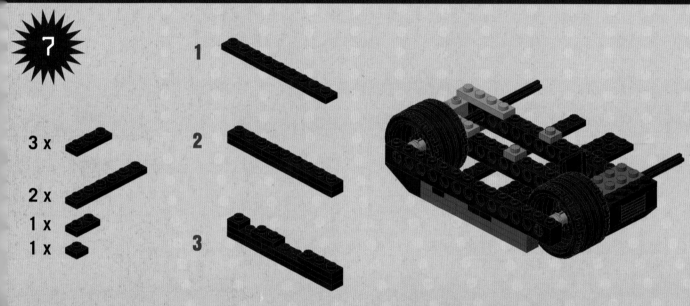

8

1 x
1 x

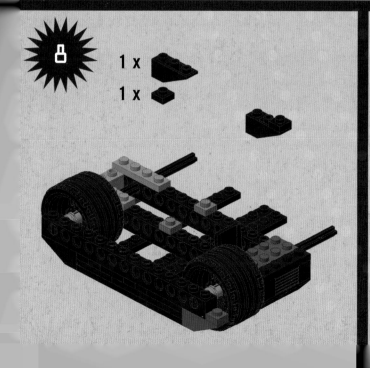

9

1 x
1 x 1 x
1 x

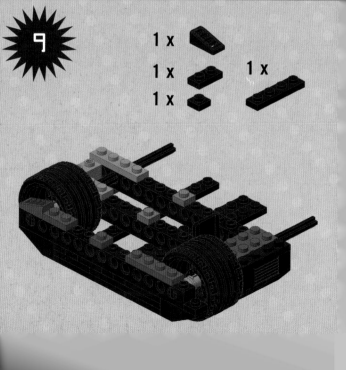

10

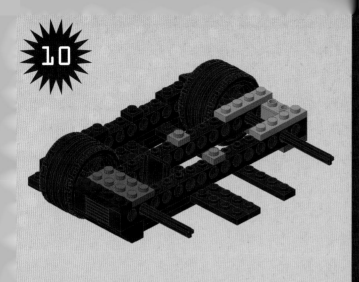

11 2 x

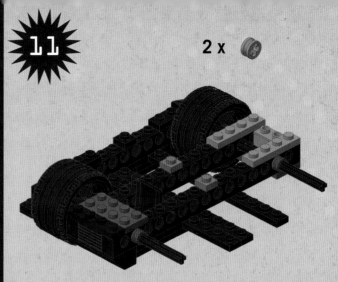

12

2 x

2 x

2 x

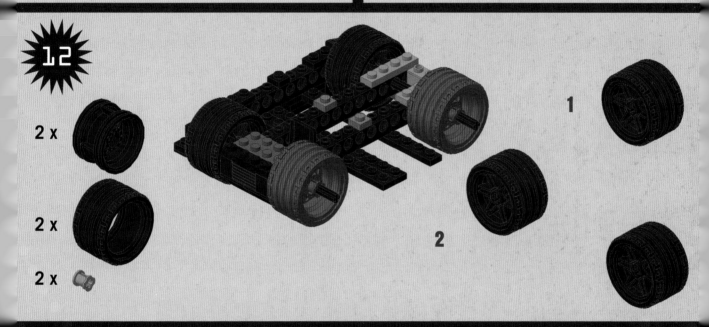

1

2

13 2 x

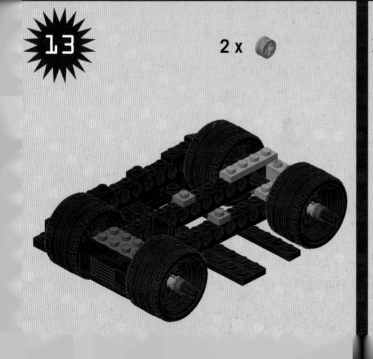

14

1 x

1 x

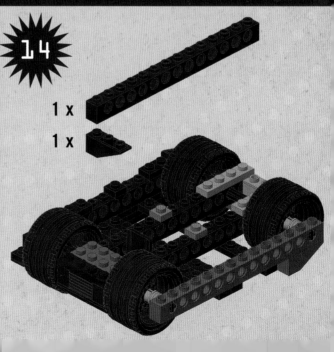

15

3 x

2 x

1 x

1 x

1

2

3

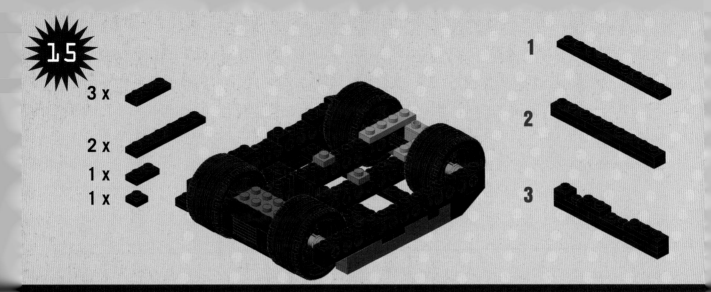

16

1 x

1 x

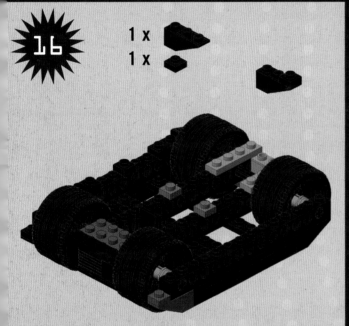

17

1 x

1 x

1 x

1 x

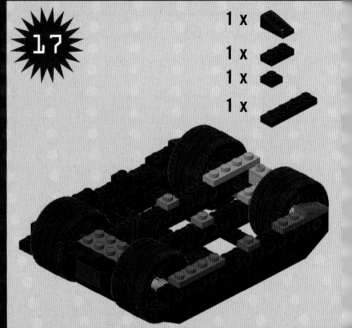

18

5 x

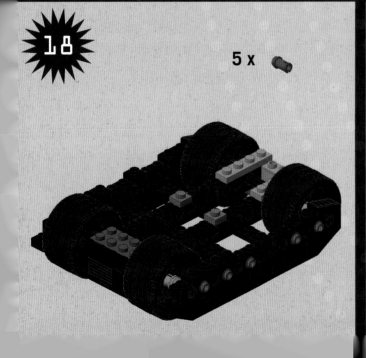

19

1 x

1 x

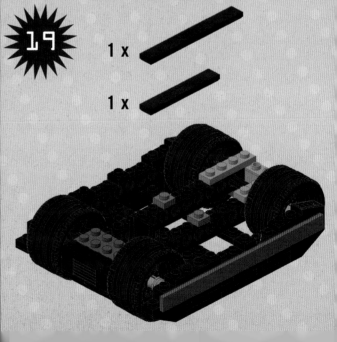

20

1 x
2 x
1 x

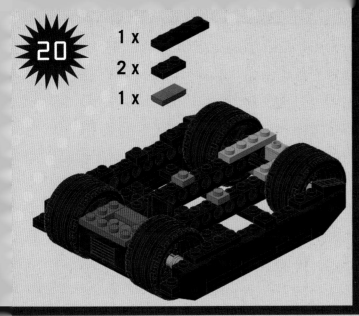

21

2 x
2 x

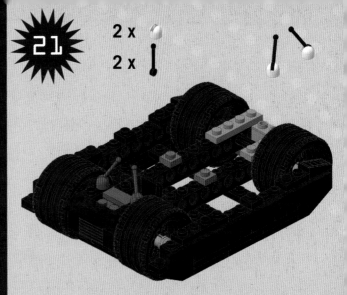

22

1 x
1 x
1 x

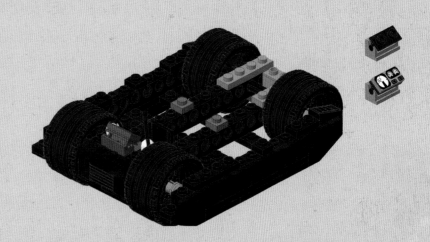

23

2 x

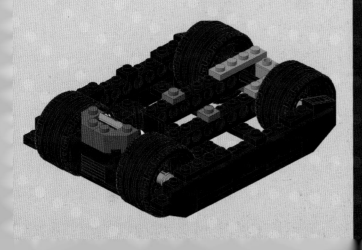

24

2 x
1 x

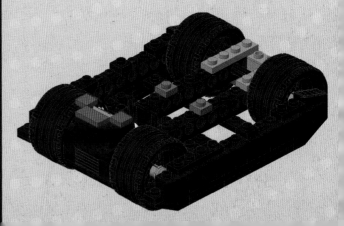

25

26

5 x

27

1 x
1 x

28

2 x
2 x

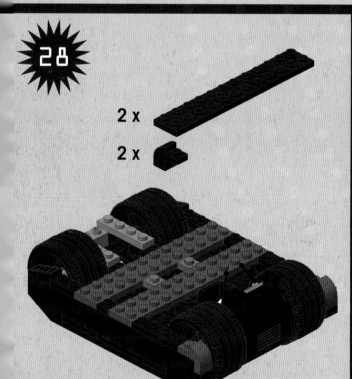

29

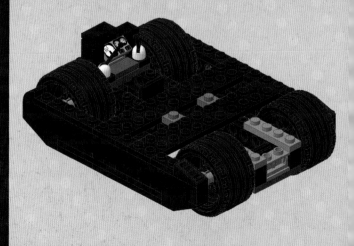

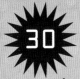

30

1 x
1 x
1 x
1 x

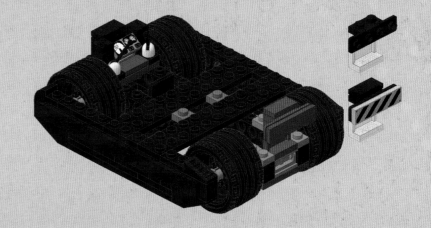

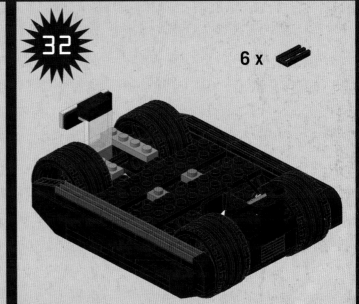

31

6 x

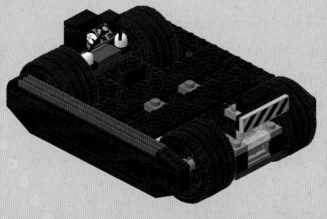

32

6 x

33

1 x
1 x
1 x

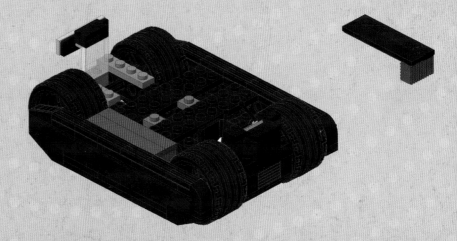

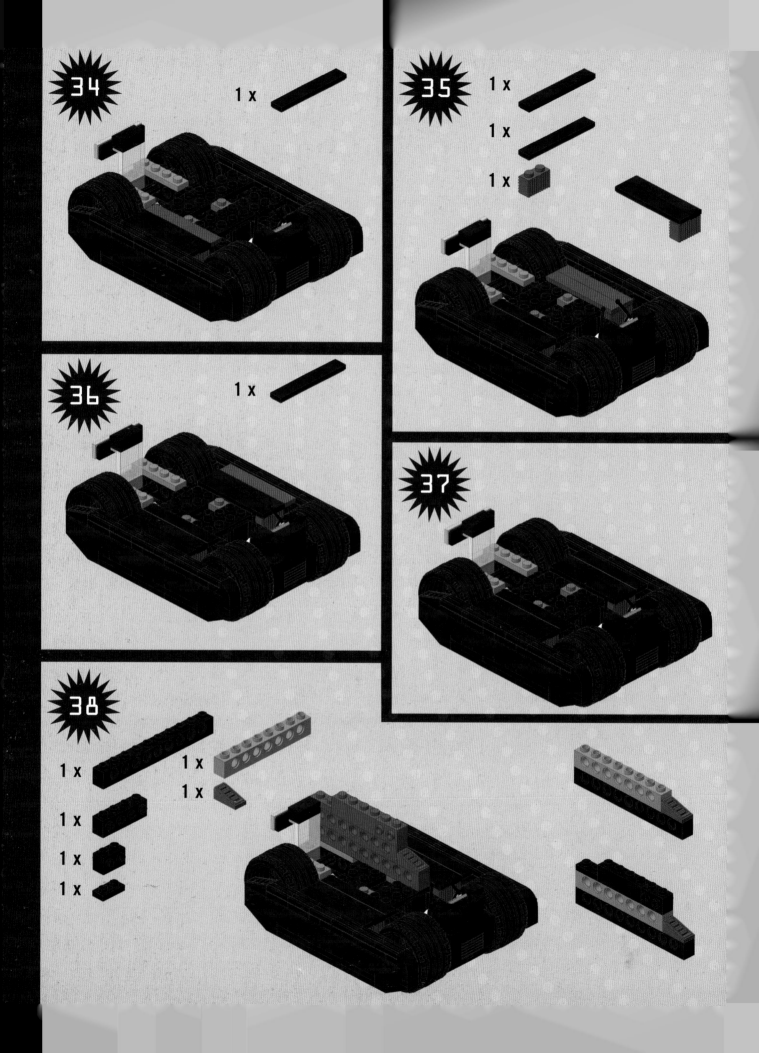

39

1 x
1 x
1 x
1 x

1 x
1 x

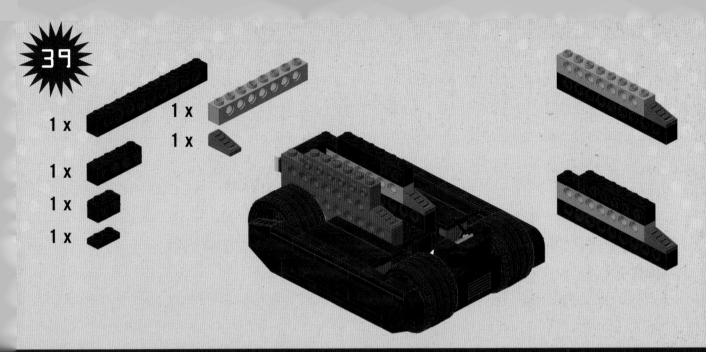

40

1 x
1 x
1 x

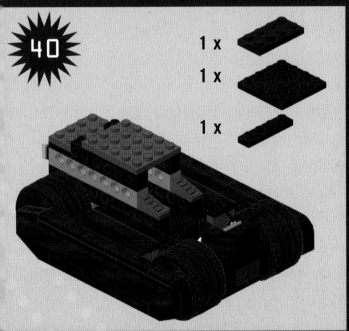

41

2 x
2 x
1 x
1 x

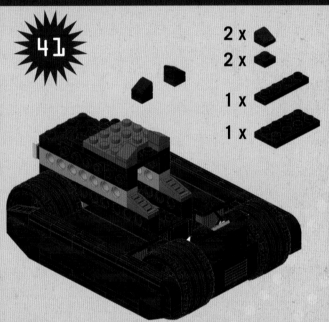

42

1 x
1 x

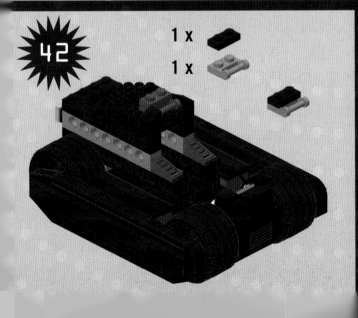

43

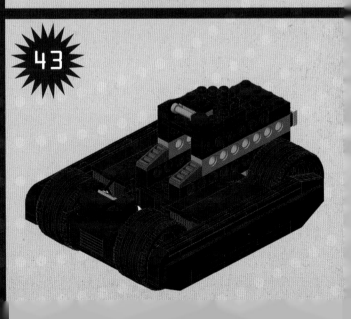

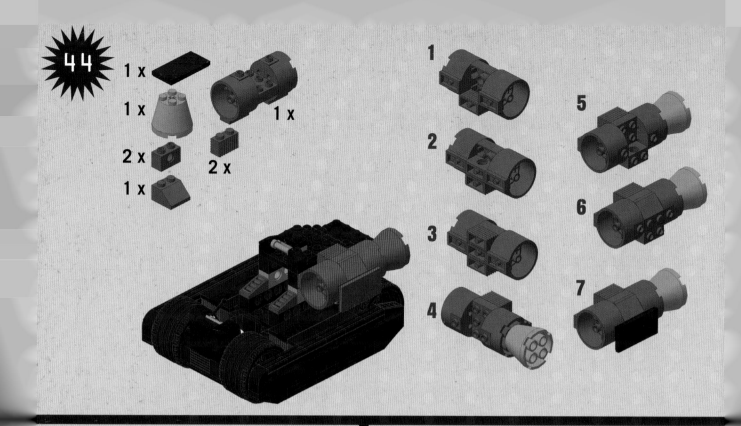

44

1 x

1 x

2 x

1 x

1 x

1

2

3

4

5

6

7

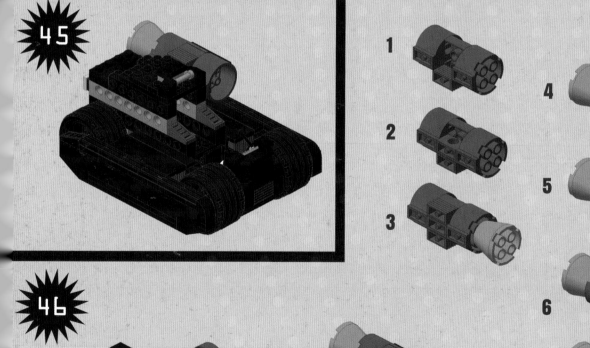

45

1

2

3

4

5

6

7

46

1 x

1 x

2 x

1 x

1 x

2 x

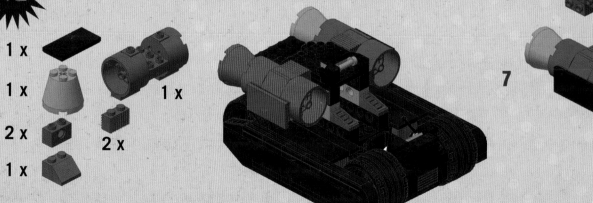

47

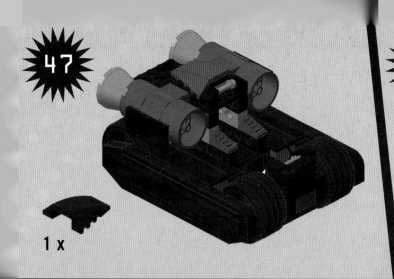

1 x

48

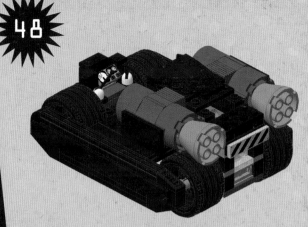

49

4 x

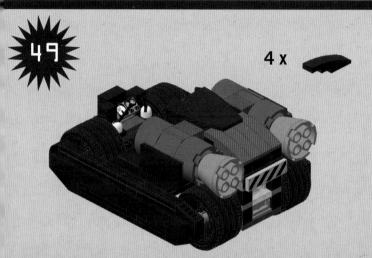

50

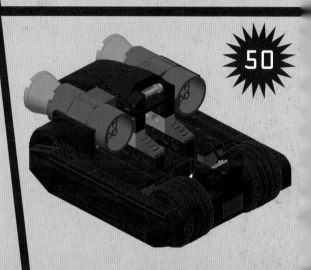

1 x

1 x

1 x

51

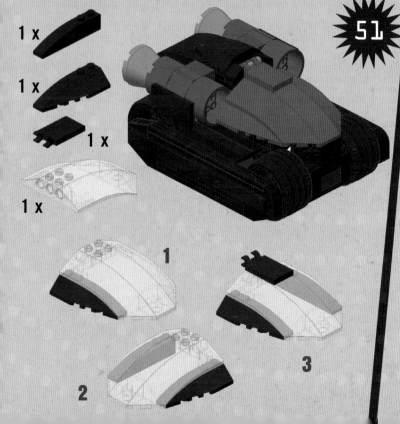

1 x

1

2

3

52

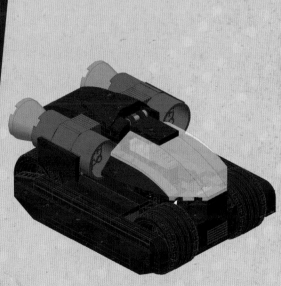

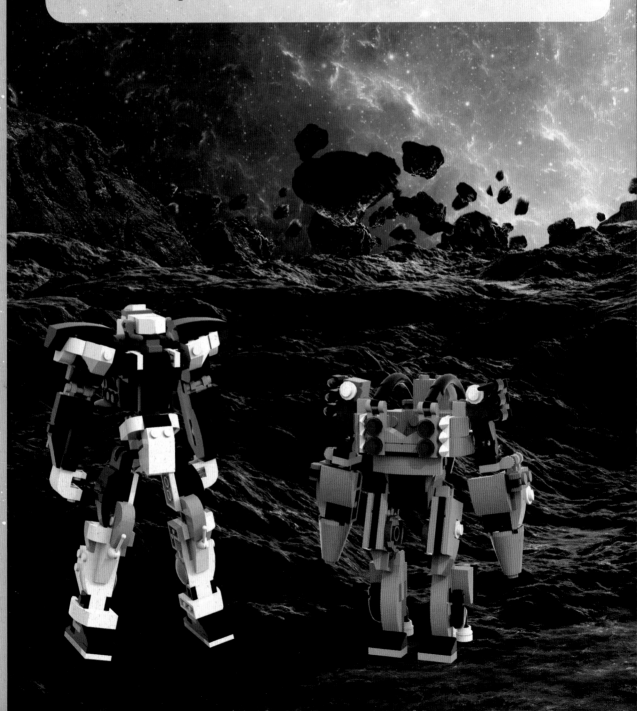

In this chapter you will find LEGO® reproductions of the best robots that have participated (and were often victorious) in the J.U.P.I.T.E.R. GAMES.

Some models, called "exosuits" (from "external suit" or "exoskeleton"), can be "worn," while others can "walk". And there are even classic anthropomorphic robots (if one overlooks their dimensions), with "arms," "legs," a "torso," and a "head" (where the cockpit is typically located). The structure of the robot is obviously dictated by the Commission's choice regarding the race course it selects for Part 3 of the Games.

Master builders have at their disposal various kinds of pieces for creating whatever they need in terms of joints, skills required for the race, etc.

For example, using plate-and-ball elements intended for making joints, they can create arms or legs.

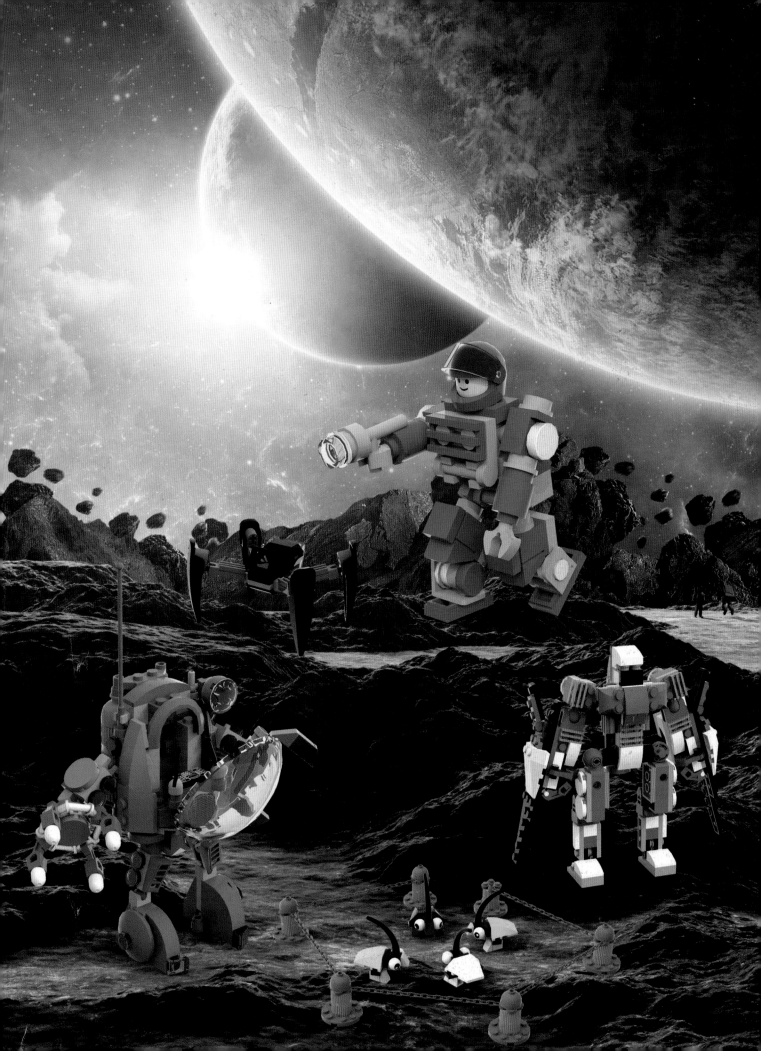

VIDEO: www.nuinui.ch/upload/lego-space-p160.zip

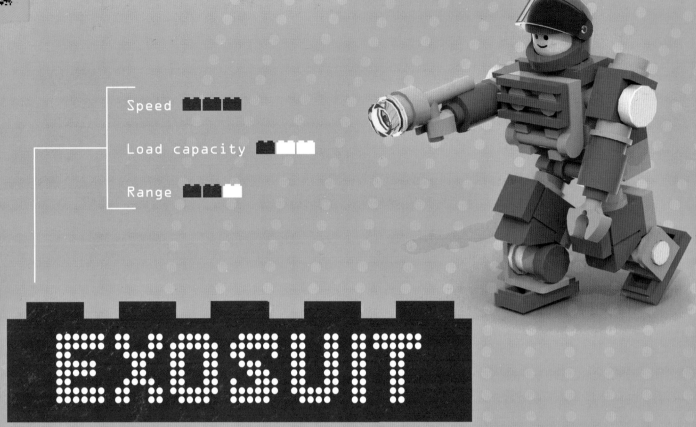

Speed ▮▮▮

Load capacity ▮▯▯

Range ▮▮▯

EXOSUIT

The very first **J.U.P.I.T.E.R. GAMES** took place at a time when some of the most promising technologies were decidedly in their early stages. When the Commission's rules were announced, teams from many planets and civilizations found themselves in a difficult situation, some because of the requirements for Part 1, others as a result of those for Part 2, and still others because of those for Part 3. The solution presented in this paragraph is the result of one of the first brilliant conceptions that came from our own Planet Earth: a so-called "exoskeleton," that is, a "wearable" robot allowing the "driver" to "steer" the robot by simply moving his own body inside the "shell" that made up the robot's body, exactly as if his mechanical alter ego were moving!

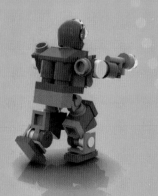

Creator/Designer: Federico Margutti

Federico is a very young LEGO® fan who lives in Milan. He began his meteoric "career" by taking part in a creativity contest (that he obviously won) announced for one of the many LEGO® piece competitions, and after a very short time he became one of the actual exhibitors at this kind of event.

CHARACTERISTICS

- gives the impression that it can be worn by a minifigure
- greatly increases the driver's strength and agility

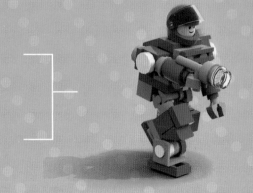

PIECES REQUIRED

1 x	2 x	2 x	2 x	1 x	1 x	4 x	1 x	2 x
3794	3070	50746	98138	3022	85984	3062	30124	3069

1 x	4 x	1 x	1 x	1 x	1 x	1 x	1 x	2 x
2412	4070	3626	6141	2447	60470	3023	30374	85861

1 x	2 x	4 x	4 x	2 x	2 x	2 x	1 x	1 x	2 x
2540	4070	48729	6141	98138	6141	32062	48336	86208	4081

 1

1 x

1 x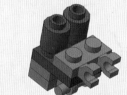

 2

1 x

1 x

3

2 x

4

1 x

1 x

2 x

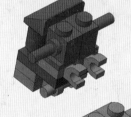

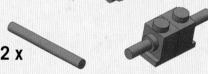

5

1 x

1 x

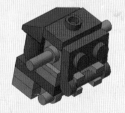

6

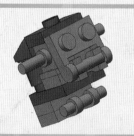

1

1 x

1 x

2

1 x

1 x

1 x

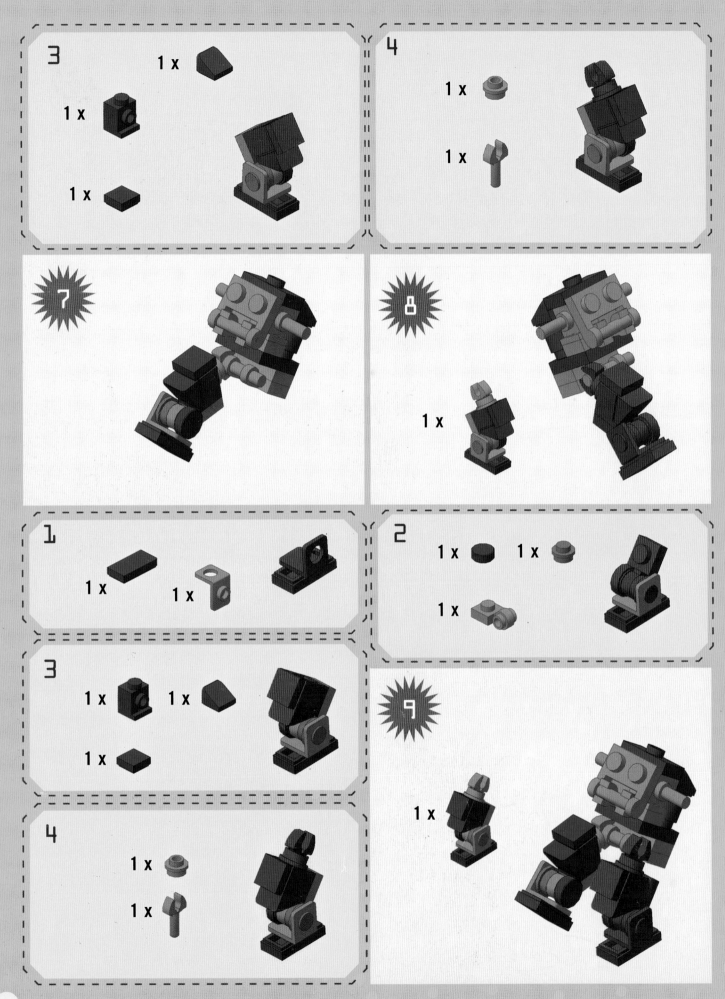

10

1 x 1 x

1 x 1 x

2 x

1 2 3

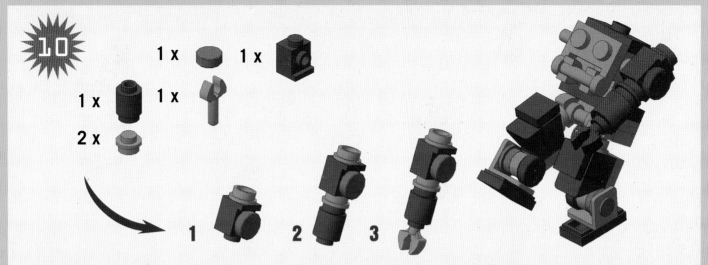

11

1 x

1 x 1 x

2 x 1 x

1 2 3

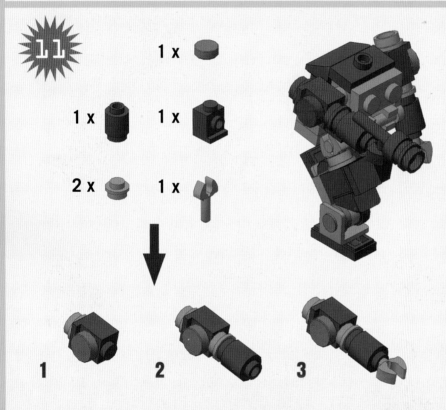

12

1 x

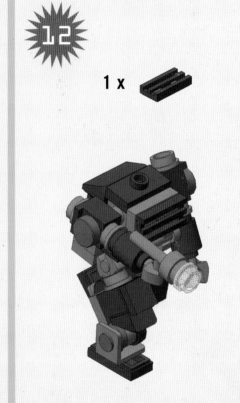

13

1 x

1 x

1 x

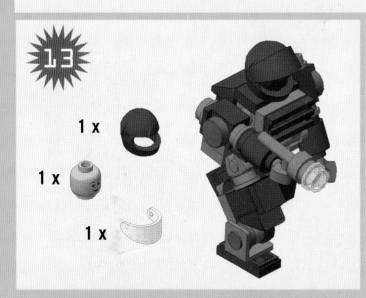

14

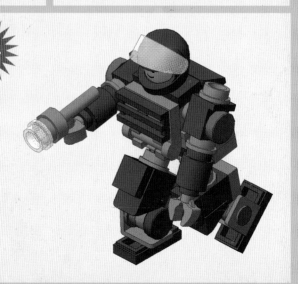

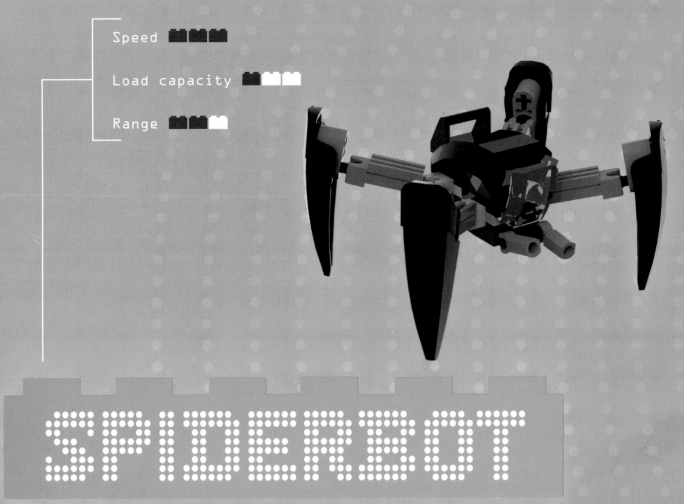

Speed ■■■

Load capacity ■□□

Range ■■□

SPIDERBOT

There was one Part 3 for which the choice of the racecourse can, at the very least, be described as dramatic. It was a "time climbing" event, in which competitors had to arrive in the shortest possible time at the top of a road between a hill and a mountain. Nothing strange—except that the big hill (or small mountain) was made out of bizarre rocks, some as sharp as razor blades and others as delicate as crystals or thin ice. (And what would happen to the racers if they broke them?) A heavy robot or armored vehicle would therefore not have been capable of "racing" up these cliffs. The robot would surely have plunged to its "death" (if not worse), while an armored vehicle would have certainly run the risk of literally being broken into pieces on the sharp rocks. The designers and engineers thought and thought but were unable to come up with a solution. One of them, who had left the laboratory to get a breath of fresh air and clear his head, suddenly had a brilliant idea. He noticed an insect, fast and agile, making its way peacefully across the lawn. Its very thin legs allowed it to avoid dangers and obstacles. He understood in a flash that the solution to their problems was to design a robot, but with the shape and appearance of the insect he had just seen. This is how the SpiderBot was born, the spider-robot, with strong but agile legs and a minimal surface area that allowed it to avoid the risk of breaking the fragile rocks and make its way safely through the sharp ones. Its weight was equally distributed among the four "legs" to reduce the pressure on a single point, and voilà—problem solved. One could say he used the power of nature!

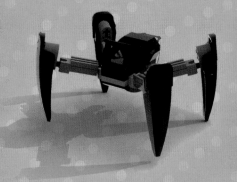

Creator/Designer: Nicola Lugato

CHARACTERISTICS

- able to accommodate one minifigure in the driver's seat

- strong, agile, and extremely maneuverable so that it can overcome any obstacle

PIECES REQUIRED

1 x	2 x	1 x	1 x	2 x	4 x	2 x	4 x	1 x
3069	13547	3021	2540	4070	6628	50746	2412	47755

1 x	1 x	4 x	4 x	1 x	1 x	4 x	2 x	4 x
2412	99207	15362	60483	30602	3023	14704	11090	14419

1

2 x

2

1 x

2 x

3

4

4 x

1 x

1 x 1 x

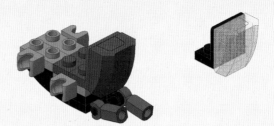

1 x 2 x

2 x

1 x

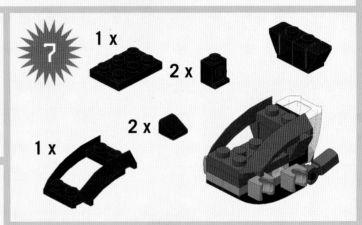

1 x

1 x

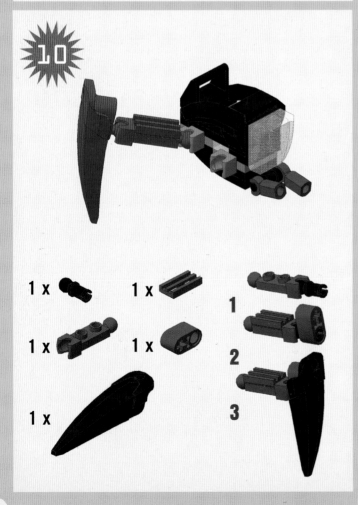

1 x 1 x

1 x 1 x

1

2

1 x 3

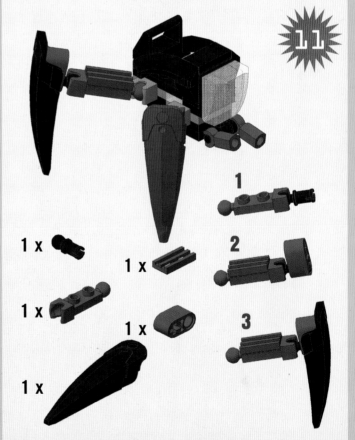

1

1 x 1 x 2

1 x 3

1 x 1 x

12

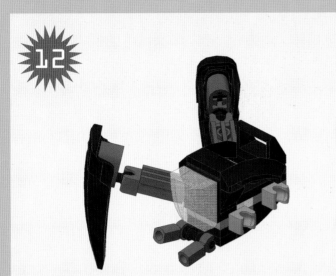

13

1 x

1 x

1 x

1 x

1 x

1

2

3

14

1 x

1 x

1 x

1 x

1 x

1

2

3

15

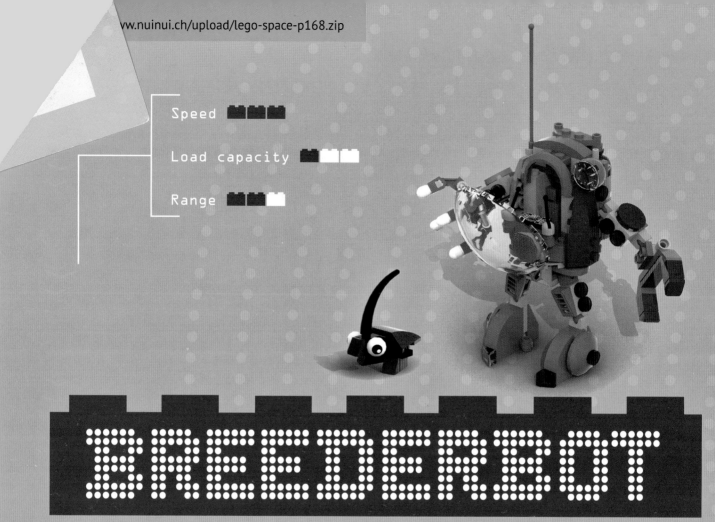

Speed ■■■

Load capacity ■ ■□□

Range ■■ ■□

BREEDERBOT

One year the J.U.P.I.T.E.R. GAMES Commission decided that Part 3 would be devoted to two ancient arts practiced on Planet Earth during past centuries: agriculture and livestock breeding. You can well imagine the consternation of many of the civilizations signed up for the competition: who remembers how to grow fruits and vegetables or how to raise "animals"? Even stranger, and a source of great bewilderment for the participants, was the objective given them by the Games Commissioners: capture the largest possible number of strange little animals called "astro-roosters" (whose origin was lost in the mists of time), known for their speed and voracity, and bring them back to their enclosures. The Commissioners would release a large number of them in a kind of big arena, and the competitors would have to construct robots ("pilotable" or "wearable" based on the tactical choices of each team) specifically designed for the task at hand. You can imagine how hard the spectators laughed. In this paragraph, you'll see the LEGO®-piece model of one of the robots that took part in this very unusual Part 3.

Creator/Designer: Nicola Lugato

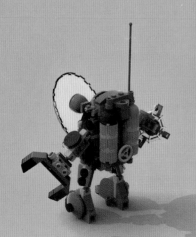

CHARACTERISTICS

- able to accommodate one minifigure in the driver's seat
- agile and highly maneuverable
- supplied with an "arm+leg" to capture the "astro-roosters" and an "arm+jaw" to hold the container with the bait for the fleeing animals

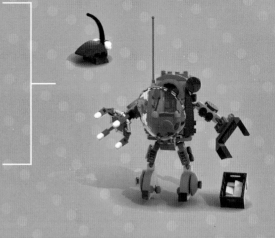

If you want to build a lot of "astro-roosters," construct an enclosure, too, and put them all inside!

PIECES REQUIRED–CHICKEN RED

2 x	2 x	1 x	1 x	2 x	4 x	2 x	4 x	1 x
3794	3070	50746	98138	3022	85984	3062	3062	3069

1 1 x

2 2 x / 2 x

3 1 x 1 x

4 2 x / 1 x / 1 x / 1 x / 1 x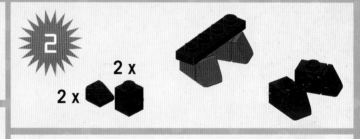

5

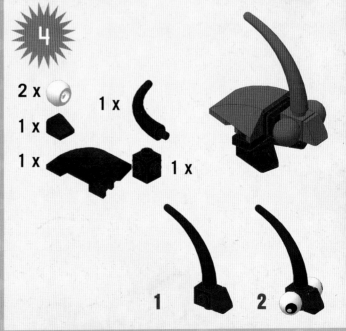

1 2

1 x	1 x	2 x	2 x	4 x	2 x	2 x	1 x	1 x	2 x	2 x
3070	50746	98138	3022	3794	98138	3022	85984	3062	30124	3069

1 x	2 x	6 x	1 x	1 x	1 x	6 x	1 x	1 x		1 x
98138	3022	3794	85984	98138	3022	3069	3069	30124		3069

1 x	2 x	2 x	4 x	1 x	1 x	2 x	1 x	2 x	2 x	4 x	1 x
98138	3022	3794	50746	98138	3022	3069	3069	3022	3069	3069	3069

1 x	1 x	6 x	1 x	6 x	6 x	1 x	2 x	1 x	5 x	2 x	2 x
98138	3022	3794	98138	3022	3794	3022	85984	3062	3022	3069	3069

4 x	3 x	1 x	2 x	2 x	1 x	1 x	1 x	2 x	3 x	1 x
85984	3062	98138	3022	3794	3022	3022	3022	3022	3069	3069

| 1 x | 3 x | 3 x | 4 x | 4 x | 2 x | 2 x | 1 x | 1 x | 1 x |
|---|---|---|---|---|---|---|---|---|---|---|
| | 3022 | 3022 | 3022 | 3022 | 3022 | 3022 | 3069 | 3069 | 3022 |

2 x	4 x	1 x	1 x	1 x
3022	3022	3022	3022	3022

1 1 x 2 x

2 1 x

3 2 x

4 1 x 1 x

5 1 x 1 x

6 2 x 1 x

170

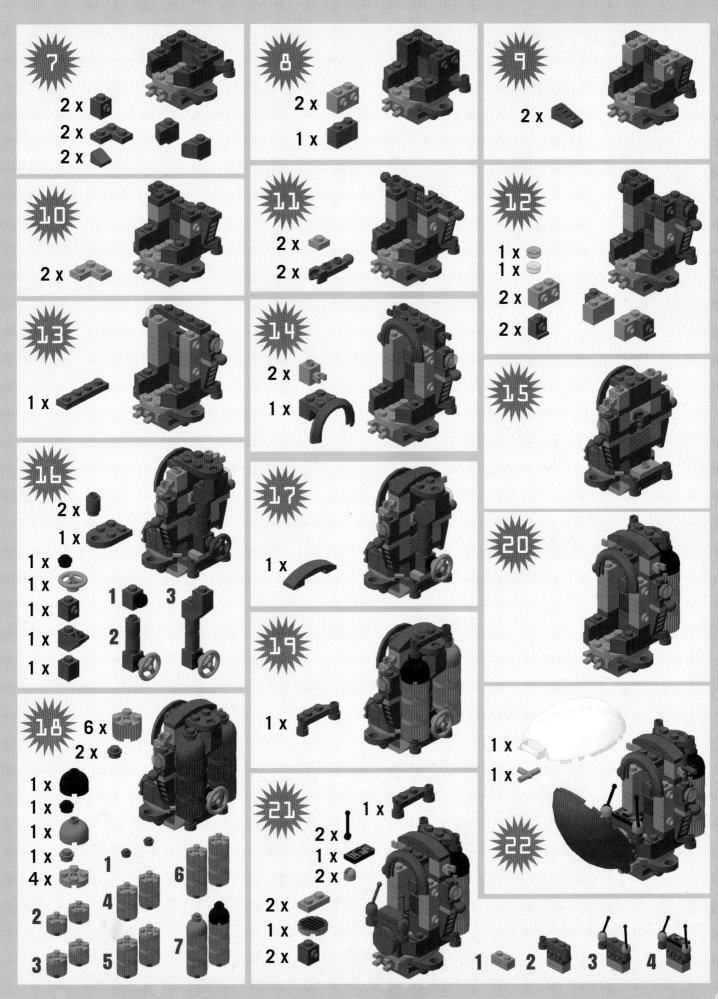

23

1 x

1 x

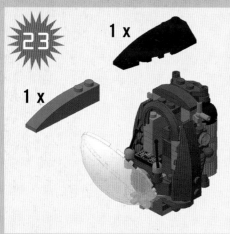

24

2

1

2 x
1 x

1 x

1 x

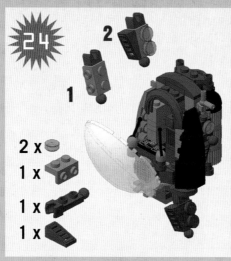

25

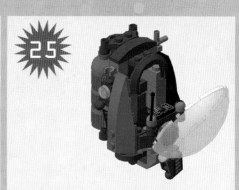

26

2 x
1 x

1 x
1 x

1

2

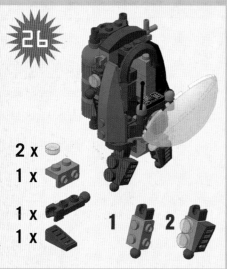

27

1 x
1 x
1 x

1 x
1 x

1 x

1 x

1 x

1 x

1 x

1

3

2

4

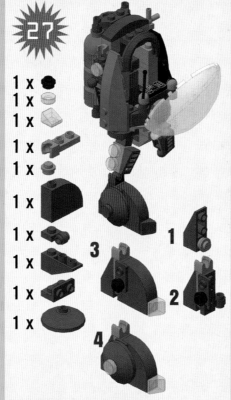

28

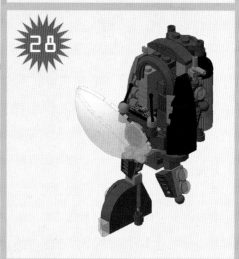

29

1 x
1 x
1 x
1 x
1 x

1 x

1 x

1 x

1 x

1 x

1

2

3

4

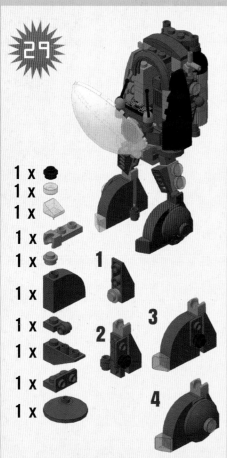

30

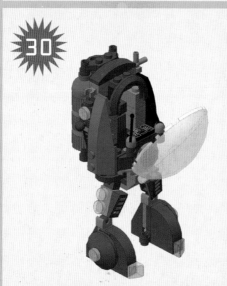

31

1 x
2 x
2 x

2 x

1 x

1 x

5

3

1

2

4

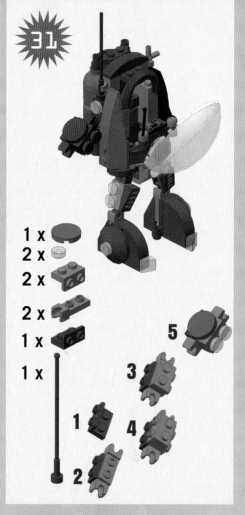

32

4 x
1 x
1 x

2 x
4 x
1 x

1
2
3
4

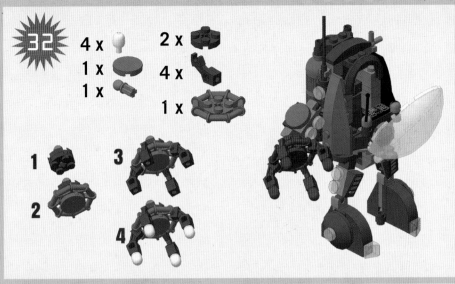

33

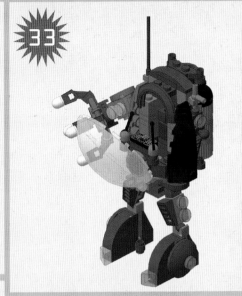

34

2 x
1 x

1 x
2 x
2 x

1
2
3
4

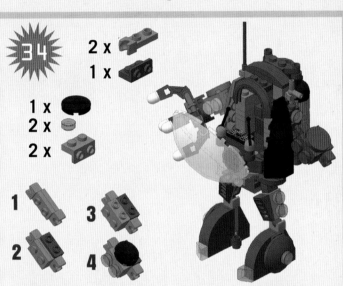

35

1 x
1 x

1
2

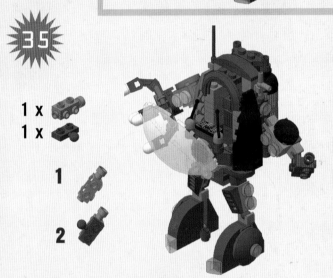

36

2 x
1 x
2 x
1 x

1
2

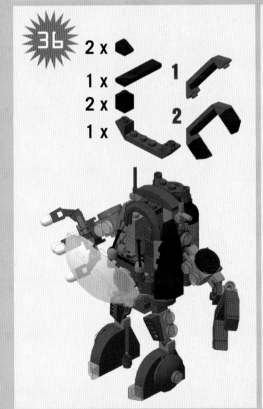

37

1 x
1 x
1 x

1
2

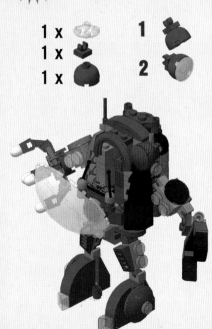

38

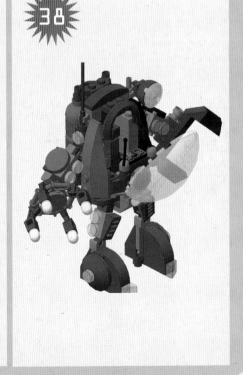

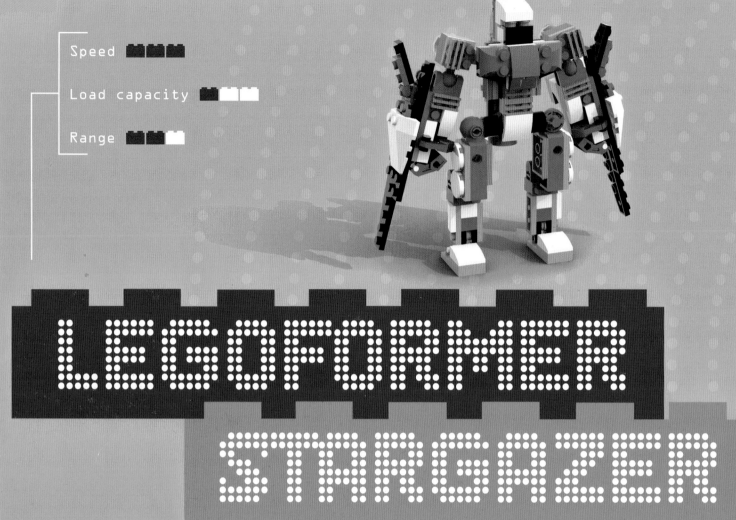

Speed ■■■

Load capacity ■■□

Range ■■□

LEGOFORMER STARGAZER

Once upon a time, on a planet far away (in a galaxy even farther away), taking part in the J.U.P.I.T.E.R. GAMES, particularly in Part 3, was a real problem. The science and technology of this planet had only recently reached the level of those more fully evolved civilizations already competing in the games for some time. These disciplines required to build spacecraft and space shuttles were sufficiently advanced. The engineering and design techniques to construct vehicles that could race on the courses chosen for Part 2 had also reached a high level.

The same for robotics and mechatronics: building a robot to compete in Part 3 wasn't difficult. However, transporting the robot to the planet it had to compete on was a major problem. If designing speedy, light, and powerful space shuttles had become possible, creating huge cargo carriers able to "fly" in space at the speed needed to carry large loads was—no one knows exactly why—an enormous challenge for technicians and scientists. What to do? Building a robot small enough to be transported by their spacecraft would have been useless, because it would certainly have been beaten by … bigger ones. Give up? Never! So? So they decided to think creatively and do something that no other planet or civilization had ever done before: construct a competitive shuttle for Part 1 of the Games that could transform into a robot to use in Part 3! Was it written in the Commission's rules that the three parts of the Games required separate vehicles? No! That's why the decision to make a transformable vehicle astonished so many people. Sometimes you need a mind free of preconceived ideas, capable of thinking outside the box!

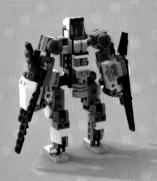

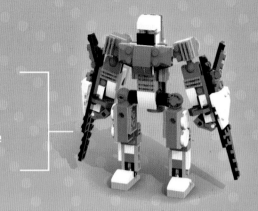

Creator/Designer: Ezra Ariella Wibowo

Ezra is a young university student living in Surabaya, a city in the eastern part of the island of Java, in Indonesia. He's a huge Transformer fan.

CHARACTERISTICS

* very powerful but also agile
* can transform into a space shuttle (and vice versa)

PIECES REQUIRED

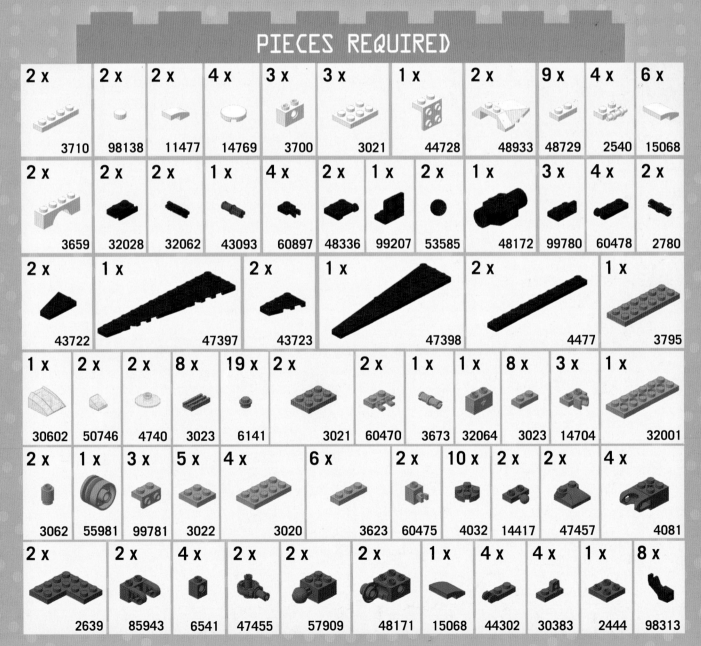

Qty	Part
2 x	3710
2 x	98138
2 x	11477
4 x	14769
3 x	3700
3 x	3021
1 x	44728
2 x	48933
9 x	48729
4 x	2540
6 x	15068
2 x	3659
2 x	32028
2 x	32062
1 x	43093
4 x	60897
2 x	48336
1 x	99207
2 x	53585
1 x	48172
3 x	99780
4 x	60478
2 x	2780
2 x	43722
1 x	47397
2 x	43723
1 x	47398
2 x	4477
1 x	3795
1 x	30602
2 x	50746
2 x	4740
8 x	3023
19 x	6141
2 x	3021
2 x	60470
1 x	3673
1 x	32064
8 x	3023
3 x	14704
1 x	32001
2 x	3062
1 x	55981
3 x	99781
5 x	3022
4 x	3020
6 x	3623
2 x	60475
10 x	4032
2 x	14417
2 x	47457
4 x	4081
2 x	2639
2 x	85943
4 x	6541
2 x	47455
2 x	57909
2 x	48171
1 x	15068
4 x	44302
4 x	30383
1 x	2444
8 x	98313

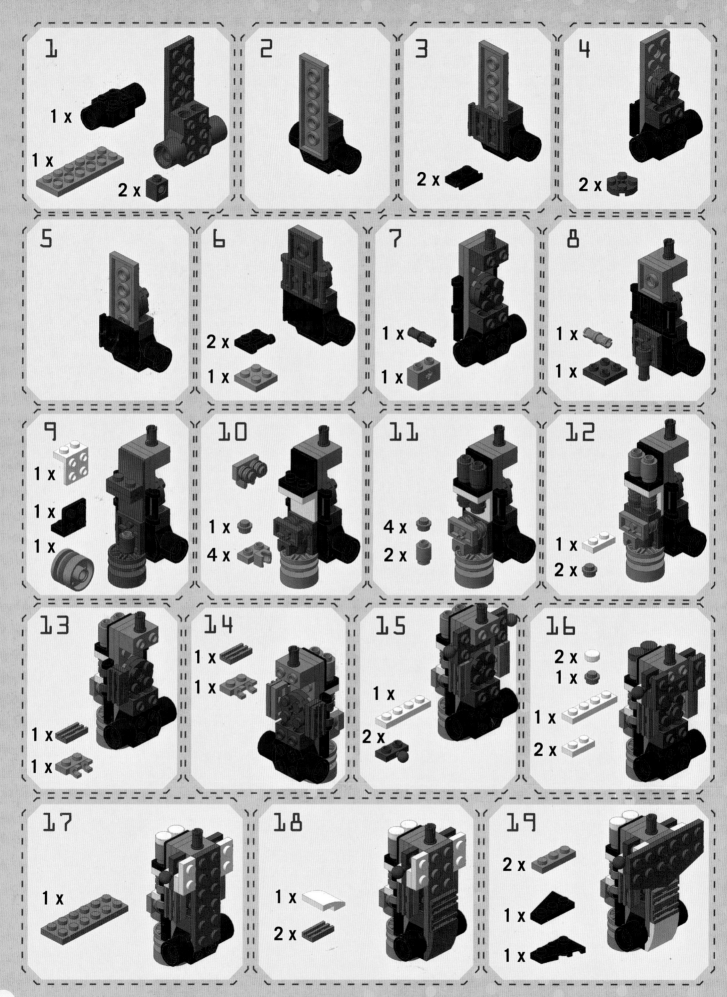

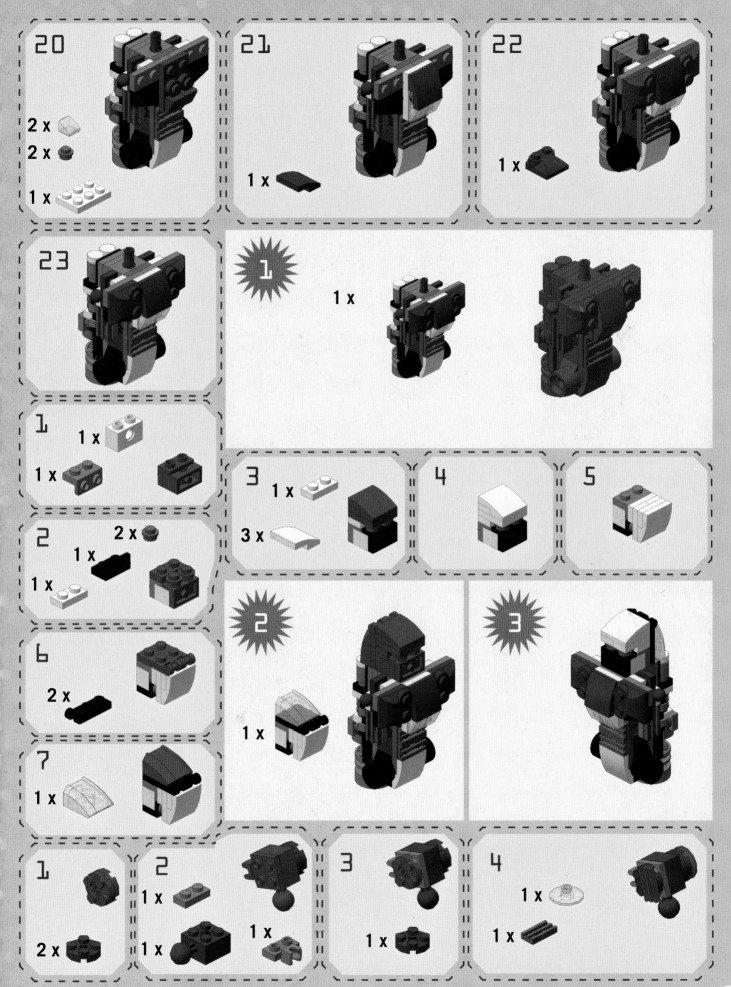

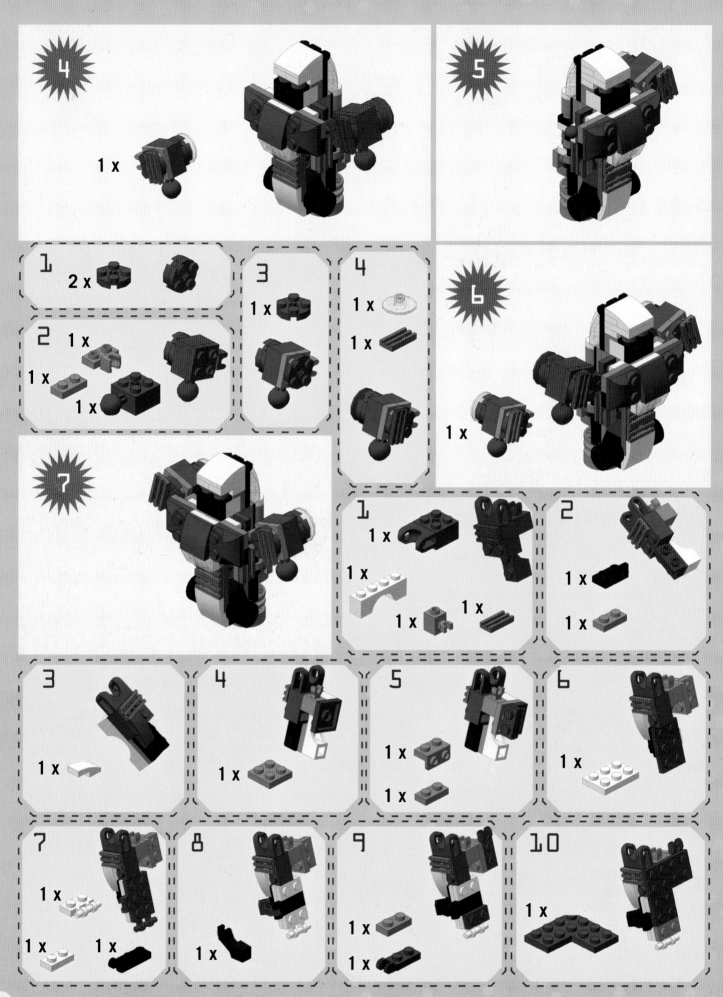

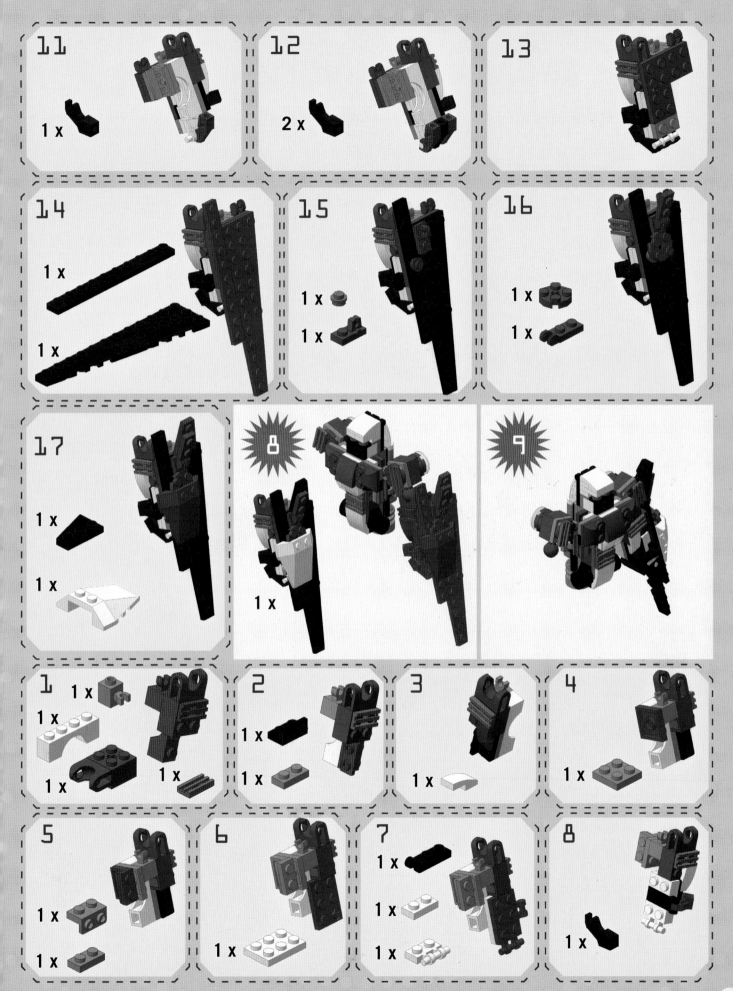

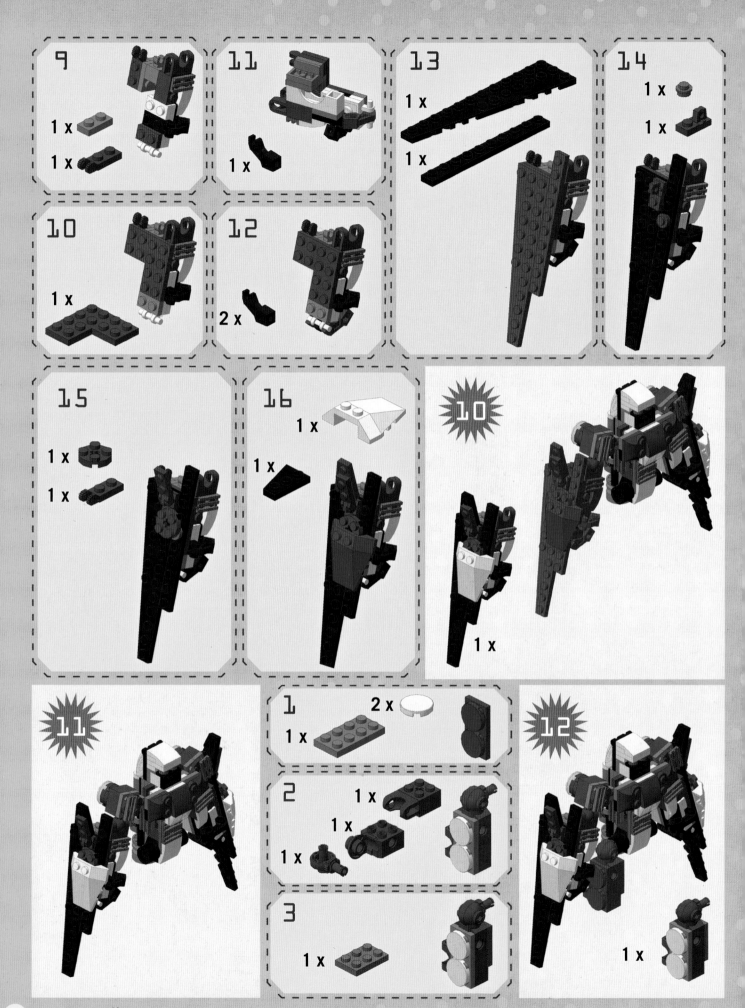

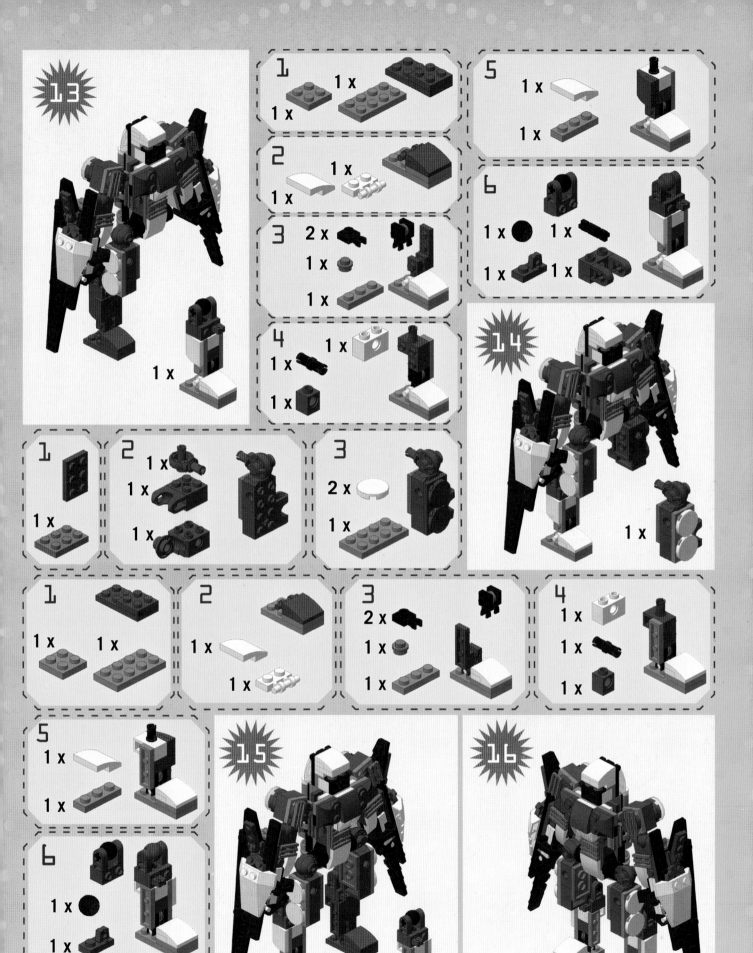

Speed ■■■

Load capacity ■□□

Range ■■□

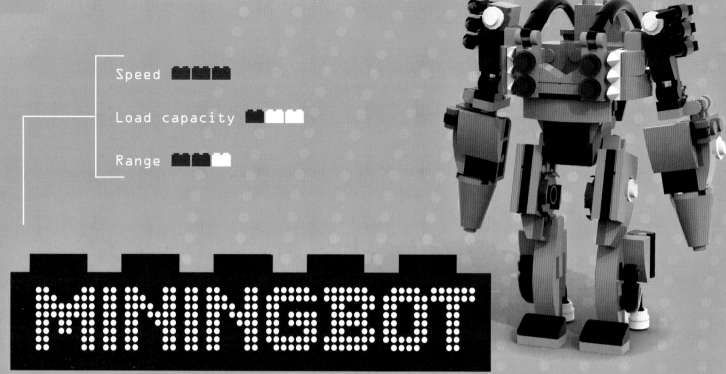

MININGBOT

Earlier, I explained that for Part 3 of the J.U.P.I.T.E.R. GAMES, the Commission chose tests of strength, skill, or speed for the robots taking part in it. In the models shown in the preceding pages, we saw many versions of these skills used in the functioning of various vehicles. In this vehicle, however, we will see the brute force of the wave engines used to propel the shuttles (for example the MATSF-5000E SUPERBANSHEE II on page 32) modified and converted for use in crushing rocks. For one year's Part 3, in fact, the participants' task was to crush the most rocks possible, starting at the base of a mountain and working their way inside with power hammer blows generated by wave engines. Of course, no one thought about the fact that a tunnel dug nonchalantly from one side of this specific mountain to the other might be convenient for the inhabitants of the region, but that's another story.

Creator/Designer: Ezra Ariella Wibowo

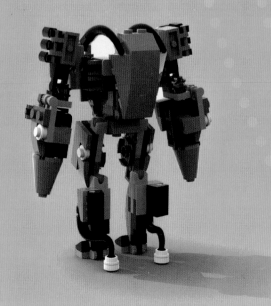

Author's note:

For this particular robot, instead of the usual console and dashboard, the designers decided to use a remote control, in case it was wiser for the driver to stay a safe distance in particularly ... risky situations. Is that something as familiar to you as it is to the author?

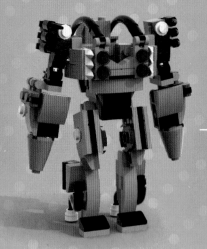

CHARACTERISTICS

- able to accommodate a minifigure in the driver's seat
- includes a remote control
- very powerful but also very agile
- its robust wave generators are capable of crushing even the biggest rocks or those composed of extremely hard elements

PIECES REQUIRED

2 x 98138	2 x 15208	8 x 6141	1 x 15573	3 x 4032	2 x 11477	4 x 60478
2 x 4081	1 x 3022	8 x 11090	3 x 85984	2 x 3937	2 x 87087	2 x 12825
5 x 3023	2 x 40379	2 x 3021	2 x 43892	6 x 53451	1 x 99780	10 x 44301
2 x 3942	3 x 93273	4 x 3069	5 x 3004	1 x 43719	1 x 47753	6 x 3024
1 x 3022	1 x 3039	4 x 44728	4 x 50746	12 x 11477	1 x 51739	7 x 3023
1 x 3021	2 x 2540	16 x 6141	1 x 10201	2 x 6134	4 x 60478	6 x 14418
4 x 60471	2 x 44301	6 x 14417	8 x 44302			

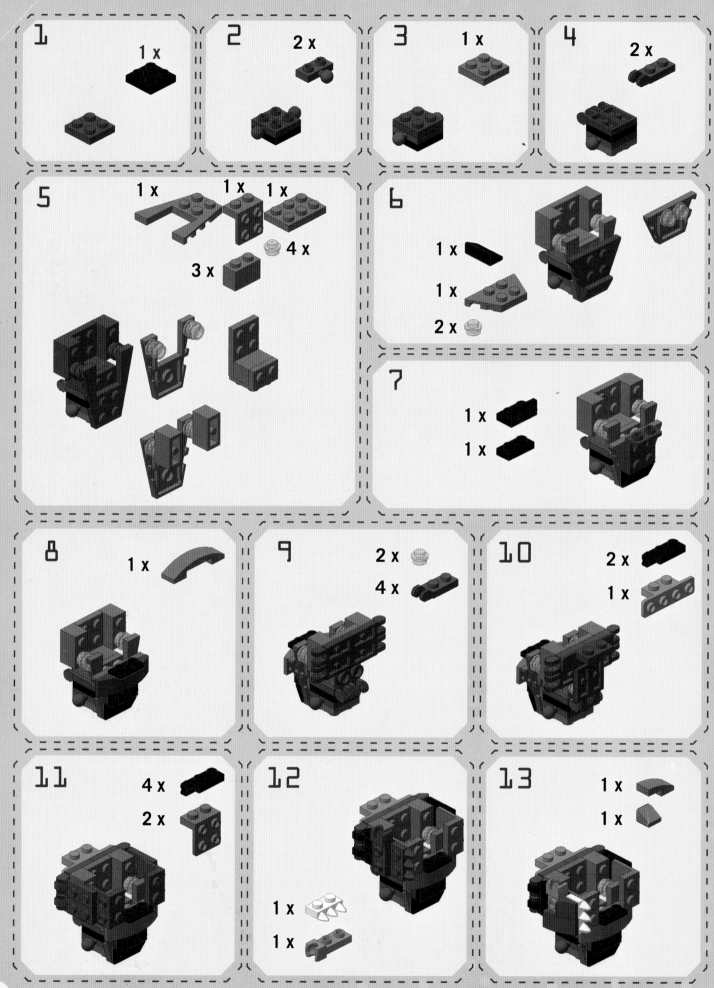

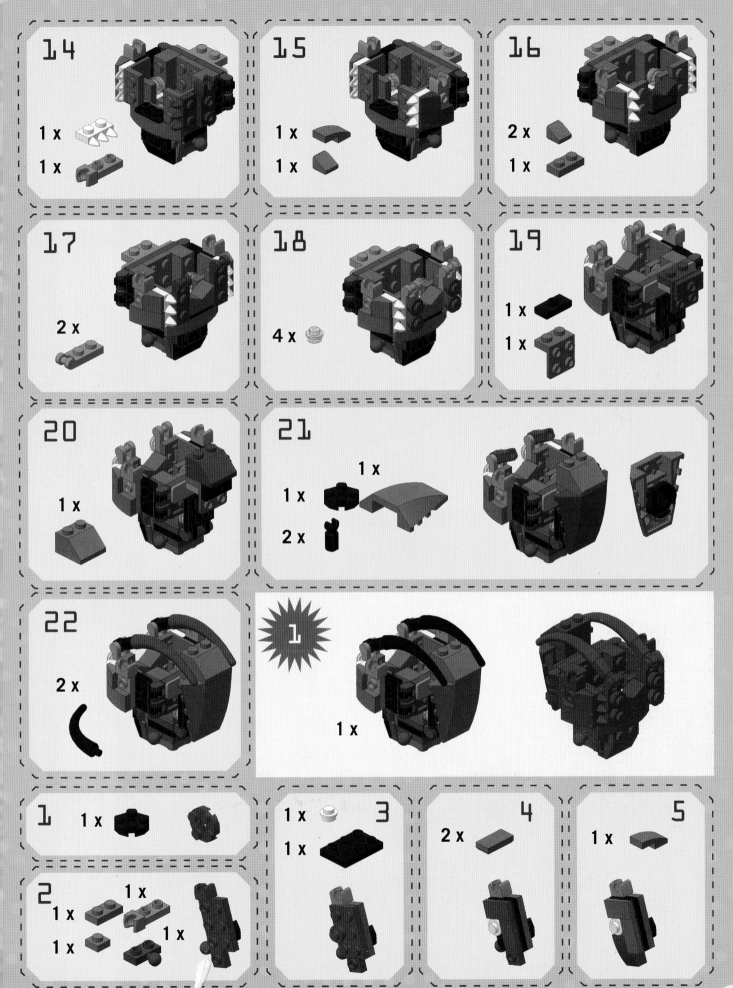

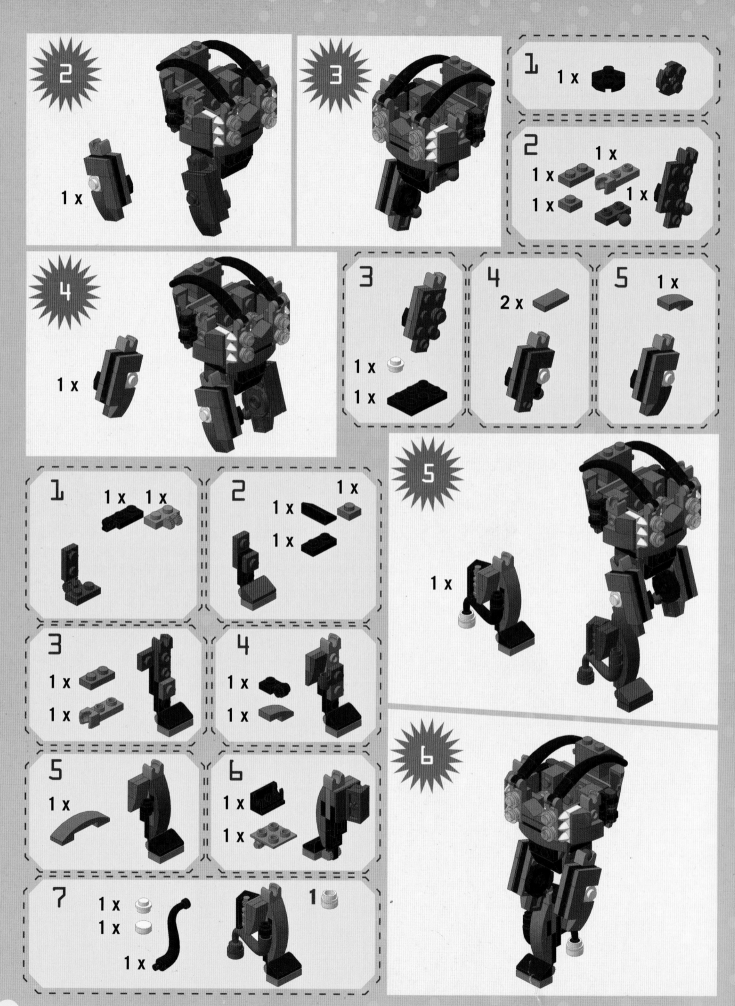

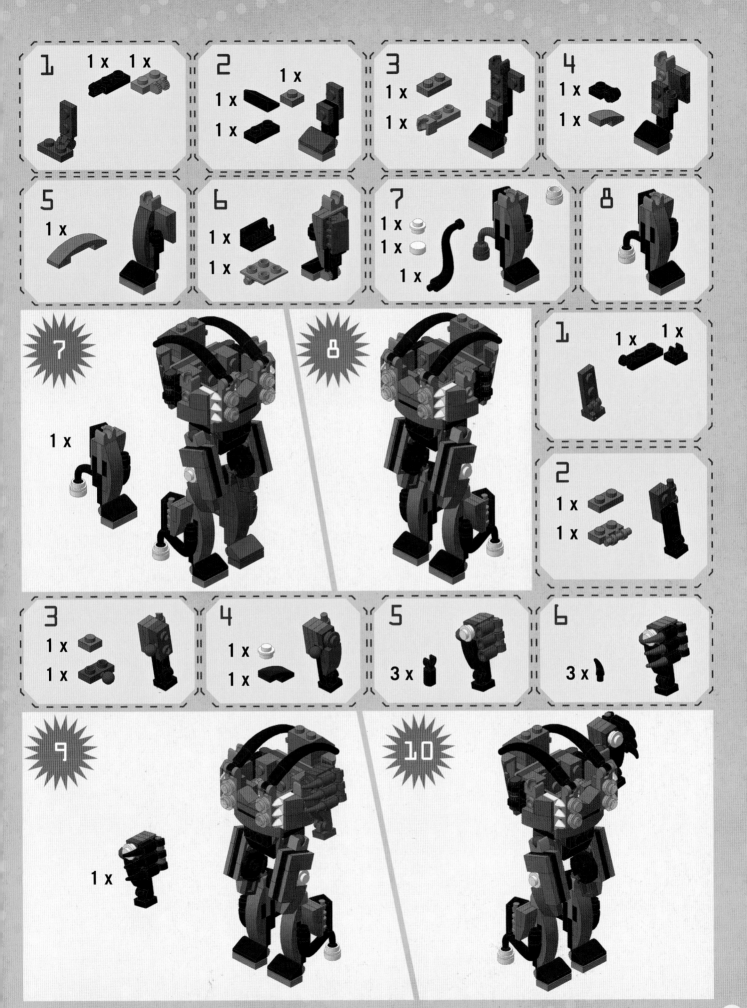

1
1 x 1 x

2
1 x
1 x

3
1 x
1 x

4
1 x
1 x

5
3 x

6
3 x

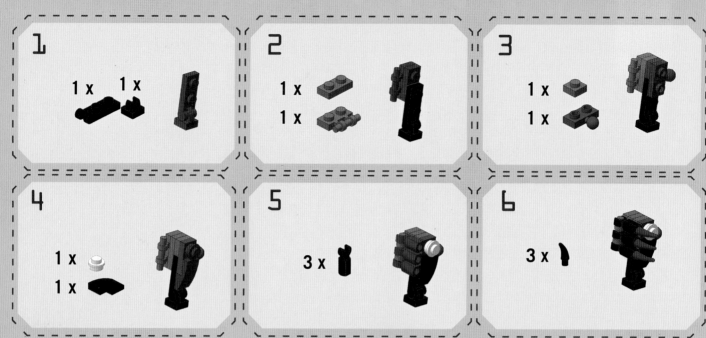

11
12

1 x

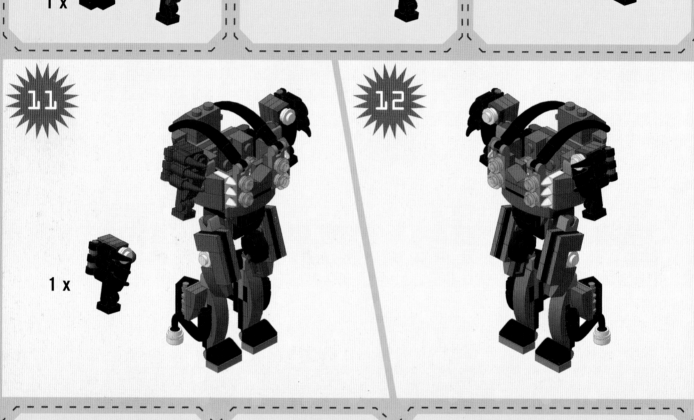

1
1 x 1 x

2
1 x

3
1 x 1 x 1 x

4
2 x
2 x

5
1 x 1 x
1 x
1 x 1 x
1 x

1
2
3

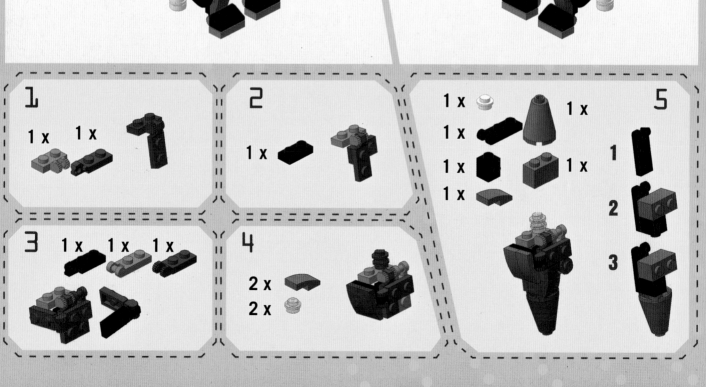

13

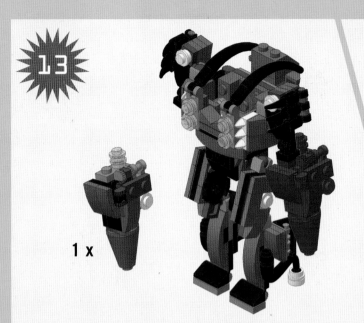

1 x

14

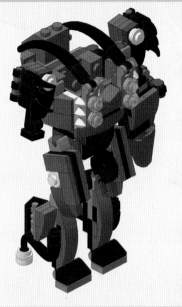

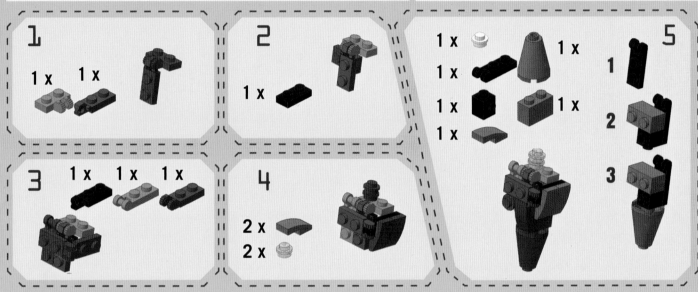

1

1 x 1 x

2

1 x

3

1 x 1 x 1 x

4

2 x
2 x

1 x
1 x
1 x
1 x

1 x
1 x

5

1
2
3

15

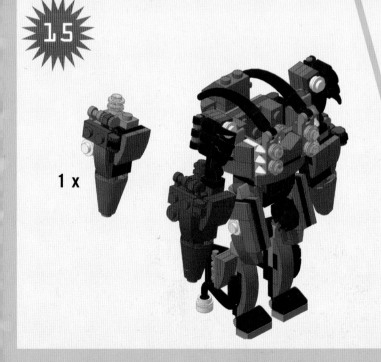

1 x

16

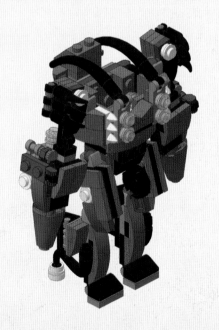

VIDEO: www.nuinui.ch/upload/lego-space-p192.zip

Speed ■■■

Load capacity ■□□

Range ■■□

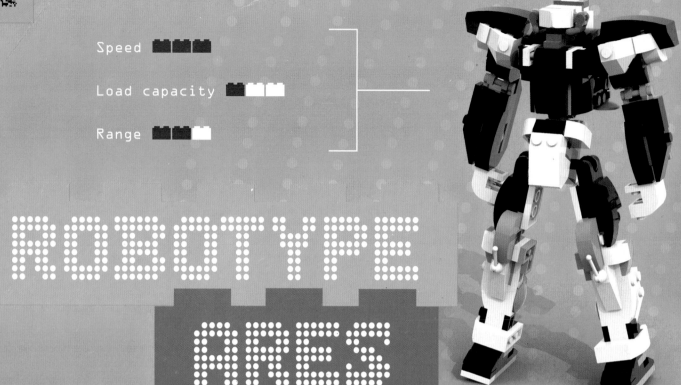

ROBOTYPE
ARES

Powerful. Strong. Fast. Big. Very big. That's the ROBOType ARES, the Champion. One year the Games Commission was late in sending the rules and objectives to the contestants. One of the civilizations most advanced in engineering, robotics and mechanotronics, the technology of materials, and the chemistry and physics of propellants decided not to worry too much about the regulations that were so slow in arriving and to design a robot that could handle any challenge, overcome any obstacle, and reach any finish line the Commission might propose. Let's say that the technicians … got a little carried away. And so, from the design and production laboratories came "him"—ROBOType ARES, the Champion. He got this name because he was so much stronger, faster, more powerful, and more enormous than all the other robots sent to the race that he was excluded from the competition and awarded a special prize. Actually, at the end of the J.U.P.I.T.E.R. GAMES, to please the spectators from every part of the universe who were shouting his name, he was allowed to compete against the other robots in a selection of challenges that they had had to face during the official Games. ARES proved to be so superior to all the other robots that he was given the title of "Champion." After that, Part 3 of the J.U.P.I.T.E.R. GAMES was never the same.

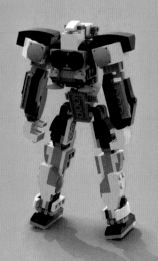

Creator/Designer: Ezra Ariella Wibowo

CHARACTERISTICS
* agile
* strong
* fast
* a real tough cookie
* adjustable "arms" and "legs"

PIECES REQUIRED

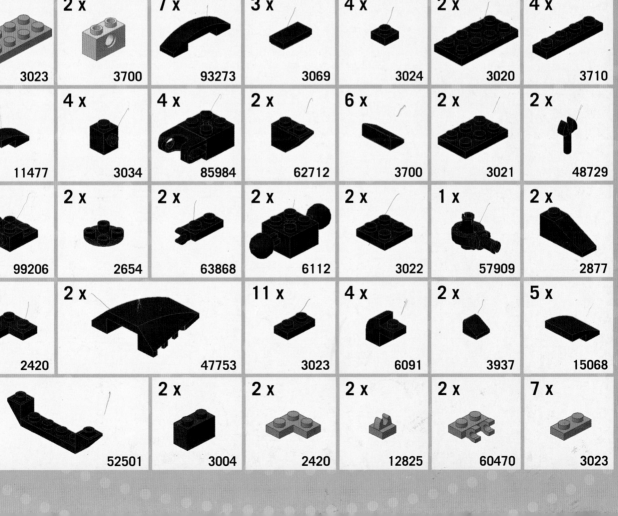

5 x 3710	3 x 11477	2 x 3665	3 x 3021	1 x 3003	2 x 93273	6 x 3005
6 x 4286	2 x 98138	4 x 2420	20 x 3023	2 x 4865	2 x 3676	12 x 6091
2 x 99206	2 x 50746	10 x 3024	2 x 73587	2 x 3660	2 x 14769	4 x 3623
2 x 3010	2 x 73983	4 x 2654	2 x 11211	5 x 48336	2 x 73983	4 x 3024
3 x 3023	2 x 3700	7 x 93273	3 x 3069	4 x 3024	2 x 3020	4 x 3710
6 x 11477	4 x 3034	4 x 85984	2 x 62712	6 x 3700	2 x 3021	2 x 48729
2 x 99206	2 x 2654	2 x 63868	2 x 6112	2 x 3022	1 x 57909	2 x 2877
4 x 2420	2 x 47753	11 x 3023	4 x 6091	2 x 3937	5 x 15068	
2 x 52501	2 x 3004	2 x 2420	2 x 12825	2 x 60470	7 x 3023	

193

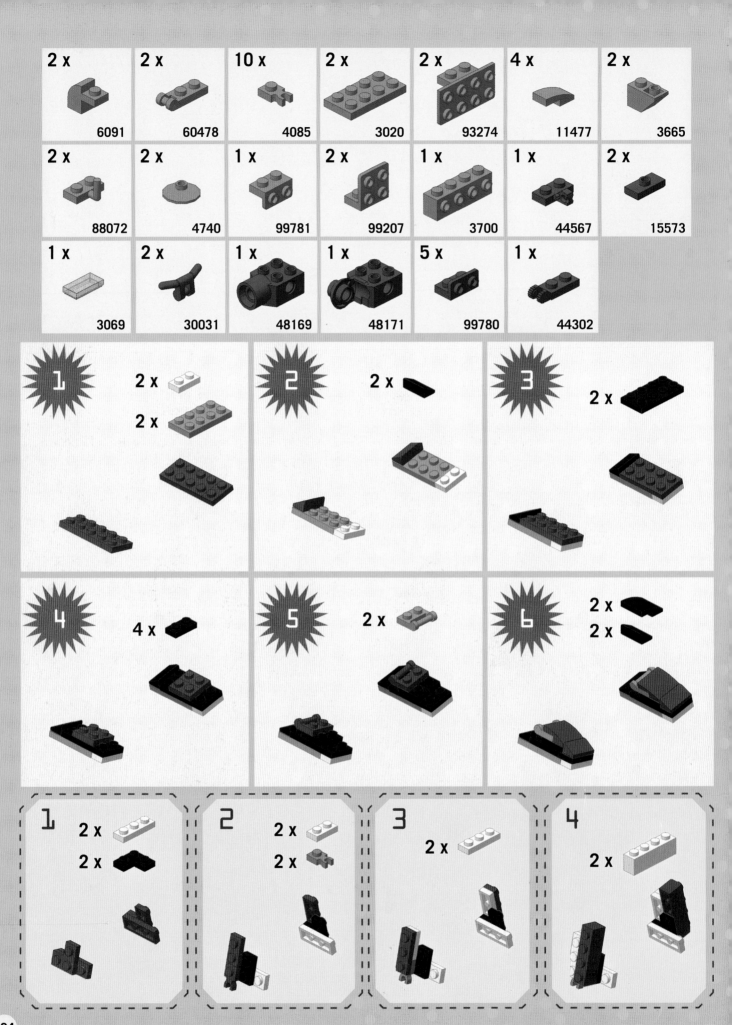

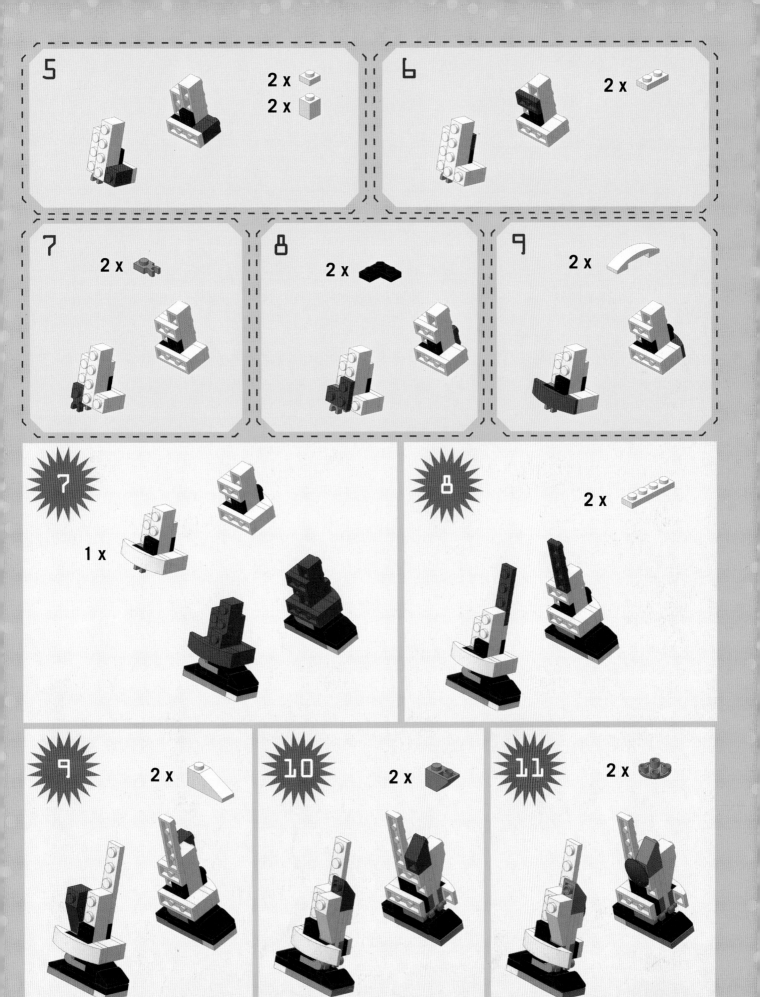

12

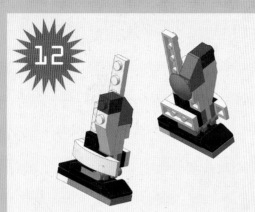

2 x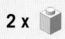

13

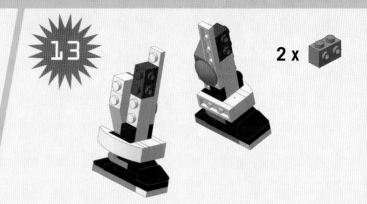

2 x

14

2 x
2 x

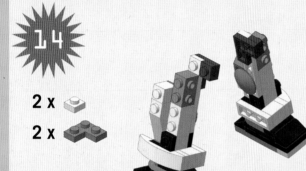

2 x

15

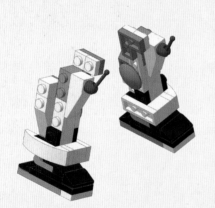

16

2 x
2 x

17

2 x

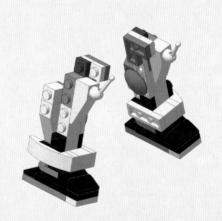

18

4 x

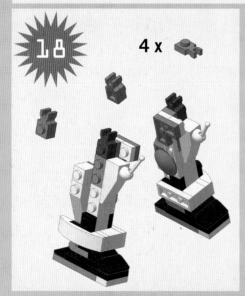

19

2 x

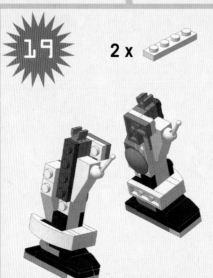

20

2 x
2 x

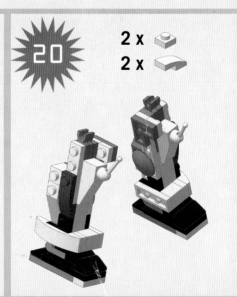

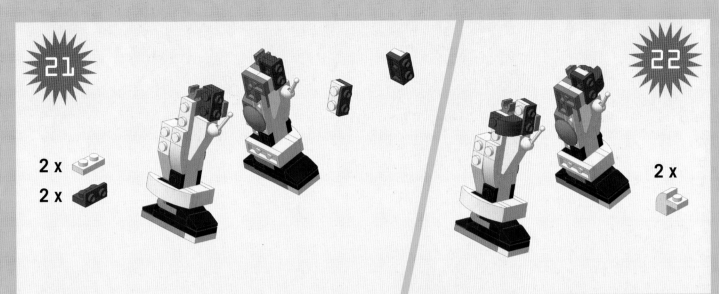

21

2 x
2 x

22

2 x

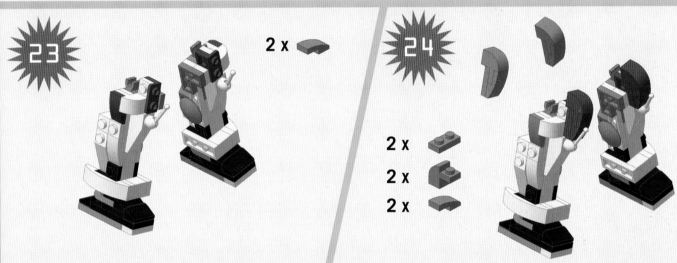

23

2 x

24

2 x
2 x
2 x

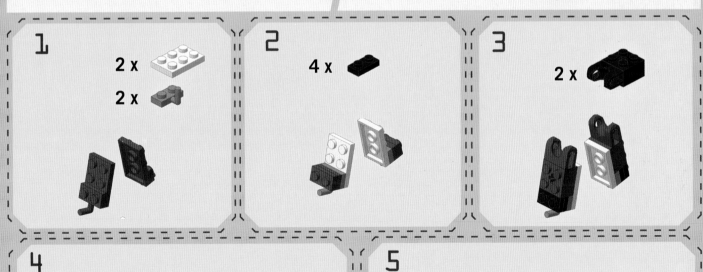

1

2 x
2 x

2

4 x

3

2 x

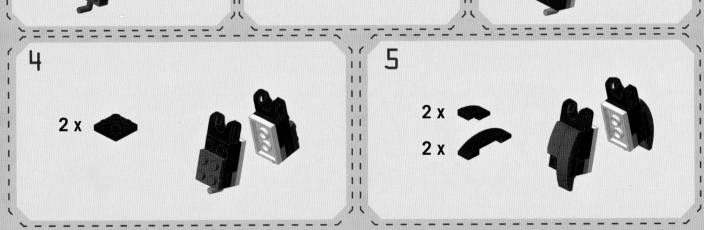

4

2 x

5

2 x
2 x

25

1 x

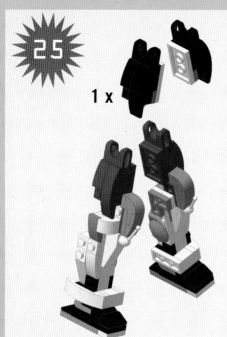

26

1 x
1 x

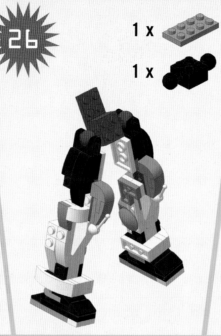

27

1 x
1 x

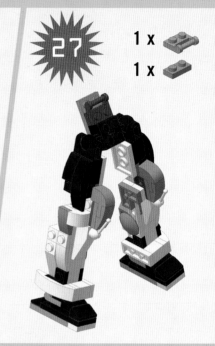

28

2 x
2 x
1 x

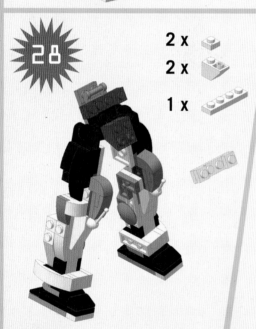

29

1 x

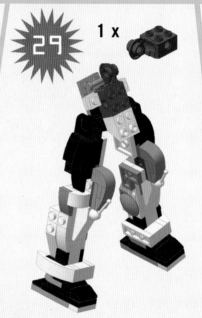

30

2 x

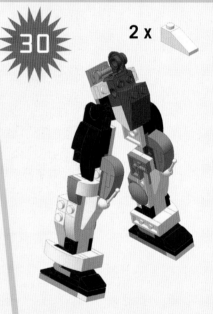

31

2 x
1 x

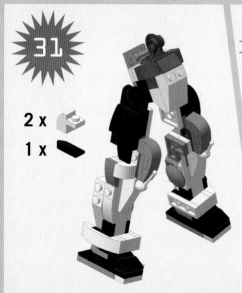

32

1 x

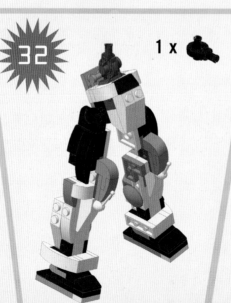

33

1 x
1 x

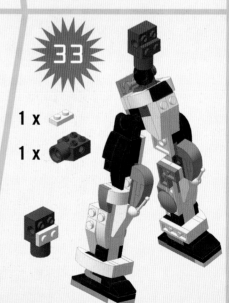

34

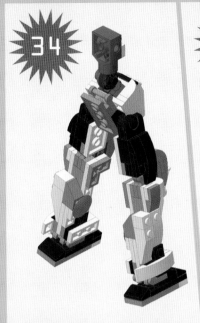

35

1 x

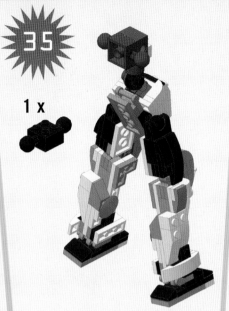

36

2 x
1 x
1 x
1 x
2 x

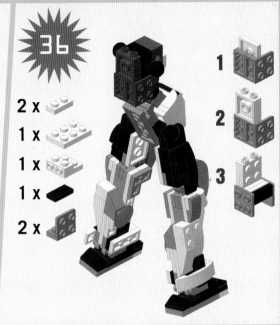

1
2
3

37

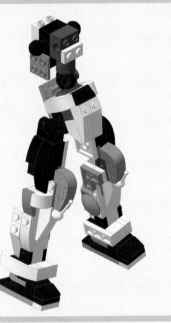

38

1 x
1 x
1 x
1 x

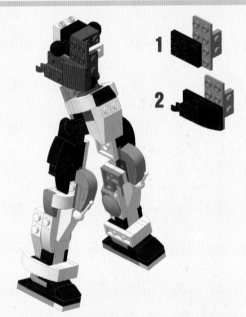

1
2

39

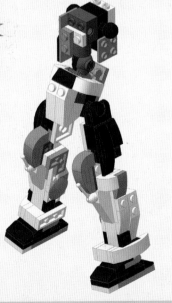

40

1 x
1 x
1 x
1 x

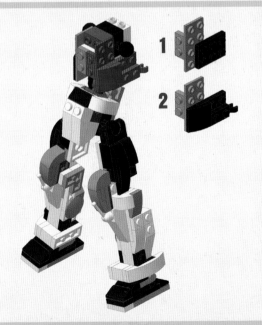

1
2

41

1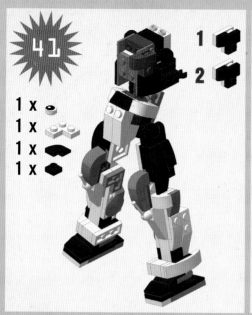
2

1 x
1 x
1 x
1 x

42

1
2

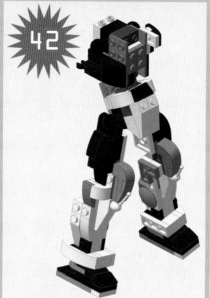

43

1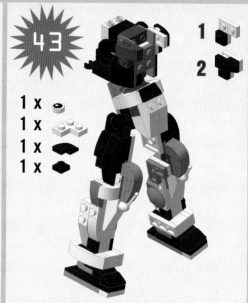
2

1 x
1 x
1 x
1 x

44

1 x
2 x

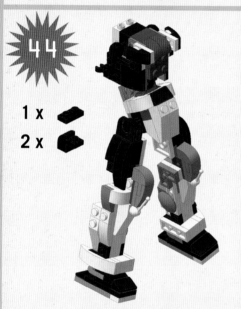

45

1 x
1 x

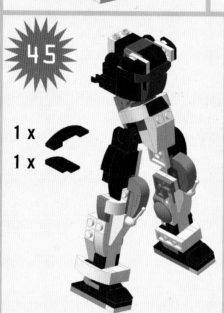

46

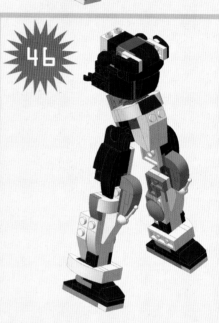

1

2 x

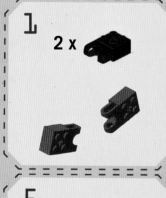

2

2 x
2 x

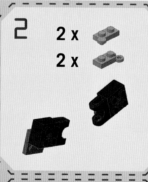

3

2 x

4

2 x
2 x

5

2 x

6

2 x

7

2 x
2 x

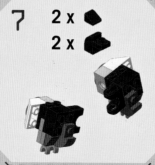

8

2 x

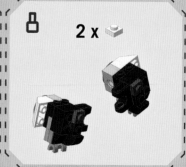

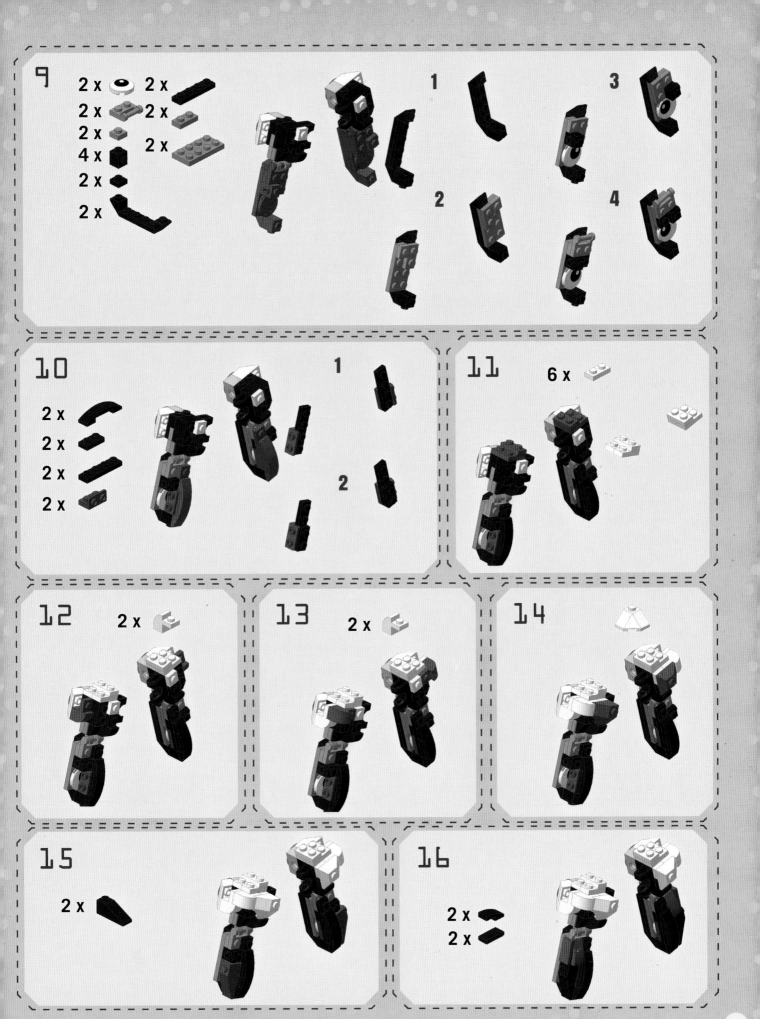

47

1 x

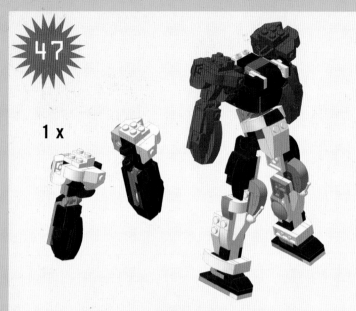

48

2 x
4 x
2 x

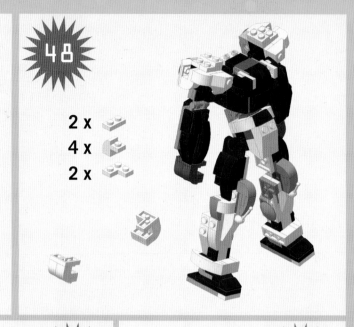

49

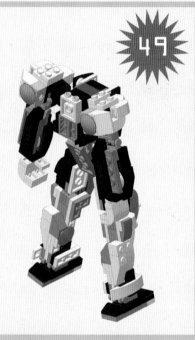

50

1 x
1 x
1 x
1 x
1
2

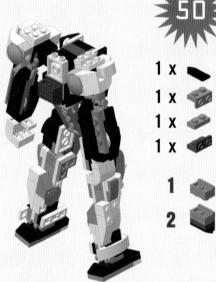

51

2 x
1 x

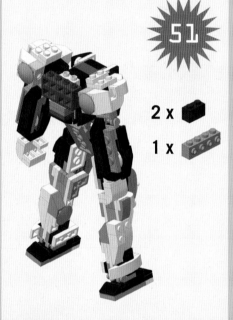

52

1 x

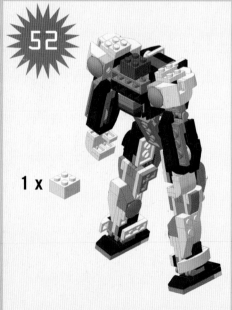

53

1 x
2 x
2 x

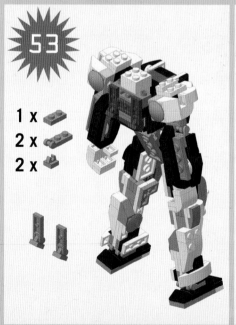

54

2 x
2 x
2 x

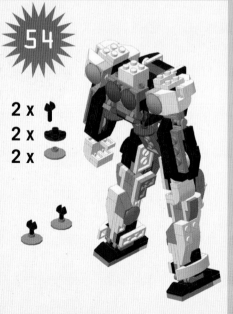

55

2 x

56

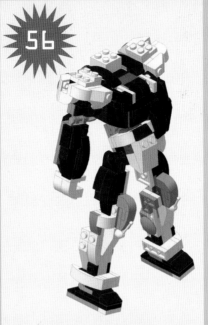

57

2 x
2 x

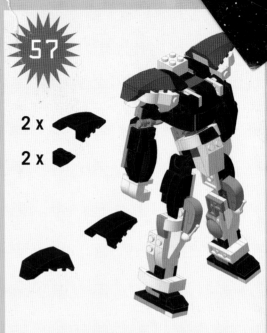

58

1 x
1 x

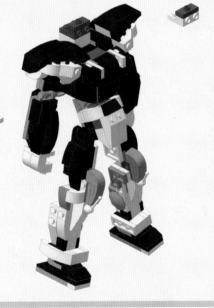

59

1 x
1 x
1 x
1 x
1 x

1
2

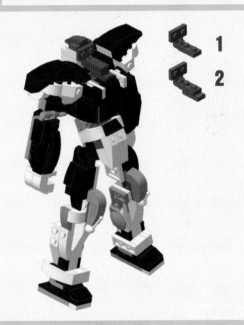

60

1 x
2 x
2 x
2 x
2 x

1
2
3

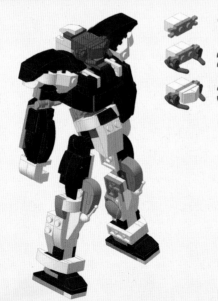

61

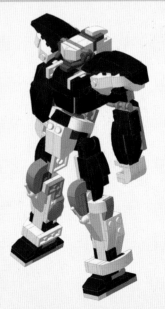

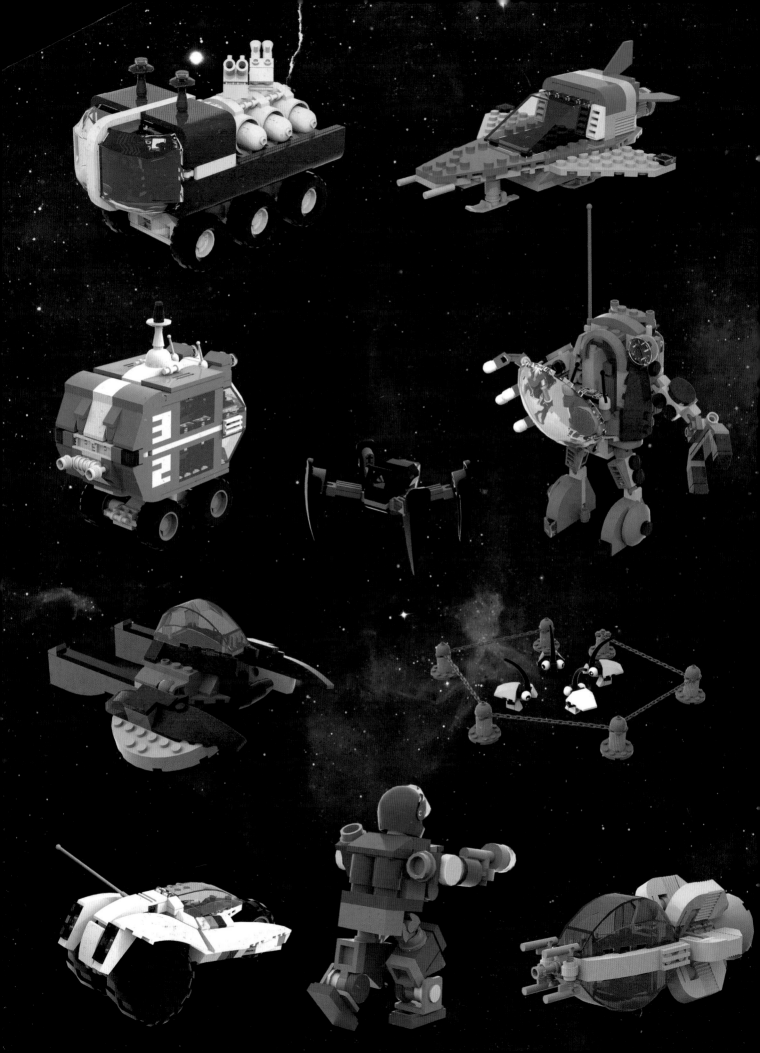

ACKNOWLEDGMENTS

This book is dedicated to my family: to my parents and to my father-in-law, because they never cease to encourage me to follow my dreams, and to my wife, Patty, who helps me to make them a reality and puts up with me while I'm trying.

I need to give my sincere thanks to everyone who contributed to the creation of this book.

Thanks to the publisher NuiNui, who maintained their faith in me after my first book, and to its staff, who did everything possible to help me bring this project to fruition.

Thank you to the ItLUG (the Italian LEGO® Users Group) for their help and support, for putting me in contact with the publisher ... and because everything began (again) with them.

Thank you to all the master builders who generously entrusted their models to me. I promise that I have taken the greatest possible care of them.

Thank you to my friends in the BrianzaLUG for their friendship and support. Thanks to the great Damiano Baldini, who is always ready to offer me help when I need it, and thanks also to Brickoni for their kindness and for everything they do for the little builders we love so much.

Thank you to Nicola Lugato, whose two software programs also made this second project possible: BluePrint for generating instructions and BlueRender for creating the digital images that appear throughout this book. Nicola's help was invaluable in configuring my computer correctly so that his two programs would work optimally and in configuring the software so that it would generate the instructions and illustrations in the format required by the publisher.

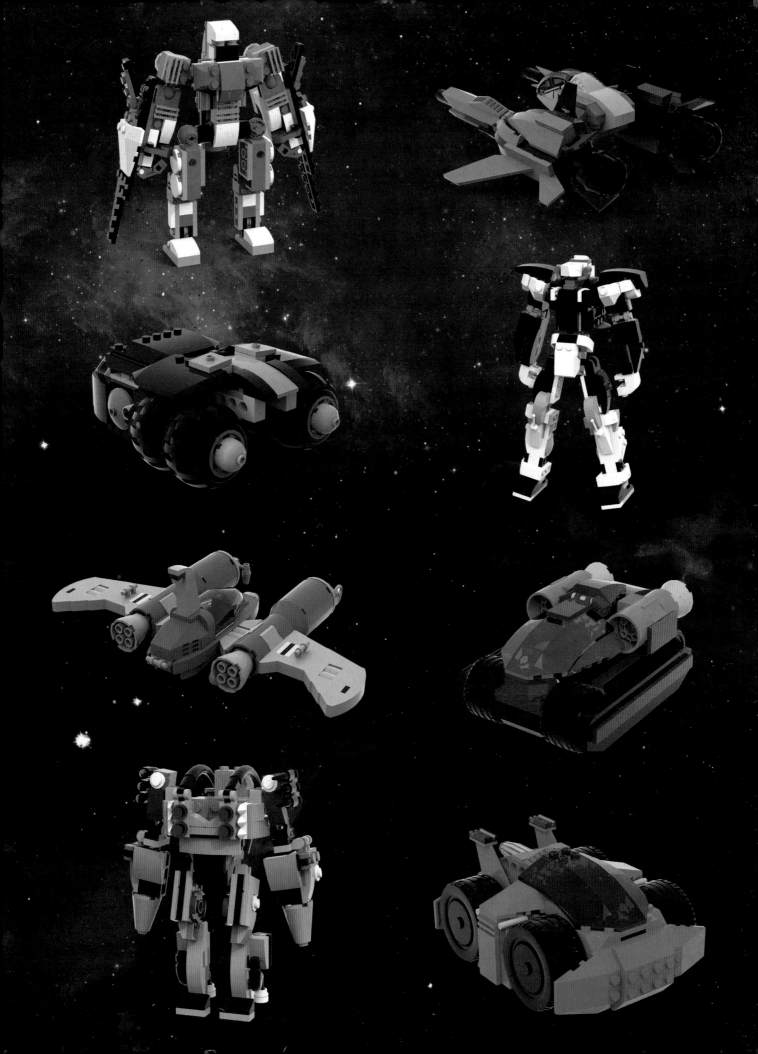

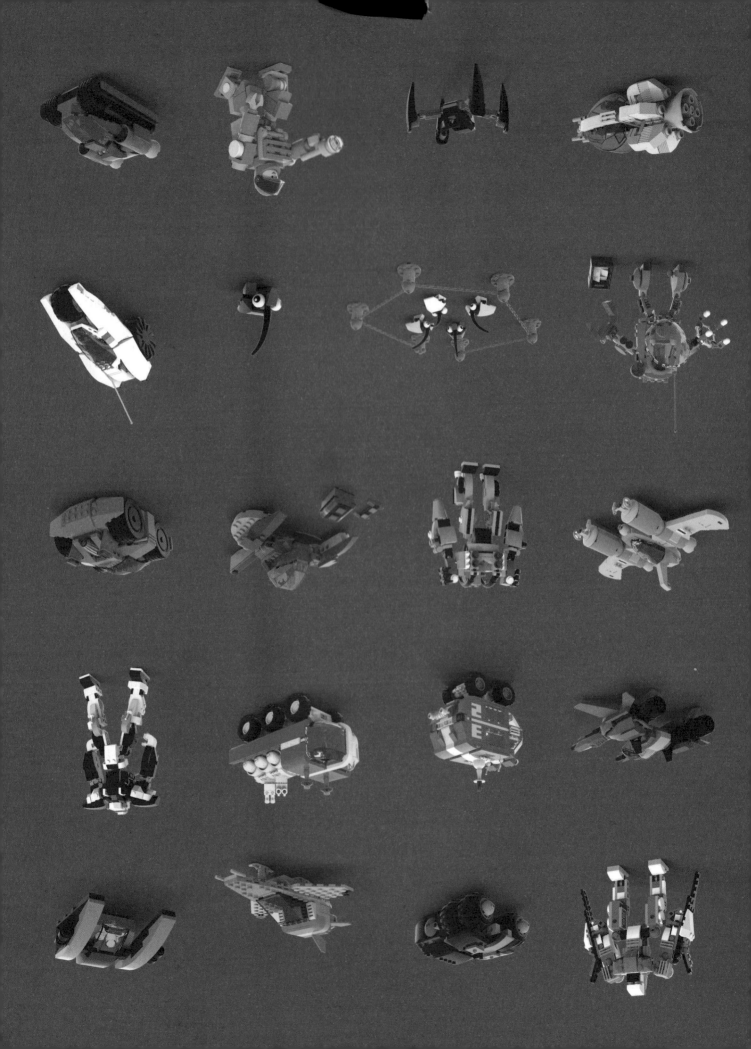

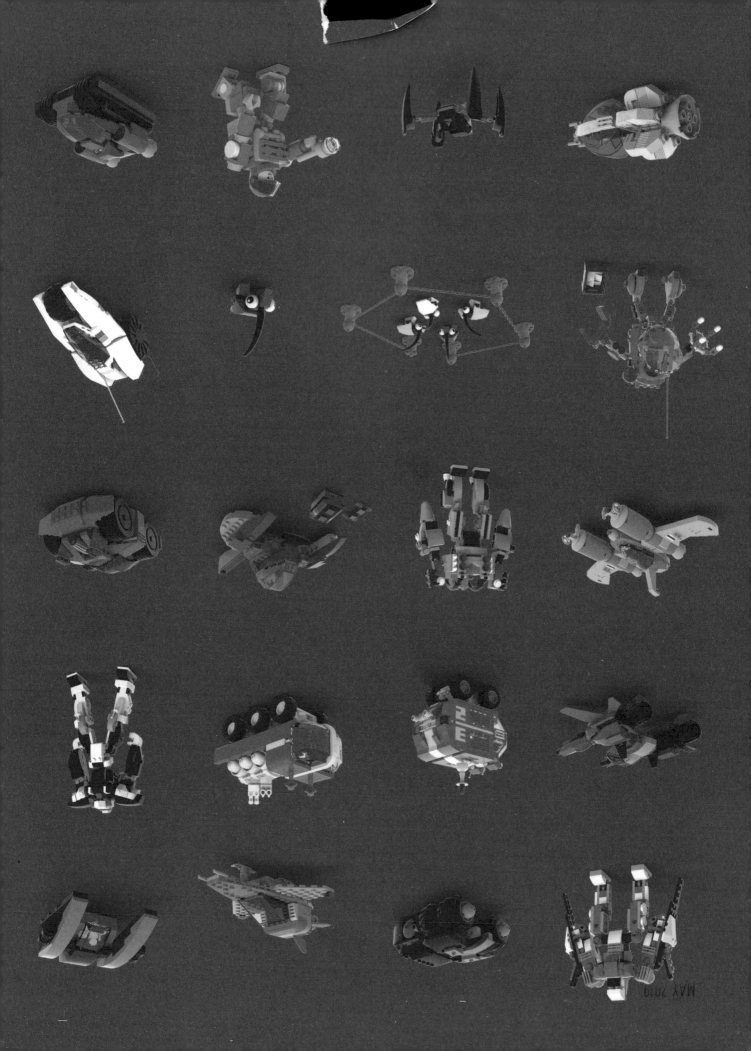

MAY 2019